ICONS

# Design

## of the 20th Century

**Cover:** Vico Magistretti, *Eclisse* lamp for Artemide, 1967
(Photo: Artemide, Pregnana Milanese)

© 2001 TASCHEN GmbH
Hohenzollernring 53, D–50672 Köln
**www.taschen.com**

© 2001 for the works by
Marianne Brandt: Bauhaus-Archiv GmbH/VG Bild-Kunst, Bonn
Charles & Ray Eames: Eames Office, Venice, CA, www.eamesoffice.com
Le Corbusier: FLC/VG Bild-Kunst, Bonn
Alphonse Mucha: Mucha Trust/VG Bild-Kunst, Bonn

© 2001 for the works by Josef Albers, Herbert Bayer, Lucian Bernhard, Max Bill,
Jean Dunand, René Lalique, Ludwig Mies van der Rohe, Gyula Pap, Charlotte Perriand,
Gerrit Rietveld, Richard Riemerschmid, Stiletto (Frank Schreiner), Bart van der Leck,
Wilhelm Wagenfeld, Frank Lloyd Wright: VG Bild-Kunst, Bonn

Editing: Susanne Husemann, Cologne
Production: Ute Wachendorf, Cologne
Design: Claudia Frey, Cologne
Cover design: Angelika Taschen, Claudia Frey, Cologne

Printed in Italy
ISBN 3–8228–5542–1

# Design

## of the 20th Century

Charlotte & Peter Fiell

TASCHEN

KÖLN LONDON MADRID NEW YORK PARIS TOKYO

Throughout the 20th century, design has existed as a major feature of culture and everyday life. Its compass is vast and includes three-dimensional objects, graphic communications and integrated systems from information technology to urban environments. Defined in its most global sense as the conception and planning of all man-made products, design can be seen fundamentally as an instrument for improving the quality of life.

To some extent, the origins of design can be traced to the Industrial Revolution and the birth of mechanized production. Prior to this, objects were craft-produced, meaning that the conception and realization of an object was most often undertaken by an individual creator. With the advent of new industrial manufacturing processes and the division of labour, design (conception and planning) was separated from making. At this time, however, design was viewed as just one of the many interrelated aspects of mechanized production. The forethought that went into design had no intellectual, theoretical or philosophic foundation and so had little positive impact on the nature of the industrial process or on society. Modern design can be seen to have evolved from 19th-century design reformers, and in particular from William Morris, who attempted to unite theory with practice. While this endeavour was largely unsuccessful due to the craft-based means of production used by Morris, his reforming ideas had a fundamental impact on the development of the Modern Movement. It was not until the early 20th century, when individuals such as Walter Gropius integrated design theory with practice through new industrial means of production, that modern design truly came into being. In an attempt to bridge the gulf between the social idealism and commercial reality that had existed up to the end of the First World War and to promote an appropriate response to the emerging technological culture, Gropius founded the Bauhaus in 1919. The goal of modern design, as pioneered and taught at the Bauhaus, was to produce work that unified intellectual, practical, commercial and aesthetic concerns through artistic endeavour and the exploitation of new technologies. While the Bauhaus advanced important new ways of thinking about design, it developed only some of the ideas necessary for the successful integration of design theory with the industrial process. The principles forged there were later developed at the New Bauhaus in Chicago, which was founded by László Moholy-Nagy in 1937, and at the Hochschule für Gestaltung, Ulm, which was founded in 1953. Both these teaching institutions made important contributions to new thinking about the unification of design theory and practice in relation to industrial methods of production.

Throughout the 20th century, the products, styles, theories and philosophies of design have become evermore diverse. This is due in large

part to the growing complexity of the design process. Increasingly in design for industrial production, the relationship between conception, planning and making is fragmented and complicated by a series of interlinked specialized activities involving many different individuals, such as model makers, market researchers, materials specialists, engineers and production technicians. The products of design that result from this multi-faceted process are not the outcome of individual designers, but the outcome of teams of individuals, all of whom have their own ideas and attitudes about how things should be. The historic plurality of design in the 20th century, however, is also due to changing patterns of consumption, changing taste, the differing commercial and moral imperatives of inventors/designers/makers, technological progress, and varying national tendencies in design.

*"design ... is a manifestation of the capacity of the human spirit to transcend its limitations."* George Nelson, *The Problems of Design*, 1957

In the study of design history, it is important to remember that the products of design cannot be fully understood outside of the social, economic, political, cultural and technological contexts that gave rise to their conception and realization. At different times in the 20th century, for example, the economic cycles of Western economies have had a significant impact on the prevalence of objects that emphasize design over styling – and vice versa. While styling is often a complementary element of a design solution, design and styling are completely distinct disciplines. Styling is concerned with surface treatment and appearance – the expressive qualities of a product. Design, on the other hand, is primarily concerned with problem solving – it tends to be holistic in its scope and generally seeks simplification and essentiality. During economic downturns, Functionalism (design) tends to come to the fore while in periods of economic prosperity, anti-rationalism (styling) is apt to flourish.

Increasingly throughout the 20th century, the interests of businesses to create competitive products have driven the evolution and diversity of design as well as the careers of individual designers. While some designers work within corporate structures, others work in consultancies or independently. Many independent designers choose to operate outside of the constraints of the industrial process, preferring to produce work that is mainly concerned with self-expression. Design is not only a process linked to mechanized production, it is a means of conveying persuasive ideas, attitudes and values about how things could or should be according to individual, corporate, institutional or national objectives. As a channel of communication between people, design provides a particular insight into the character and thinking of the designer and his/her beliefs about what is important in the relationship between the object (design solution), the user/consumer, and the design process and society. To this extent, this book

does not promote a single unifying theory of design or ideology. Rather, its aim is to highlight the pluralistic nature of design and the idea that, historically, design can be viewed as a debate between conflicting opinions about such issues as the role of technology and the industrial process, the primacy of utility, simplicity and affordability over luxury and exclusivity, and the role of function, aesthetics, ornament and symbolism in practical objects for use.

This survey of design in the 20th century features those concepts, styles, movements, designers, schools, companies and institutions that have shaped the course of design theory and practice, or have advanced the development of innovative forms, materials applications, technical means and processes, or have influenced taste, the history of style in the applied and decorative arts, and culture and society in general. The areas of activity covered include: furniture, product, textile, glass, ceramic, metalware and graphic design, with interior design and architecture receiving only occasional mention. While a certain amount of industrial design has also been included, a companion book, entitled *Industrial Design*, is dedicated to this broad field of study, which encompasses among other things the realms of transport, military, medical, heavy industrial, sports and safety-equipment design.

The geographic area covered by this book has been limited to mainly Europe and North America, with a few outlying countries. While the scope of the book's subject demands selectivity, it is hoped that those entries chosen for inclusion will be seen as broadly representative of the many different currents in thinking and approaches to design over the last hundred years.

Through highlighting the diverse nature of design, a further aim of this book is to demonstrate that the attitudes, ideas and values communicated by designers and manufacturers are not absolute, but are conditional and fluctuate. Design solutions to even the most straightforward of problems are inherently ephemeral as the needs and concerns of designers, manufacturers and society change. Perhaps the most significant reason for diversity in design, however, is the general belief that, despite the authority and success of particular design solutions, there is always a better way of doing things.

# Catalogue

Aalto to Zanuso

### Alvar Aalto

1898 *Kuortane, Finland*
1976 *Helsinki*

Hugo Alvar Hendrik Aalto studied architecture at the Helsingin Teknilien Korkeakoulu, Helsinki from 1916 to 1921. For the next two years, he worked as an exhibition designer and travelled extensively in central Europe, Italy and Scandinavia. In 1923, he established his own architectural office in Jyväskyla, which later moved to Turku (1927–1933) and then Helsinki (1933–1976). In 1924, he married the designer, Aino Marsio (1894–1949) and for five years they conducted experiments together into the bending of wood. This research led to Aalto's revolutionary chair designs of the 1930s. In 1929, he co-designed an exhibition to celebrate Turku's 700th anniversary – his first complete and Modern structure for Scandinavian public display. His most celebrated architectural projects were his own house in Turku (1927), which is generally regarded as one of the first expressions of Scandinavian Modernism, the Viipuri Library (1927–1935), the Paimio Tuberculosis Sanatorium (1929–1933) and the Finnish Pavilion for the New York World's Fair (1939).

Having turned to laminated wood and plywood as his materials of choice in 1929, Aalto began investigating veneer bonding and the limits of moulding plywood with Otto Korhonen, the technical director of a furniture factory near Turku. These experiments resulted in Aalto's most technically innovative chairs, the *No. 41* (1931–1932) and the cantilevered *No. 31* (1932), both of

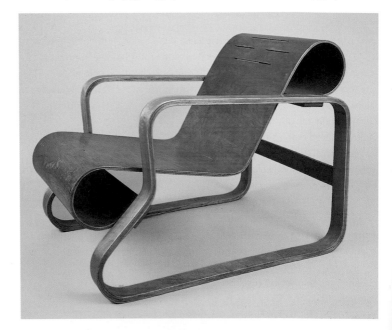

▸ *Model No. 41*
*Paimio* chair for
Huonekalu-ja
Rakennustyötehdas
(later manufactured
by Artek), 1930–1931

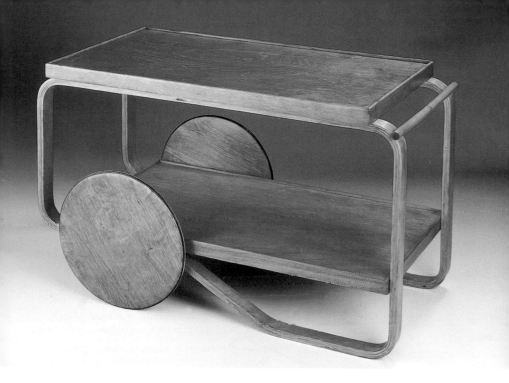

▲ *Model No. 98* tea trolley for Artek, 1935–1936

which were designed contemporaneously with or as part of the Paimio Sanatorium scheme. These designs signalled to the international avant-garde a new trend in materials towards plywood and established Aalto as one of the pre-eminent designers this century. The sales success of his furniture designs, such as the *L-legged* stacking stools (1933), led Aalto and his wife to form the manufacturing company Artek in 1935.

Aalto believed that his most important contribution to furniture design was his solving of the age-old problem of connecting vertical and horizontal elements. His bentwood solution developed in conjunction with Korhonen, which Aalto dubbed "the little sister of the architectonic column", allowed legs to be attached directly to the underside of a seat without the need for any framework or additional support. This novel technique gave rise to his series of *L-leg* (1932–1933), *Y-leg* (1946–1947) and *fan-leg* (1954) furniture. Aalto's designs are notably characterized by the use of organic forms, for example, his famous *Savoy* vase of 1937. Originally entitled "Eskimoerindens skinnbuxa" (Eskimo woman's leather trousers) and manufactured by Iittala, the *Savoy* vase is said to have been inspired by the fjord shorelines of his native Finland. Aalto strongly believed that design should

be humanizing and he rejected man-made materials such as tubular metal in furniture, because, for him, they were unsatisfactory to the human condition.

Aalto's work was very well received in Britain and America during the 1930s and 1940s and, as one of the founding fathers of Organic Design, his design philosophy was highly influential to post-war designers such as Charles and Ray Eames. As an early opponent of the Modern Movement's alienating machine aesthetic and rigidly rationalist approach to design, Aalto stated: "The best standardization committee in the world is nature herself, but in nature standardization occurs mainly in connection with the smallest possible units, cells. The result is millions of flexible combinations in which one never encounters the stereotyped." (cited in Andrei Gozak, *Alvar Aalto vs. the Modern Movement*, Helsinki 1981, p. 78)

Aalto believed that design should not only acknowledge functional requirements but should also address the psychological needs of the user and that this was best achieved through the use of natural materials and especially wood, which he described as "the form inspiring, deeply human material" (Göran Schildt, *Alvar Aalto Sketches*, Cambridge, Mass. 1987, p. 77). Aalto's pioneering organic designs not only provided a new vocabulary of form, they also eloquently represented, to the general public, the acceptable face of Modernism. In 1952, he married the architect Elissa Mäkiniemi, with whom he collaborated until his death.

Aalto's life and work was celebrated by the Museum of Modern Art, New York through three exhibitions held in 1938, 1984 and 1997.

▼ *Models No. X601 & X600 fan-leg* stools for Artek, 1954

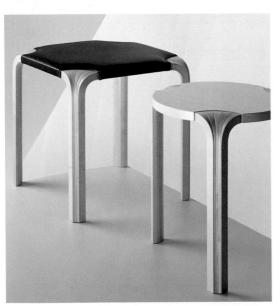

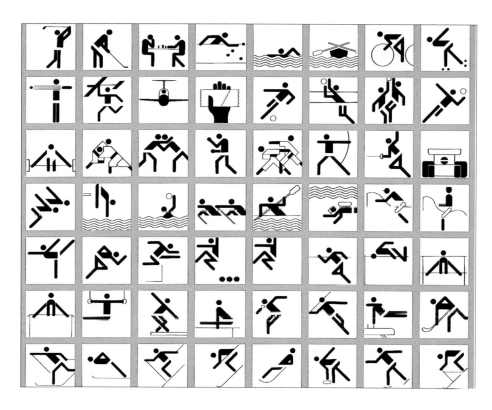

Otl Aicher studied sculpture at the Akademie der Bildenden Künste, Munich from 1946 to 1947 before setting up his own graphics studio in 1948 in Ulm, which was moved to Munich in 1967 and Rotis, Allgäu in 1972. During the 1950s, working alongside Hans Gugelot and Dieter Rams, Aicher formulated a coherent and rational design aesthetic for Braun. From 1949 to 1954, he was involved in the founding and development of the Hochschule für Gestaltung, Ulm – the most influential post-war German design school. In 1952, he married a co-founder of the school, Inge Scholl, and from 1954 to 1965 he lectured in the visual communications department at Ulm and was a visiting lecturer at Yale University. He subsequently held the directorship of the Hochschule für Gestaltung from 1962 to 1964 and his teachings and writings on design theory were notable for their advancement of Utopian ideals and, ultimately, Radical Design. Although Aicher mainly worked as a designer of corporate identities, he is best known for his graphics for the 1972 Munich Olympic Games, which incorporated a system of universally recognizable pictograms.

**Otl Aicher**
1922 Ulm, Germany
1991 Rotis, Germany

▲ Pictograms designed for the Munich Olympic Games, 1972

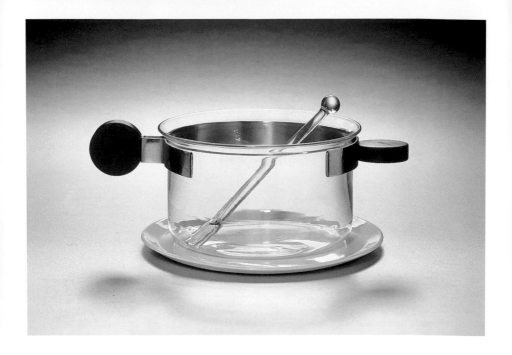

## Josef Albers

1888 *Bottrop, Germany*
1976 *New Haven,*
*Connecticut*

▲ Tea glass by
Jenaer Glaswerke
Schott & Gen. and
Meissen porcelain
factory for the Bau-
haus Dessau, 1926

Josef Albers initially trained as a primary school teacher and taught in West-
phalia from 1905 to 1913. He later studied at the Königliche Kunstschule,
Berlin from 1913 to 1915 and under Jan Thorn-Prikker at the Kunstgewerbe-
schule, Essen, where he stayed on as a teacher for three years. Albers subse-
quently attended the Akademie der Bildenden Künste, Munich from 1919 to
1920, and from 1920 to 1933 studied and taught at the Bauhaus in Weimar
and Dessau. After completing the preliminary course on 1921, he helped to
establish a glass-painting workshop at the school, which he directed from
1923. Albers also taught on the Bauhaus' preliminary course in form and in
1925 was the first student to become a master. That same year, Albers mar-
ried the textile designer, Anni Fleischmann, and in 1928 became director of
the carpentry workshop at the Bauhaus. When the Bauhaus was closed by
the National Socialists in 1933, he emigrated to the USA, teaching at Black
Mountain College, North Carolina for the next sixteen years. From 1950 to
1960, Albers was director of the design department at Yale University, New
Haven and from 1953 to 1954, was also a visiting professor at the Hoch-
schule für Gestaltung, Ulm. Although his work was eclectic at times, it was
fundamentally characterized by simplified abstracted geometric forms and
a minimal use of materials.

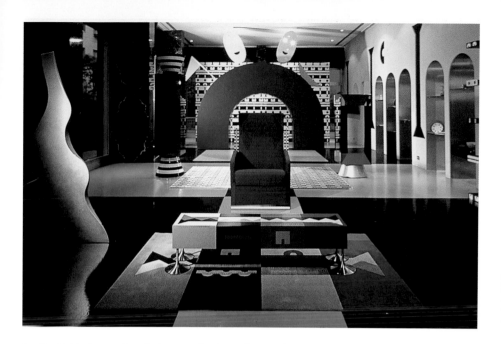

Studio Alchimia was founded in 1976 by the architect Alessandro Guerriero (b. 1943), initially as a gallery to display experimental work that was not constrained creatively by industrial production. The studio's allusion to alchemy intentionally mocked the scientific rationale behind Modernism. Alchimia subsequently grew into an influential design studio with contributions from Ettore Sottsass, Alessandro Mendini, Andrea Branzi, Paola Navone (b. 1950) and Michele De Lucchi among others. The ironically entitled Bau.Haus 1 and Bau.Haus 2 collections, of 1978 and 1979 respectively, drew inspiration and references from popular culture and ultimately Kitsch. During the 1980s, Mendini became the Studio's leading exponent and his redesigns of classic furniture, such as Gio Ponti's *Superleggera* chair and Marcel Breuer's *Wassily* chair, ridiculed the pretensions of Good Design and thereby good taste. Mendini's *Mobile Infinito* series of 1981 allowed the user to alter the position of the applied decorative elements, thus facilitating a creative interaction. Politically charged, elitist and self-consciously intellectual, Studio Alchimia's designs were fundamental to the second wave of Italian Radical Design, which culminated in the popularization of Anti-Design in the 1980s.

**Studio Alchimia**
Founded 1976
*Milan*

▲ *Olli* and *Soli*
collections, 1988

**Archizoom**
**Associati**
1966–1974
*Florence*

▼ **Archizoom**
**Associati**, *Safari*
modular livingscape
for Poltronova, 1968

Archizoom Associati was founded by Andrea Branzi, Paolo Deganello, Gilberto Corretti (b. 1941) and Massimo Morozzi (b. 1941) in Florence in 1966, and took its name from the British architectural group Archigram and an issue of their journal *Zoom*. Archizoom created radical architectural projections such as *Wind City* (1969) and *No-Stop City* (1970) in an attempt to demonstrate, among other things, that if Rationalism was taken to an extreme it became illogical and thereby anti-rational. Archizoom stated that: "The ultimate aim of modern architecture is the elimination of architecture itself." (A. Branzi, *The Hot House; Italian New Wave Design*, London 1984, pp. 73–74). In 1966 and 1967, Archizoom organized two exhibitions of "Superarchitettura" with Superstudio in Pistoia and Modena. In 1968, Dario (b. 1943) and Lucia Bartolini (b. 1944) joined the group which, from 1971 to 1973, researched fashion design. They also produced several notable furniture designs including the *Dream Beds* series (1967), the *Safari* sectional seating unit (1968), the *Superonda* sofa (1966) and the *Mies* chair (1969), all of which drew references from popular culture and Kitsch while mocking the pretensions of Good Design. In 1972, Archizoom was included in the "Counterdesign as Postulation" section of the landmark exhibition "Italy: The New Domestic Landscape" held at the Museum of Modern Art, New York.

Art Deco was an international decorative style, rather than a design movement, which emerged in Paris during the 1920s. Prior to this, elements of the style had already appeared in the work of the Wiener Werkstätte, the Italian furniture designer Carlo Bugatti and the Russian Constructivists. Taking over from the turn-of-the-century Art Nouveau, which with its ahistorical bearing looked to natural forms, Art Deco drew its stylistic references from an eclectic range of sources including ancient Egyptian civilization, tribal art, Surrealism, Futurism, Constructivism, Neo-Classicism, geometric abstraction, popular culture and the Modern Movement. Leading exponents of the new style, such as Jacques-Émile Ruhlmann, espoused for the most part the ideal of superlative craftsmanship and incorporated exotic woods and luxury materials such as shagreen and mother-of-pearl in their designs. Its reliance on private patronage, most notably from the French couturiers, Paul Poiret and Jacques Doucet, and its incompatibility with industrialized production ensured that Art Deco was a relatively short-lived style, inevitably overtaken by more progressive approaches to design.

The "Exposition Internationale des Arts Décoratifs et Industriels Modernes", held in Paris in 1925, included Le Corbusier's Pavillon de l'Esprit Nouveau as well as Ruhlmann's Hôtel du Collectionneur and exhibits by other well-known Art Deco designers such as Pierre-Émile Legrain. It was from the title of this landmark exhibition that the term Art Deco was eventually coined. From the beginning, the Art Deco style spanned the work of designers such as René Lalique, Jean Dunand (1877–1942), and Edgar-William Brandt (1880–1960) as well as the creations of modernists such as Eileen Gray, Pierre Chareau and Robert Mallet-Stevens. Indeed, even designers closely associated with the Modern Movement, such as Le

▼ **Edgar-William Brandt**, *La Tentation* floor lamp, c. 1925 (base by E.-W. Brandt, shade by Daum Frères)

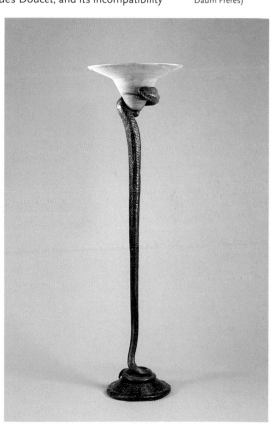

Corbusier and Jean Prouvé, were at times inspired by the sumptuousness of Art Deco.

After 1925 the style was expressed in the work of many designers, not only in France and continental Europe but increasingly in Britain and the United States. It was particularly well received in America where designs such as Paul Frankl's *Skyscraper* furniture and William van Alen's Chrysler Building (1928–1930) in New York – perhaps the ultimate expression of Art Deco architecture – were seen to encapsulate the aspirations of the nation.

In Britain, the Art Deco style was more subdued than elsewhere and was subtly expressed in the architecture and product design of Wells Coates. The style was also frequently used in Britain for cinemas, especially those owned by Odeon, which projected, inside the silver-screen world of Art Deco, boudoirs and Hollywood-style chromed glamour. During the 1930s, the style became increasingly popular owing to its associations with this dreamlike Hollywood lifestyle and, as a result, was eventually fully embraced by mainstream manufacturers. Although Bakelite had been developed in America in 1907, it was not until the late 1920s that this thermoset plastic became a viable material for large-scale mass-production. The sculptural Art Deco style was eminently suited to the moulding requirements of this new medium and during the 1930s Art Deco radio casings, together with a plethora of other Bakelite objects, were mass produced. The Art Deco style, however, became increasingly debased with the production of kitsch objects that had little in common with the superior craftsmanship of earlier French Art Deco objects. Eventually, the style was curtailed by the advent of the Second World War when its essential reliance on decoration and its maximalist aesthetic could no longer be sustained.

In the 1960s, Art Deco began to enjoy a reappraisal both on the collectors' market and among young designers disillusioned with Modernism. During the 1980s, post-modern designers such as Robert Venturi, Hans Hollein and Charles Jencks paid homage to Art Deco through their own idiosyncratic work which, like that of their antecedents, revelled in excess and exuberance.

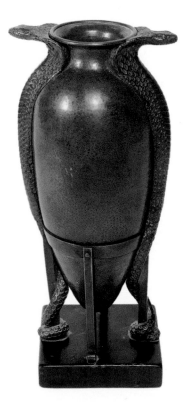

▼ Jean Dunand,
Snakevase, c. 1913

Art Nouveau was an ahistorical style that emerged during the 1880s. It was inspired by the earlier British Arts & Crafts Movement, which was sometimes known as the "New Art". During the 1890s, Charles Rennie Mackintosh and designers associated with the Vienna Secession, such as Josef Maria Olbrich, introduced abstracted naturalistic forms to design that were curvilinear while others, such as Hermann Obrist and August Endell, pioneered the use of whiplash motifs.

One of the greatest exponents of Art Nouveau was the Belgian architect Victor Horta, whose Hotel Tassel (1892–1893) was one of the first expressions of the style in architecture. This residential project innovatively incorporated ironwork as both a structural and decorative device, and the designer's use of stem-like columns that branched into swirling tendrils led to the coining of the term "Horta Line". Similarly, in France, the style became known as "Style Guimard" in recognition of the writhing and intertwined forms employed by Hector Guimard – most, notably for his cast-iron entrances to the Paris Métro (c. 1900). There, the term "Le Style Moderne" was also used to

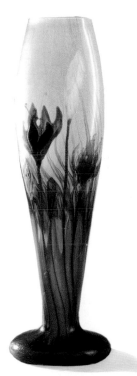

▶ **Émile Gallé**,
Cameo vase with
autumn crocus
decoration, 1899

identify Art Nouveau, while in Germany the name Jugendstil was adopted. In Spain, especially in Catalonia, the Art Nouveau style flourished through the work of Antonio Gaudí y Cornet and his followers. They generally referred to Art Nouveau as "Modernisme" while in Italy the term "Stile Liberty" was coined in recognition of the role played by the London department store Liberty & Co. in the promotion of the style.

Émile Gallé and other designers associated with the École de Nancy produced notable furniture and glassware in the Art Nouveau style. The sinuous lines

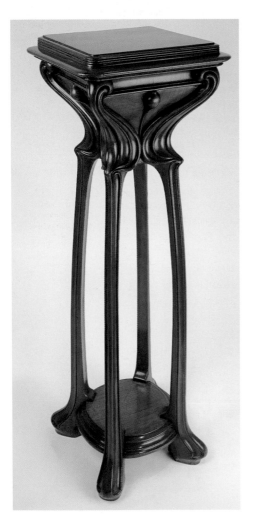

◄ **Eugène Gaillard**,
Pedestal for
J. P. Christophe,
c. 1901–1902

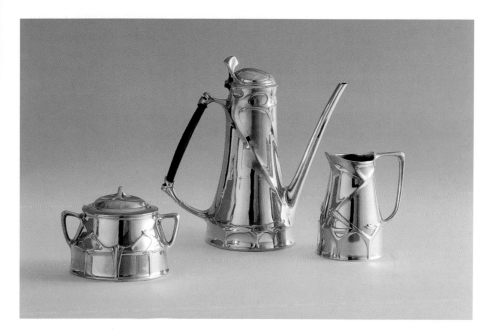

and the elongation of floral forms, which readily identify Art Nouveau, were directly inspired by the natural world rather than past styles. Indeed, the abstracted and bulbous forms of Louis Comfort Tiffany's Favrile vases capture the very essence of nature. The reason designers of the 1890s looked to nature for inspiration had much to do with earlier scientific research into the workings of the natural world such as Darwin's treatise *On the Origin of Species*, published in 1859, the botanical illustrations of Ernst Haeckel (1834–1919) and the exquisite photographic flower studies taken by Karl Blossfeldt (1865–1932) in the late 19th century.

With its outright rejection of historicism, Art Nouveau can be considered the first truly modern international style. It became inextricably linked to the decadence of the *fin-de-siècle*, however, owing to its reliance on ornamental motifs. As a result, it was overtaken stylistically in the early 20th century by the machine aesthetic and the avant-garde's preference for simple geometric forms better suited to industrial production.

▲ **Friedrich Adler,**
Coffee service for
Metallwarenfabrik
Orion, 1904

Although Walter Gropius was put forward for the directorship of the Kunst-gewerbeschule at Weimar, which had been founded by Henry van de Velde in 1908, it closed before he could take up the position in 1915. Gropius maintained his contacts, however, at Weimar's other art school, the Hoch-schule für Bildende Kunst. As a soldier during the First World War, Gropius became anti-capitalist, his sympathies lying more with the craft ideals of the Helgar workshops than with the Deutscher Werkbund and its belief in in-dustrial production. While at the front, Gropius formulated his "Proposals for the establishment of an educational institution to provide artistic advi-sory services to industry, trade and craft". In January 1916, his recommenda-tions for the merging of the Kunstgewerbeschule and the Hochschule für Bildende Kunst into a single interdisciplinary school of craft and design were sent to the Großherzogliches Sächsisches Staatsministerium.

▼ **Fritz Schleifer,**
Poster for the
Bauhaus Exhibition
in Weimar, 1923

In April 1919, Gropius was duly appointed director of the new Staatliches Bauhaus in Weimar and that same year the Bauhaus Manifesto was pub-lished. The Bauhaus, which means "building house", sought to reform edu-cational theory and, in so doing, bring unity to the arts. For Gropius, construction or "making" was an important social, symbolic and in-tellectual endeavour and this senti-ment pervaded Bauhaus teaching. The curriculum included a one-year preliminary course where students were taught the basic principles of design and colour theory. After completing this foundation year, students entered the various work-shops situated in two buildings and trained in at least one craft. These workshops were intended to be self-supporting, relying on private com-missions. The tutors were known as "masters" and some of them were members of local guilds, while the students were referred to as "apprentices".

During the Bauhaus' first year, Gropius appointed three artists: Jo-hannes Itten, who was responsible

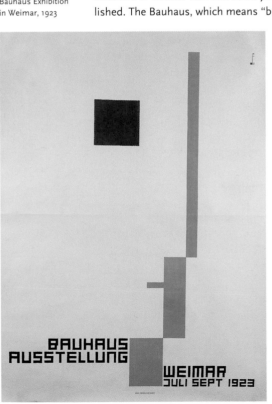

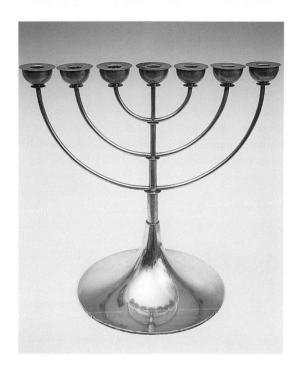

◄ Gyula Pap,
Candelabra made in
the metal workshop
in Weimar,
1922–1923

for the preliminary course, Lyonel Feininger (1871–1956) and Gerhard
Marcks. These tutors were joined by other Expressionists – Georg Muche
(1895–1987) at the end of 1919, Paul Klee (1879–1940) and Oskar Schlem-
mer (1888–1943) in 1921 and Wassily Kandinsky (1866–1944) in 1922.
During the earliest period of the Bauhaus, it was the charismatic Itten
who played the most important role.
Itten's classes, which often commenced with breathing exercises and gym-
nastics, were based on "intuition and method" or "subjective experience
and objective recognition". He believed that materials should be studied so
as to unveil their intrinsic qualities and encouraged his students to make in-
ventive constructions from *objets trouvés*. Itten also taught theories of form,
colour and contrast as well as the appreciation of art history. In accord with
Gropius, Itten believed that natural laws existed for spatial composition just
as they did for musical composition and students were taught the impor-
tance of elemental geometric forms such as the circle, square and cone.
Like Kandinsky, Itten attempted to reintroduce the spiritual to art.
Both Itten and Muche were highly involved with the Mazdaznan sect and
tried to introduce its teachings to the Bauhaus. Heads were shaved, loose

monk-like garments worn, a vegetarian diet with vast amounts of purifying garlic and regular fastings adhered to, acupuncture and hot baths practised. However, this Mazdaznan adventure into meditation and ritual undermined Gropius' authority and turned students against him. Eventually, conflict arose between Gropius and Itten and the latter subsequently left in December 1922, marking the end of the Expressionist period at the Bauhaus. Josef Albers and László Moholy-Nagy were appointed as Itten's successors and although they followed the fundamental framework of his preliminary class, they rejected his ideologies for individual creative development and pursued a more industrial approach with students being taken on factory visits. Given Itten's bizarre teaching methods and the school's underlying socialist bearing, it is not surprising that, as a state institution, the Bauhaus attracted much political opposition in Weimar. The local authorities there, under

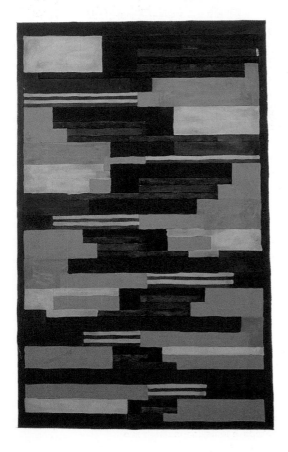

◄ **Lena Bergner,**
Design for a bedroom
carpet, 1928

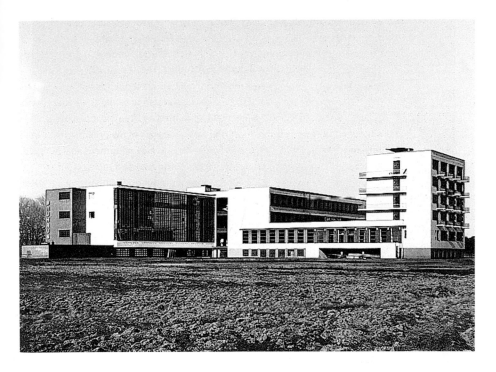

pressure from local guilds who were concerned that work would be taken from their own members by Bauhaus students, demanded the staging of an exhibition so as to justify the State's continued support. The exhibition held in 1923 not only featured work from the Bauhaus but also included De Stijl designs such as Gerrit Rietveld's *Red/Blue chair* of 1918–1923. The influence of De Stijl on the Bauhaus cannot be overstated, indeed Theo van Doesburg had lectured in Weimar. Another development seen at the 1923 exhibition was the new image that the Bauhaus forged for itself – the graphics from this period were self-consciously modern incorporating "New Typography", which was undoubtedly inspired by De Stijl and Russian Constructivism. Although this landmark exhibition received critical acclaim internationally, especially from the United States, it did not allay local fears. When Weimar became the first city in Germany to elect the National Socialist German Workers' Party, the school's grant was halved and in 1925 Gropius was forced to move the Bauhaus, which was by then regarded as a hotbed of communism and subversion.

The school was relocated to Dessau where the ruling Social Democrats and the liberal mayor were far more politically receptive to its continuation and

success. This industrial city, which was benefitting from the assistance loans from America made available by the Dawes Plan, offered the Bauhaus the financial support it so desperately needed. The aid was granted on the understanding that the school would part-fund itself through the production and retail of its designs. The amount of money offered meant that a new purpose-built school could be constructed and so, in 1926, the Staatliches Bauhaus moved into its newly completed Dessau headquarters, designed by Walter Gropius. In nearby woodland, a series of masters' houses of stark geometric design were constructed, which served as blueprints for future living. The Bauhaus Dessau building itself, with its highly rational pre-fabricated structure, marked an important turning point for the school from crafts towards industrial Functionalism. The masters were now referred to as professors and were no longer involved with the guilds while the school instituted the issuing of its own diplomas. By now, Gropius had become disillusioned with socialism and believed that Henry Ford's type of industrial capitalism could benefit workers and that in order to survive the Bauhaus needed to adopt an industrial approach to design.

▼ Marcel Breuer,
*Lattenstuhl* made
in the furniture
workshop in Weimar,
1922–1924

With the conviction that a better society could be created through the application of functionalism, Bauhaus designs were now conceived for industrial production and a machine aesthetic was consciously adopted. In November

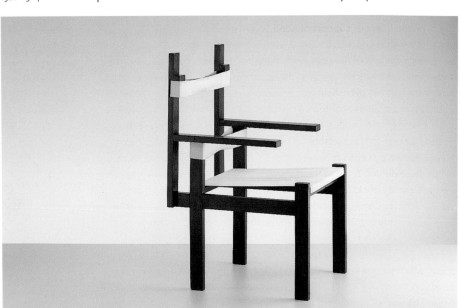

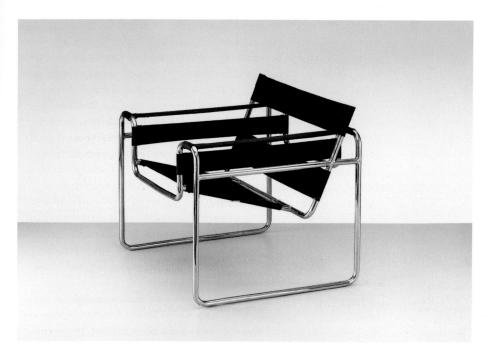

1925, with the financial support of Adolf Sommerfeld, Gropius realized his long-held ambition of establishing a limited company to promote and retail the school's designs. Bauhaus GmbH duly produced a catalogue, designed by Herbert Bayer, which illustrated Bauhaus products. The sales of these items were far from overwhelming, however. For the most part, this was no doubt due to the severity of the products' aesthetic but there was a further problem: though they appeared to be machine-made, the majority of the products were in fact unsuitable for industrial production. A few licensing agreements were drawn up between the Bauhaus and outside manufacturers but these did not bring in the revenues Gropius had hoped for.

In 1928, Gropius tried to hand over the directorship of the Bauhaus to Ludwig Mies van der Rohe so that he could spend more of his time designing, but Mies refused. Eventually, the Swiss architect, Hannes Meyer (1889–1954), who had been appointed professor of the architecture department when it opened in April 1927, agreed to take over the position at the school, which by now was subtitled "Hochschule für Gestaltung" (Institute of Design).

Meyer, who was a Communist, held the directorship until July 1930. He believed that form had to be governed by function and cost so that products

▲ **Marcel Breuer,** *Model No. B3 Wassily* chair, Bauhaus Dessau, 1926

would be both practical and affordable for working-class consumers. He attempted to introduce lectures on economics, psychology, sociology, biology and Marxism to the curriculum and closed the theatre workshop and reorganized the other workshops in an effort rid the school of the costly "artiness" of previous years. During Meyer's tenure, the Bauhaus' approach to design became more scientific and the earlier Constructivist influence all but vanished. At this time, the Bauhaus also became more politicized with the school site being used as the focus for the political activities of a group of Marxist students. By 1930, there was a Communist cell of thirty-six students, which began to draw some unfavourable press. Upon the instigation of Gropius and Kandinsky, the city of Dessau authority fired Meyer when it was discovered he had provided funds for striking miners.

Under pressure to de-politicize the Bauhaus for its own survival, Mies van der Rohe took over the directorship. He promptly closed the school, replaced its existing statutes, then reopened it and forced the 170 students to re-apply. Five students who had been close to Meyer were expelled. A new curriculum was established with the preliminary course becoming non-compulsory. The study of architecture was given greater importance, which effectively turned the Bauhaus into a school of architecture. Although the applied

▼ **Karl Hermann Haupt**, Design for a covered box, 1923

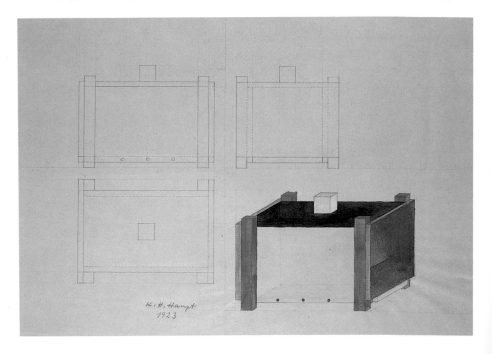

art workshops continued, their remit was to supply only products that could
be industrially manufactured. With Mies, architectural theory triumphed for
a while over politics as he introduced, with his partner Lilly Reich, the new
apolitical program of "Bau und Ausbau" (building and development). In Oc-
tober 1931, the National Socialists, who had been pushing for the closure of
the Bauhaus, swept to power in Dessau winning 19 out of 36 seats and, on
the 22nd August 1932, a motion was passed for the closure of the school.
The Bauhaus was subsequently re-established by Mies as a private school
in Berlin but its political past caught up with it when the National Socialists
eventually seized power in the city. The Gestapo raided the school's
premises looking for incriminating communist literature and sealed the
building, effectively closing it down. On the 19th July 1933, the masters gath-
ered together and voted to dissolve the Bauhaus – formally marking the end
of this truly remarkable institution.
Many of the masters, including Mies, Marcel Breuer, Walter Gropius, and
Josef Albers emigrated to the United States to escape persecution and in
1937 László Moholy-Nagy became the director of the short-lived New
Bauhaus in Chicago. A year later, a retrospective of Bauhaus design was
held at the Museum of Modern Art, New York, and the school's reputation

as the most important design institution of the 20th century grew. The Functionalist approach to design pioneered at the Bauhaus had a fundamental impact on subsequent industrial design practice and provided the philosophical bedrock from which the Modern Movement evolved. The Bauhaus also had a profound and widespread impact on the way in which design was subsequently taught and this was most especially felt at the Hochschule für Gestaltung, Ulm.

▼ **Wilhelm Wagenfeld**, Tea set for Jenaer Glaswerke Schott & Gen., c. 1930

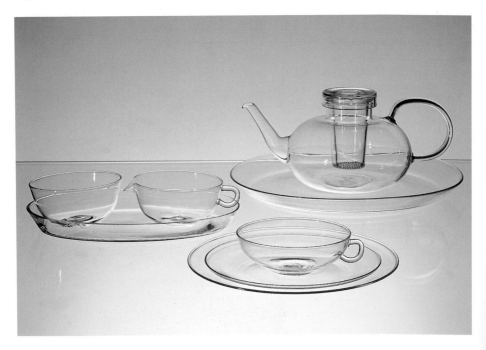

Herbert Bayer served a design apprenticeship from 1919 to 1920 in the Linz-based office of Georg Schmidthammer and produced his first typographical work there. In 1920, he worked in the studio of Emanuel Margold (1889–1962) in Darmstadt, before studying at the Bauhaus in Weimar from 1921 to 1923, where he was taught mural-painting by Oskar Schlemmer (1888–1943) and Wassily Kandinsky (1866–1944). In 1923/1924, he spent a period of time painting and took a trip to Berchtesgaden and Italy. On his return to Germany in April 1925, he became a teacher and a "young master" at the Bauhaus in Dessau. Until 1928, he headed the school's new workshop for printing and publicity, which later became known as the workshop for typography and advertisement design. In this position, Bayer was responsible for all the Bauhaus publicity material and also the layout of the Bauhaus series of books. Importantly, Bayer introduced lower-case sans-serif typography to Bauhaus graphics and encouraged the use of photographic images in advertising design. From 1928, Bayer headed the Berlin studio of the advertising agency Dorland, and was later responsible for the exhibition design of the German section at the 1930 Paris "Exposition de la Société des Artistes Décorateurs". In 1938, Bayer emigrated to the United States and that same year designed the catalogue for the "Bauhaus 1919–1928" exhibition held at the Museum of Modern Art, New York. He was a director of Dorland International until 1945, and from 1946 to 1956 was a consultant to the Container Corporation of America. From 1946, he was involved in the design of the Aspen Cultural Center, Colorado. Bayer also worked as a design consultant for many other American corporations including the Atlantic Richfield Company and the General Electric Company. In 1975 he moved to Montecito, California.

**Herbert Bayer**
*1900 Haag am Hausruch, Austria*
*1985 Montecito, California*

▼ Catalogue cover for "Staatliches Bauhaus in Weimar 1919–1923" exhibition, 1923

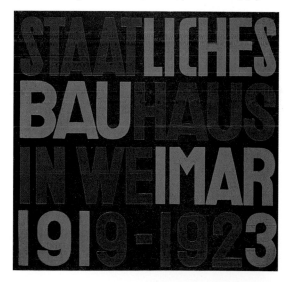

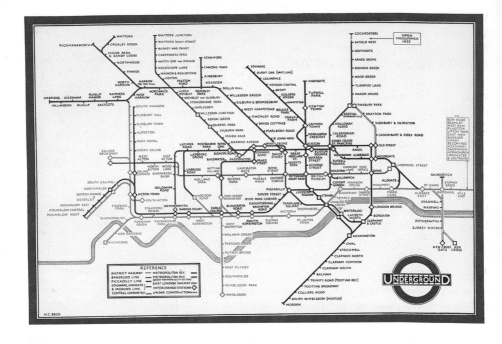

## Henry Beck

1903–1974

From 1909, the commercial manager of London Underground, Frank Pick, was responsible for the commissioning of graphic design work. He commissioned designers such as Edward Johnson (1872–1944) and Edward McKnight Kauffer, but the most important graphic work produced for the company was designed by Henry Beck who had trained as an engineering draughtsman. The mapping of the London Underground system was becoming increasingly complicated and the maps of it from the 1920s were difficult to follow as they attempted to depict the actual geographic positions of the lines and stations. Beck re-designed the map in 1933 using a diagrammatic approach, which showed the spatial relationship of the stations to one another, rather than the geographical distances between them. This ingenious schematic map used colour symbolically and was worked up from an octagonal grid so that the lines and stations were placed together either at right angles or at 45 degrees, which provided great visual clarity. The inclusion of the River Thames also gave the map a strong and unmistakable London identity.

▲ London
Underground Map
for London
Transport, 1933

Mario Bellini studied architecture at the Politecnico di Milano, graduating in 1959. From 1961 to 1963, he was design director at La Rinascente, the influential chain of Italian department stores. In 1963, he founded an architectural office with Marco Romano and later, in 1973, established Studio Bellini in Milan. Since 1963, he has held the position of chief design consultant for Olivetti and his designs for the company include the *Divisumma 18/28* calculators (1973) and the *Praxis 35* and *Praxis 45* typewriters (1981). From 1969 to 1971, he was the president of ADI (Associazione per il Disegno Industriale), and in 1972 showed a mobile micro-living environment entitled *Kar-a-Sutra* at the "Italy: The New Domestic Landscape" exhibition held at the Museum of Modern Art, New York. This led to his appointment as a research and design consultant for the car manufacturer Renault in 1978. During the 1970s, Bellini organized workshops to explore the complex relationships that exist between humans and their man-made environment – a theme that has informed all his work. From 1986 to 1991, Bellini was editor of *Domus* and since 1979 he has been a member of the Scientific Council for the Milan Triennale's design section. He held the positions of professor of design at the Istituto Superiore del Disegno Industriale, Venice from 1962 to 1965, professor of industrial design at the Hochschule für angewandte Kunst, Vienna from 1982 to 1983 and professor of industrial design at the Domus

**Mario Bellini**
b. 1935 *Milan*

▼ *Programma 1a* calculator for Olivetti, 1965

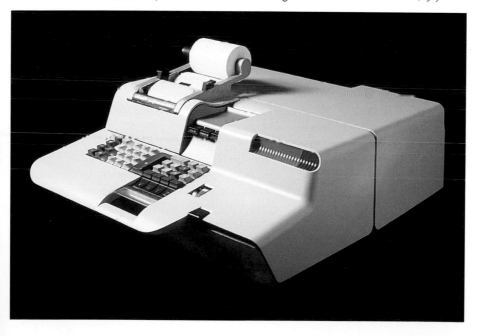

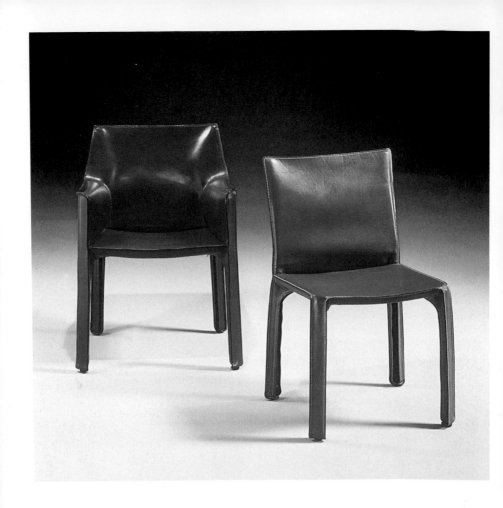

Academy, Milan from 1986 to 1991. Bellini has also been a visiting lecturer to many other design colleges including the Royal College of Art, London. His most notable furniture designs include the *Le Bambole* seating system for B&B Italia (1972), the *Cab* seating for Cassina (1977) and the *Figura* office seating programme co-designed with Dieter Thiel for Vitra (1985). He has also designed lighting for Flos, Artemide and Erco and audio equipment for Yahama and BrionVega. Bellini has received numerous design accolades including seven Compasso d'Oro awards.

Lucian Bernhard studied at the Akademie der Kunst, Munich before moving to Berlin in 1901, where he began designing commercial posters using rounded serif typography, boldly outlined images and a reduced colour palette. These posters were influenced by the graphic work of the two British artists, William Nicholson (1872–1949) and James Pryde (1869–1941) who worked under the name of "Beggarstaffs" in England. One of Bernhard's first designs was executed for a competition to design an advertisement for Priester matches. His visually striking and prize-winning entry (1905), with its bold lettering and elimination of superfluous detailing, helped to establish his reputation. Bernhard was one of the leading exponents of the German Plakatstil, an approach in which simplified images were set against a plain background, accompanied by only a short copyline or company name. Bernhard was also a leading figure in the design of the Sachplakat (object poster), which boldly presented the advertised product with its brand name but without any advertising copy explaining its merits. In 1909, he helped found the magazine for collectors, *Das Plakat* (later known as *Gebrauchsgraphik*), which reproduced his poster designs and used the Bernhard Antiqua typeface that he had previously designed for Bauer, Frankfurt. In 1914,

**Lucian Bernhard**
1883 *Stuttgart*
1972 *New York*

▼ Lithographic
poster for Stiller
advertising shoes,
c. 1908

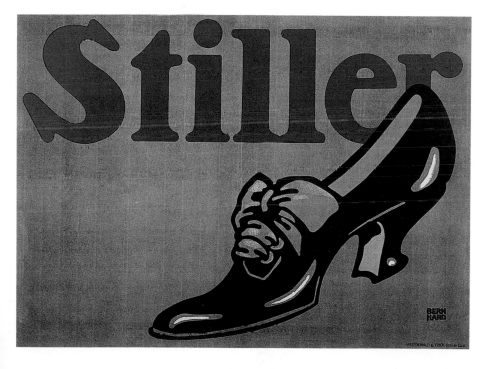

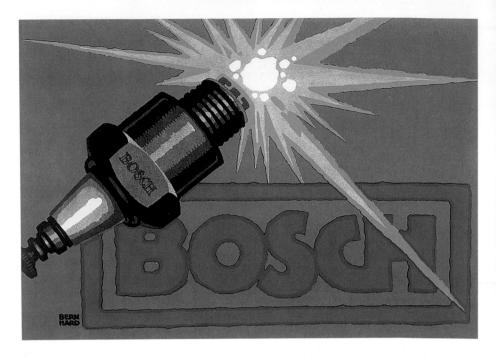

Bernhard designed his colourful and bold advertising posters and packaging for Bosch spark plugs. While living in Berlin he was one of a stable of graphic designers, including Hans Rudi Erdt (1883–1918) and Julius Gipkens (1883–1960s), who regularly submitted designs to the printers, Hollerbaum & Schmidt, well-known for their progressive Sachplakat advertising. In 1920, Bernhard was the first professor of poster design at the Akademie der Kunst Berlin. Three years later, he moved to New York and opened a design studio there, while continuing to run his office in Berlin. In the United States, he designed several fonts for American Type Founders (during his career he invented some thirty-six new typefaces) and many logos and posters as well as advertising, most notably for Amoco. In America, Bernhard also undertook stage design and interior design commissions. In 1928, together with fellow émigré designers Paul Poiret (1879–1944) and Bruno Paul and the American artist, Rockwell Kent (1882–1971), he established the interior design consultancy, Contempora.

Fulvio Bianconi moved to Venice with his family while still a child. During his youth, he worked in a glass studio in Madonna dell'Orto, and later studied at the Accademia di Belle Arti and the Liceo Scientifico in Venice. He first worked as a glass painter and earned a living painting portraits of guests staying in Venetian hotels. In 1935, he moved to Milan, where he designed perfume bottles for Visconti di Modrone. Then, in 1939, he worked for Motta and, after the Second World War, was employed by Gi Vi Emme, a perfume manufacturer, to design perfume bottles and graphics as well as a mural for the company's dining room. In 1948, Bianconi met Paolo Venini and began working for his glass studio. That same year, Venini exhibited Bianconi's playful glass Commedia dell'Arte figurines at the Venice Biennale. From 1948 to 1951, Bianconi designed more figurines for Venini as well as his famous and often copied handkerchief vase, or *Fazzoletto*. Other designs for Venini included his colourful patchwork and striped vessels known as *Pezzato* (pieced) and *A Spicchi* (sliced), which were exhibited at the 1951 Milan IX Triennale. From 1951, Bianconi worked as an independent designer, his glassware being produced by a number of manufacturers including Cenedese and Danese. For the next decade, he continued designing biomorphic vessels with motifs inspired by Abstract Expressionism and his tartan-like *Scozzese* vessels for Venini. During the 1960s, Bianconi also designed a vase with an internal spiral motif for Vistosi, which won an award at the 1964 Milan XIII Triennale, and a series of vases known as *Informali*. Gradually, through the 1970s, his work became increasingly sculptural. In more recent years, he has designed for the Swiss glass manufacturer, Hergiswil. During his long career, Bianconi also worked as a graphic designer for HMV, Pathé, Fiat and Pirelli as well as the publishing houses, Mondadori and Garzanti.

**Fulvio Bianconi**
1915 *Padua, Italy*
1996 *Milan*

▼ *Pezzato* vase for Venini, 1951

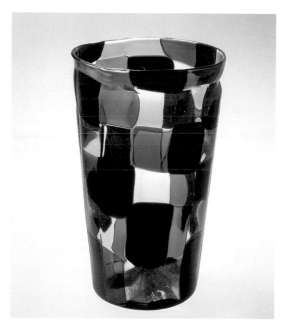

## Max Bill

1908 *Winterthur, Switzerland*
1994 *Berlin*

Max Bill studied silversmithing at the Kunstgewerbeschule, Zurich from 1924 to 1927, during which period his designs were influenced by Cubism and Dada. He then studied art for two years at the Dessau Bauhaus and fully embraced the school's functionalist approach to design. On completion of his studies, Bill returned to Zurich and worked as a painter, architect and graphic designer. He became the leading exponent of Constructivism within the Swiss School of graphics and during the 1930s designed graphics for the Wohnbedarf store in Zurich. He had established his own architectural office by 1930 and, as a member of the SWB (Schweizerischer Werkbund), designed the Neubühl estate near Zurich (1930–1932) in the modern style. In 1931, he adopted Theo van Doesburg's concept of "concrete art", which argued that universality could only be achieved through clarity. From 1932 onwards, he also worked as a sculptor and became a member of various art organizations including the Abstraction-Création group in Paris, the Allianz (Association of Modern Swiss Artists), the CIAM (Congrès International d'Architecture Moderne) and the UAM (Union des Artistes Modernes). In 1944, he turned his attention to industrial design and his subsequent aluminium wall clock (1957), manufactured by Junghans, and minimalist *Ulmer Hocker* stool (1954) are among his best-known products. Bill was responsi-

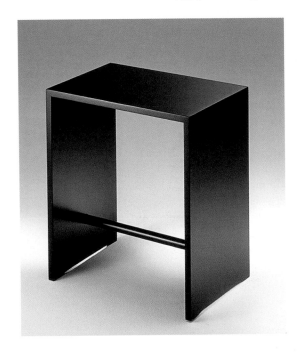

◄ *Ulmer Hocker,* 1954
(reissued by Zanotta)

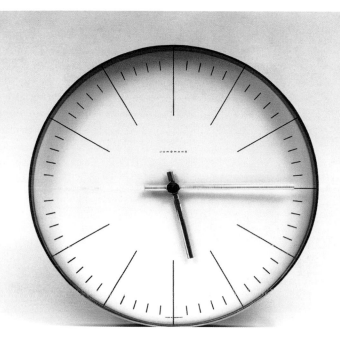

ble for setting up the German awards and exhibitions "Die Gute Industrie-form", and co-founded the influential Hochschule für Gestaltung, Ulm in 1951, becoming the school's rector and head of its architectural and product design departments for the first five years. At Ulm, Bill championed Bauhaus-type geometric formalism, believing that products based on mathematical laws had an aesthetic purity and thereby a greater universality of appeal. This approach to design was continued by Hans Gugelot when he took over Ulm's product design department and was particularly influential to his pupil Dieter Rams. Upon leaving Ulm, Bill set up his own Zurich-based studio in 1957 and concentrated on sculpture and painting. He was the chief architect of the "Educating and Creating" pavilion at the Swiss National Exhibition of 1964 and the same year was made an honorary member of the AIA (American Institute of Architects). While the geometric formalism that Bill and many other exponents of the Modern Movement promoted was intended as a means of achieving greater universality, its severity and lack of humanizing qualities prevented its wide scale acceptance.

▲ *Model No. 32/0389 wall clock, for Junghans, 1957*

## Marianne Brandt

*1893 Chemnitz, Germany*
*1983 Halle/Saale*

Marianne Brandt enrolled at the Staatliches Bauhaus, Weimar in 1924. She served an apprenticeship in the metal workshop, which was then directed by László Moholy-Nagy. After taking her journeyman's exam, Brandt became deputy director of the workshop and organized projects in collaboration with the lighting manufacturers, Körting & Mathiesen AG (Kandem) in Leipzig and Schwintzer & Gräff, Berlin. At the Bauhaus, she worked alongside fellow metal-workers, Christian Dell and Hans Przyrembel (1900–1945), and co-designed the *Kandem* light with Hin Bredendieck (b. 1904) in 1928, as part of a class project. From 1928 to 1929, Brandt was the assistant master of the metal workshop at the Dessau Bauhaus. In 1929, she worked in the architectural office of Walter Gropius in Berlin and, over the next three years, developed new design concepts for the Metallwarenfabrik Ruppelwerk, Gotha. She then returned to Chemnitz, where she took up painting. During this period, she tried to license some of her products to the department store Wohnbedarf. Brandt taught at the Hochschule für Bildende Künste, Dresden from 1949 to 1951 and at the Institut für angewandte Kunst, East Berlin from 1951 to 1954, during which time she visited China and organized an industrial design exhibition there on behalf of the German government.

Marcel Lajos Breuer won a scholarship in 1920, which allowed him to study at the Akademie für Bildende Künste in Vienna. Dissatisfied with the institution, he remained there for only a brief period before finding work in a Viennese architectural office. From 1920 to 1923, he studied at the Staatliches Bauhaus, Weimar, completing the basic course, the carpentry apprenticeship and his journeyman's exam. During his tuition there, Breuer designed his *African chair* (1921) and his *Slatted chair* (1922–1924). After the completion of his studies, he went to Paris, where he worked in an architectural office. On his return the following year, Breuer became a "young master" and was appointed head of the carpentry workshop at the Bauhaus, which had by then moved to Dessau. Here, he designed his first tubular metal chair the *B3* (1925) – the innovative choice of material having been reputedly inspired by his recently purchased Adler bicycle. Breuer subsequently designed a whole range of tubular metal furniture including chairs, tables, stools and cupboards, which were manufactured and distributed by Standard-Möbel, Berlin. Tubular metal offered many benefits – affordability, hygiene and an inherent resiliency that provided comfort without the need for springing – and Breuer regarded his designs as essential equipment for modern living. At the Bauhaus, Breuer also designed the interiors and furnishings for the school's new complex and for the masters' houses. His *B3* or *Wassily* chair

**Marcel Breuer**
1902 *Pécs, Hungary*
1981 *New York*

▼ *Model No. ti 2* chair and *Model No. ti 13* stool for Bauhaus Dessau, 1924

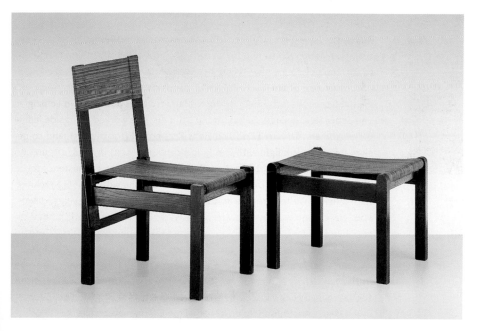

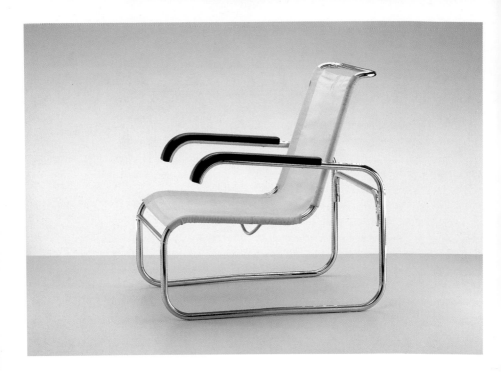

was designed originally for Wassily Kandinsky's accommodation. Breuer not
only created standardized furnishings – in 1926 he also designed a small
standardized metal house and, a year later, his *Bambos* house. That year he
made a graphic about the evolution of seat furniture, which concluded with
his dematerialist ideal of sitting on "springy columns of air". Breuer con-
tinued to teach at the Bauhaus until April 1928 and, for the next three years,
directed his own architectural practice in Berlin, which employed the former
Bauhaus student, Gustav Hassenpflug (1907–1977). During this period,
Breuer continued to design furniture, interiors and department stores while
his building projects remained unrealized. He was commissioned by the
Deutscher Werkbund to design interiors for the German section at the 1930
"Société des Artistes Décoratifs Français" exhibition. In 1931, with little work
available due to the economic downturn, Breuer closed his office in Berlin
and travelled to the South of France, Spain, Greece and Morocco. The next
year, he completed his first architectural commission, the Harnischmacher
House, Wiesbaden and designed the Wohnbedarf furniture store, Zurich.
Then, two years later, he joined Alfred (b. 1903) and Emil Roth (1893–1980)
in designing the Doldertal Houses, a pair of experimental apartment blocks

in Zurich, for Sigfried Giedion (1888–1968), the founder of the Wohnbedarf company. From 1932 to 1934, Breuer developed a range of pliant furniture using a patented method of construction that incorporated flat bands of steel and aluminium. This range of metal furniture was manufactured by Embru and retailed by Wohnbedarf. In 1933 and 1934, he visited Switzerland and worked in Budapest with Farkas Molnár and Josef Fischer on an unrealized architectural project. To escape Nazi persecution on account of his Hungarian Jewish origins, Breuer emigrated to London in 1935, initially working in partnership with the architect, F. R. S. Yorke (1906–1962). Together, they completed several architectural commissions including houses in Sussex, Hampshire, Berkshire and Bristol and the Gane Pavilion in Bristol (1936), which combined wood and local stone (a far cry from the Bauhaus aesthetic of steel and glass). Breuer and Yorke also designed a "Civic Centre for the Future", which remained unrealized. Later, as controller of design at Jack Pritchard's company Isokon, Breuer produced five plywood furniture designs between 1935 and 1937, which were basically translations of his earlier metal designs. These Isokon designs reflected the popularity of Alvar

▲ Typist's desk
(variant of *B21*) for
Thonet, c. 1928

Aalto's earlier plywood furniture, which had been exhibited in Britain in 1933. While in London, three years later, Breuer also designed a group of plywood furniture for Heal & Sons. In 1937, Breuer moved to the United States of America, Walter Gropius having offered him a professorship at Harvard University's School of Design in Cambridge, Massachusetts. They also set up an architectural practice together in Massachusetts, designing the Pennsylvania Pavilion at the 1939 New York World's Fair and several private houses, including Gropius' own residence. In 1941, Gropius and Breuer dissolved their partnership and Breuer established his own architectural practice, which he moved to New York in 1946. During the late 1940s and 1950s, Breuer designed some seventy private houses, mainly in New England, and in 1947 built a home for himself in New Canaan, Connecticut. The Museum of Modern Art, New York initiated a touring exhibition of his work in 1947 and the following year invited him to build a low-cost house in the museum's grounds, which would suit the needs of an average American family. He furnished this project with affordable plywood cut-out furniture. In 1953, Breuer worked as part of a team on the new UNESCO building in Paris and also designed the Bijenkorff department store, Rotterdam. He founded Marcel Breuer and Associates in New York in 1956, and around that time, like Le Corbusier, made concrete his material of choice. He used this medium

▼ Armchair for
Isokon Furniture
Company, 1936

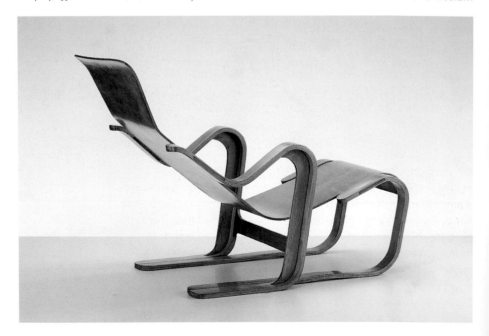

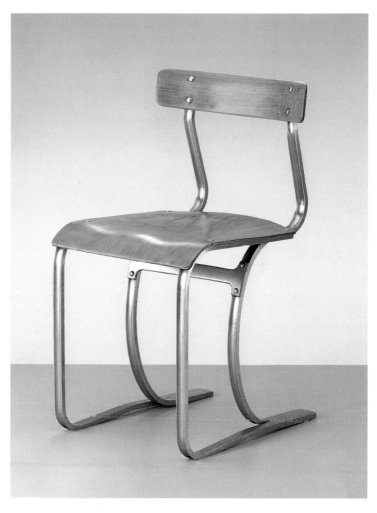

► *Model No. 301* chair produced by Ebru for Wohnbedarf, 1932–1934

in a highly sculptural and innovative way for his design of the monumental Whitney Museum of American Art, New York (1966). Breuer was one of the foremost exponents of the Modern Movement and the enduring appeal of his highly democratic furniture designs, such as the iconic *B3* chair and the hugely successful *B32* or *Cesca* cantilevered chair (1928), testifies to his mastery of aesthetics and production methods.

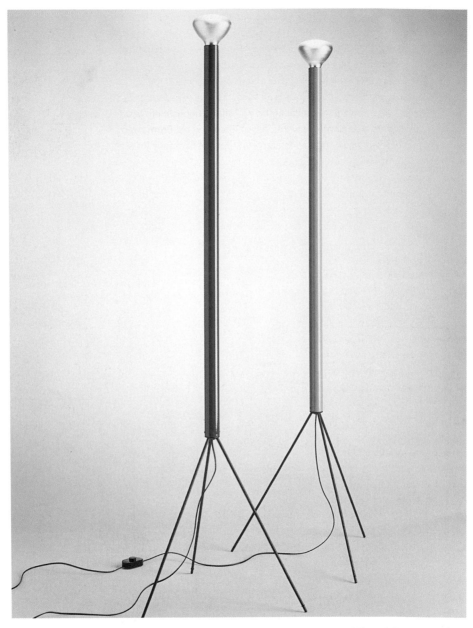

▲ **Achille & Pier Giacomo Castiglioni**, *Luminator*
floor lamp for Gilardi and Arform, 1955

► **Achille Castiglioni**, *Gibigiana*
directional table lamp for Flos, 1980

The eldest of the Castiglioni brothers, Livio studied architecture at the Politecnico di Milano, graduating in 1936. In 1938, Livio and Pier Giacomo established a studio together with Luigi Caccia Dominioni (b. 1913), designing silver and aluminium cutlery. Their most notable design, the *Phonola* (1939), was the first Italian radio made in Bakelite and as such changed the future design of radios, which had hitherto mostly been cased in wooden boxes. The design was awarded a gold medal at the VII Milan Triennale of 1940, where the designers also curated a whole exhibition of radios. From 1940 to 1960, Livio worked as a design consultant, first for the company Phonola from 1939 to 1960 and later for Brionvega from 1960 to 1964. From 1959 to 1960, he was president of the ADI (Associazione per il Disegno Industriale). Livio also designed many audio-visual presentations and collaborated with his younger brothers on several lighting projects. His best-known design, the snake-like *Boalum* light (1970), was executed in conjunction with Gianfranco Frattini (b. 1926).

## Livio, Pier Giacomo & Achille Castiglioni

Livio Castiglioni
1911 *Milan*
1979 *Milan*

Pier Giacomo and Achille Castiglioni graduated from the Politecnico di Milano, in 1937 and 1944 respectively. Achille joined his elder brothers' design studio in Piazza Castello and during the post-war years they undertook town-planning and architectural commissions as well as exhibition and product design. The brothers were extremely active and helped establish the Milan Triennale exhibitions, the Compasso d'Oro awards and the ADI. When Livio left the partnership in 1952, the two younger brothers continued to design together until Pier Giacomo's death in 1968. They designed the "Colori e forme nella casa d'oggi" exhibition at the Villa Olmo, Como, where, for the first time, they exhibited their "ready-made" designs of 1957 – the *Mezzadro* (Sharecropper's Stool), incorporating a tractor seat, and the *Sgabello per Telephono* (Telephone

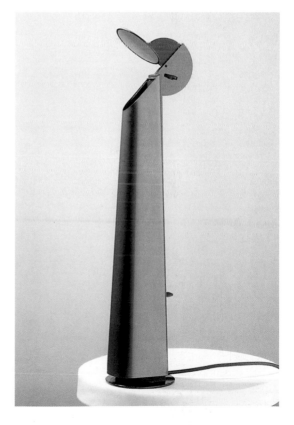

Pier Giacomo
Castiglioni

1913 *Milan*
1968 *Milan*

▾▸ **A. & P. G.**
**Castiglioni**, *Mezzadro*
readymade stool, 1957
(reissued by Zanotta)

▾ **A. & P. G.**
**Castiglioni**, *Sella*
readymade stool, 1957
(Reissued by Zanotta)

Stool), with a bicycle seat. The brothers also created less radical designs, such as the Neo-Liberty style *Sanluca* armchair (1959) for the furniture manufacturer, Dino Gavina, whose company offices in Milan they fitted out in 1963. Other notable creations of Pier Giacomo and Achille Castiglioni include the *Tubino* desk lamp (1951), the *Luminator* floor lamp (1955), the *Arco* floor lamp (1962) and the *Taccia* table lamp (1962). In 1966, they designed the *Allunaggio* seat, which was inspired by the first moon landing. Their long and prestigious client list included Kartell, Zanotta, Brionvega, Bernini, Siemens, Knoll, Poggi, Lancia, Ideal Standard and Bonacina.

After Pier Giacomo's death, Achille continued to work in industrial design, creating such well-known pieces as the *Lampadina* table lamp (1972) for Flos, his sleek cruet set (1980–1984) for Alessi and the *Gibigiana* directional table lamp (1980) for Flos. The brothers had much influence on the following generation of Italian designers, with Pier Giacomo teaching at the Politecnico di Milano from 1946 to 1968 and with Achille acting as professor of artistic industrial design from 1970 to 1977 and as professor of interior

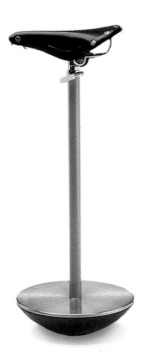

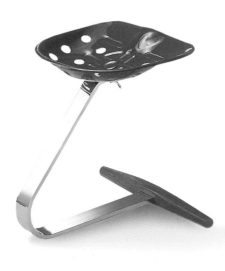

architecture and design from 1977 to 1980 at the Politecnico di Torino. Additionally, from 1981 to 1986, Achille Castiglioni was professor of interior design at the Politecnico di Milano and then became professor of industrial design there.

During his long career, which has spanned over half a century, Achille Castiglioni has been honoured with eight Compasso d'Oro awards as well as numerous other design prizes. While the language of design he and his brothers pioneered was grounded in Rationalism, it was tempered with ironic humour and sculptural form – an unusual approach to design that has been described as "rational expressionism". This, and the remarkably consistent quality of his designs, which are both structurally inventive and aesthetically pleasing, make Achille Castiglioni one of the most important figures in Italian design of the 20th century.

Achille Castiglioni
b. 1918 *Milan*

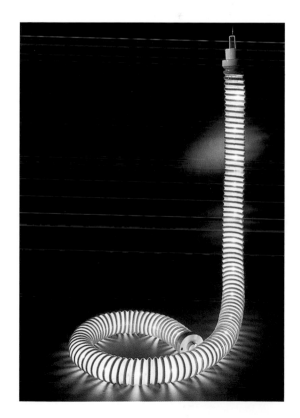

▶ **Livio Castiglioni &**
**Gianfranco Frattini**,
*Boalum* lamp for
Artemide, 1969

**Wells Coates**

1895 *Tokyo*
1958 *Vancouver*

Wells Coates was born in Tokyo, where his Canadian father worked as a missionary. Prior to this, his mother had been a pupil of the architects, Louis Sullivan (1856–1924) and Frank Lloyd Wright in Chicago. From 1913 to 1915, Wells Coates studied engineering at the University of British Columbia, Vancouver. However, his studies where curtailed by the outbreak of the First World War and he was drafted, first as an infantryman and later as a pilot. After the war, he returned to the University of British Columbia, graduating in 1921. He subsequently moved to Britain and, from 1922 to 1924, took a doctorate in engineering at the University of London. From 1923 to 1926, he worked as a journalist for the *Daily Express* and for a brief period was one of their correspondents in Paris. During this time he wrote from a humanist perspective, viewing design as a catalyst for social change. In London in 1928, he designed fabrics for the Crysede Textile Company and interiors for the firm's factory in Welwyn Garden City, incorporating plywood elements. From 1931, Coates was a consultant to Jack Pritchard's plywood products company, Isokon – a firm pioneering Modernism in Britain. Coates was also commissioned by Pritchard in 1931 to design the Lawn Road Flats, Hampstead, which are seminal examples of British Modern Movement architecture. In 1933, Coates co-founded MARS (Modern Architecture Research Group) and established design partnerships with Patrick Gwynne

▼ Desk for PEL, 1933

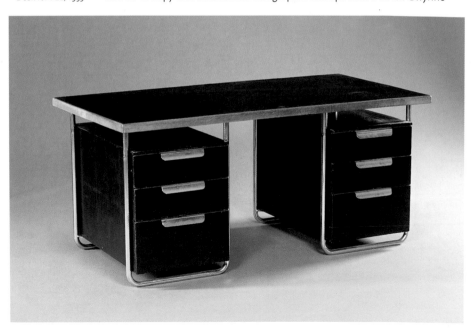

in 1932 and David Pleydell-Bouverie in 1933. From 1932, he designed a series of bakelite radios for Ekco, including his famous circular *Ekco AD65* (1934), which were conceived for industrial production and were among the first modern products available to British consumers. After the Second World War, Coates worked in Vancouver, designing aircraft interiors for De Havilland and BOAC, while in the 1950s he produced designs for television cabinets.

▼ *Ekco AD65* radio
for E.K. Cole, 1934

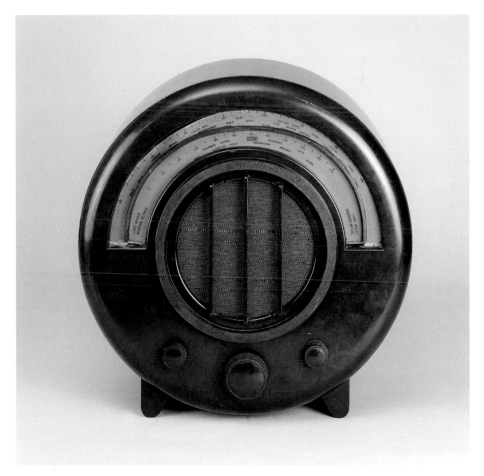

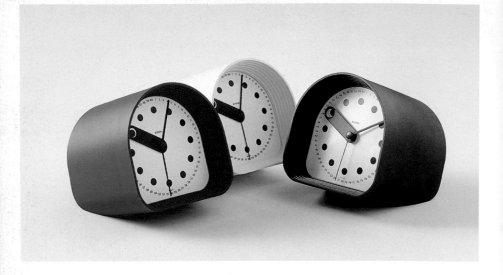

## Joe Colombo

1930 *Milan*
1971 *Milan*

Cesare "Joe" Colombo trained as a painter at the Accademia di Belle Arti di Brera, Milan until 1949 and then studied architecture at the Politecnico di Milano until 1954. In 1951, he joined the Movimento Nucleare (Nuclear Painting Movement), which had just been founded by Sergio D'Angelo (b. 1931) and Enrico Baj (b. 1924). For the next four years, Colombo was active as an abstract expressionist painter and sculptor, exhibiting his work with other group members in Milan, Como, Brescia, Turin, Palermo, Verviers, Venice and Brussels. Later in 1955, Colombo became a member of the Art Concret Group, but around 1958 gave up painting to pursue a career in design. Prior to this, he had worked on an exhibition for the X Milan Triennale of 1954, documenting the ceramic designs that resulted from the International Meetings held in Albisola. At this Triennale, Colombo also created three outside seating areas, which were combined with a shrine-like display of television sets. After the death of his father in 1959, Colombo was left to run the family business, which manufactured electrical equipment. During this time, he began experimenting with new materials, including reinforced plastics, as well as novel construction techniques and manufacturing methods. In 1962, Colombo established his own design office in Milan, focusing on architectural and interior design projects, the majority of which were for mountain hostels and ski-resort hotels. These early designs reveal an interest in function born out of structures with strong sculptural qualities. In 1964, Colombo was awarded the IN-Arch prize for his interiors for a hotel in Sardinia (1962–1964), which included ceiling fixtures made from

▲ *Optic* clocks for Alessi, 1970

► *Acrilica* table lamp for O-Luce, 1962

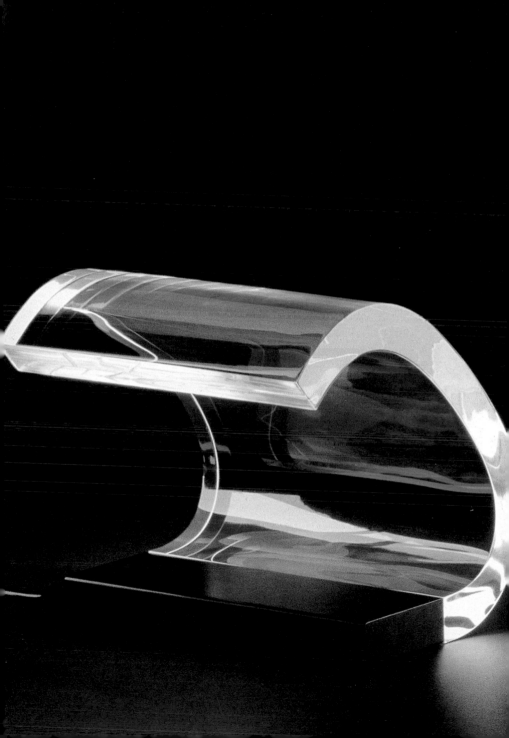

perspex prisms that diffracted the light. With his brother Gianni, Colombo developed this idea in his design for the *Acrilica* lamp (1962). His first design for Kartell was the *No. 4801* chair (1963–1964), which was constructed of three interlocking plywood elements. The fluidity of this chair's form anticipated his later designs in plastics, such as the *Universale No. 4860* chair (1965–1967), which was the first adult-sized chair to be manufactured in injection-moulded plastic (ABS). Colombo produced other innovative designs for furniture, lighting, glassware, door handles, pipes, alarm clocks and wristwatches. He also created a professional camera, the *Trisystem* (1969), an air-conditioning unit for Candy (1970), in-flight service trays for Alitalia (1970) and an ergonomically resolved motorized drafting table (1969). From the beginning of his career, Colombo was interested in domestic systems products, as his early Combi-Centre container unit (1963) demonstrates. This interest in systems furnishings gave rise to his *Additional Living System* (1967–1968), *Tube* chair (1969–1970) and *Multi* chair (1970), all of which could be assembled in a variety of ways so as to provide a wide assortment of flexible sitting positions, thus reflecting his primary goal in design – adaptability. His most forward-looking designs, however, were his integrated micro-

▶ *Central living block* of the *Wohnmodell* 1969 shown at the Visiona I exhibition for Bayer, 1969

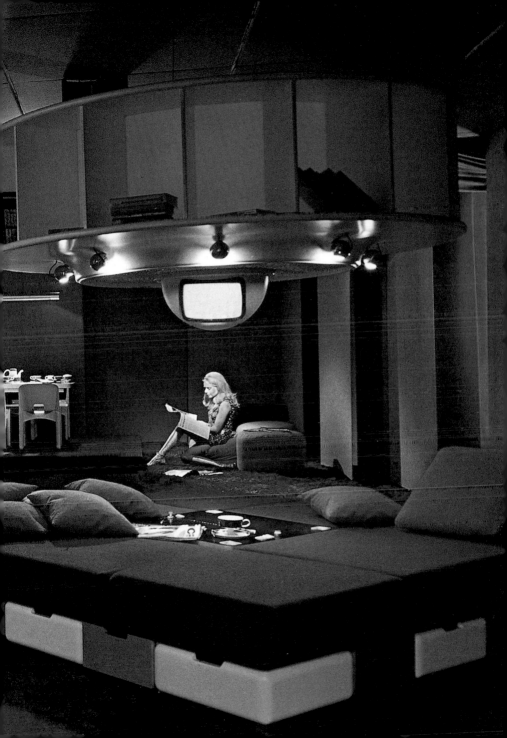

environments. These included his Visiona habitat of the future shown at Bayer's Visiona exhibition in 1969, which comprised a space-age "Barbarella-like" interior where furnishings transmuted into structural elements and vice versa. Traditional furniture items were replaced with functional units, such as the *Night-Cell* and *Central-Living blocks* and the *Kitchen-Box*, so as to create a dynamic and multi-functional living environment. For his own apartment, Colombo designed the *Roto-living* and *Cabriolet-Bed* units (both 1969), and these were followed by his *Total Furnishing Unit* (1971), which was a highly influential example of "Uniblock" design. Shown at the 1972 "Italy: The New Domestic Landscape" exhibition at the Museum of Modern Art, New York, the *Total Furnishing Unit* was proposed as a complete machine for living and comprised four different units: kitchen, cupboard, bathroom and bed/privacy – all within a twenty-eight square metre space. Colombo designed products for O-Luce, Kartell, Bieffe, Alessi, Flexform and Boffi, and received ADI (Associazione per il Disegno Industriale) awards in 1967 and 1968 as well as a Premio Compasso d'Oro in 1970. His remarkably prolific and illustrious career was cut tragically short in 1971 when he died, at the age of forty-one, from heart failure.

▼ *Spider* lamp for O-Luce, 1965

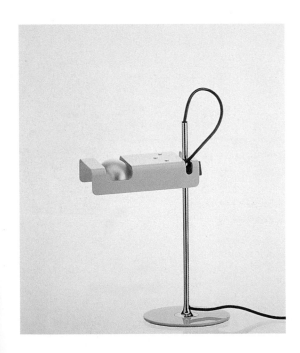

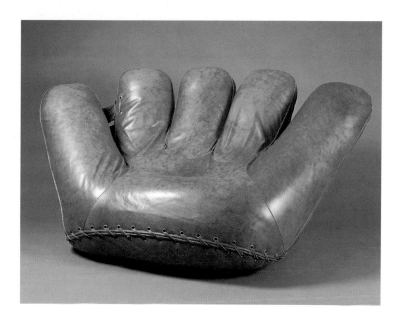

Gionatan De Pas, Donato D'Urbino and Paolo Lomazzi trained at the Politecnico di Milano and set up an architecture and design office together in 1966. Initially, they experimented with modular and inflatable PVC furniture designs. Their subsequent *Blow* chair (1967) was the first mass-produced piece of inflatable furniture and became an icon of 1960s' Pop culture.

In 1970, the office assisted in the design of the Italian Pavilion at the Osaka World Fair, and in 1972 participated in the "Italy: The New Domestic Landscape" exhibition held at the Museum of Modern Art, New York. Their *Joe* chair (1970), named after the American baseball legend Joe DiMaggio, was inspired by the oversized and out-of-context sculptures of Claes Oldenburg (b. 1929).

In 1979, De Pas, D'Urbino & Lomazzi were awarded a Compasso d'Oro at the Milan Triennale for their *Sciangai* coat rack (1974) and a year later, the office designed the "Italian Furniture Design 1950–1980" exhibition in Cologne. In 1987 an exhibition of the group's work was held in Kyoto. During the 1980s, they also made a television programme, entitled "Dal cucchiaio alla città: il design italiano dal 1950 al 1980" (From the Spoon to the City). For over three decades, De Pas, D'Urbino & Lomazzi have consistently produced well-executed designs for flexible, interchangeable and adaptable furniture and lighting, ranging from radical to more main-

**De Pas, D'Urbino & Lomazzi**

De Pas
1932 *Milan*
1991 *Milan*

D'Urbino
b. 1935 *Milan*

Lomazzi
b. 1936 *Milan*

▲ *Joe* chair for
Poltronova, 1970

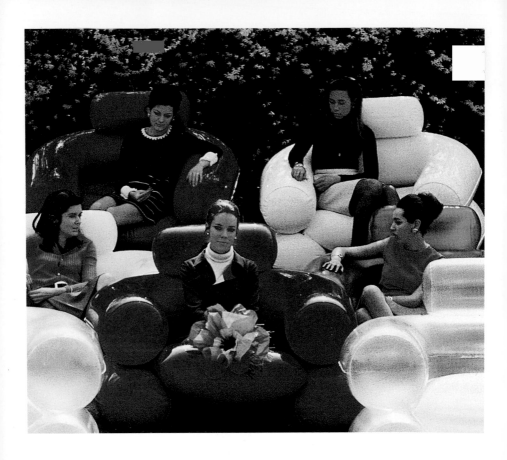

▲ Zanotta
advertisement for
*Blow* chairs, c. 1968

stream solutions, which have been manufactured by Acerbis, Artemide,
BBB, Bonacina, Cassina, Driade, Palina, Poltronova, Stilnovo and Zanotta
among others.

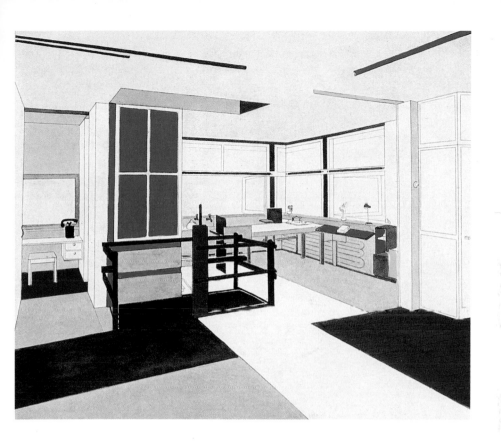

In October 1917, a small group of Dutch architects, designers and artists established an art journal entitled *De Stijl*. Led by Theo van Doesburg, the group initially included Piet Mondrian (1872–1944), Bart Anthony van der Leck (1876–1958), Vilmos Huszár, Jacobus Johannes Pieter Oud, Robert van 't Hoff (1887–1979), Jan Wils (1891–1972) and Georges Vantongerloo (1886–1965). The magazine became a forum for art and design debates and eventually the focus of a larger and wider ranging group of intellectuals. This loosely organized movement shared a common objective, that of absolute abstraction. The journal not only featured the latest developments in avant-garde Dutch art and design but also the work of the Russian Constructivists, the Dadaists and the Italian Futurists. The publication called for a purification of art and design through the adoption of a universal language of abstracted cubism or, as Piet Mondrian described it, Neo-Plasticism. De Stijl members believed that the search for honesty and beauty would ultimately

**De Stijl**

*Founded 1917*
*Netherlands*

▲ **Gerrit Rietveld,**
Isometric drawing
of the interior of the
Rietveld-Schroeder
House in Utrecht,
1927

bring harmony and enlightenment to humanity. Theo van Doesburg, who was editor-in-chief of the magazine, tirelessly promoted the De Stijl message on his numerous trips to Belgium, France, Italy and Germany. In 1921, he established contacts with staff at the Staatliches Bauhaus in Weimar, and a year later gave a De Stijl course of lectures in Weimar. Theo van Doesburg also developed links with Constructivists, such as El Lissitzky and László Moholy-Nagy. The De Stijl movement not only influenced developments in the fine arts, its members also designed extremely influential furniture, interiors, textiles, graphics and architecture. Gerrit Rietveld's revolutionary *Red/Blue* chair of 1918–1823, which in its design encapsulated the philosophy of the De Stijl Movement, was exhibited at the Staatliche Bauhaus in 1923 and inspired Marcel Breuer's later tubular metal *B3 Wassily* chair of 1925–1927. Like Rietveld's *Red/Blue* chair, De Stijl architecture and interior designs were characterized by the use of strong geometric forms and coloured block-like elements that delineated space. Partitions were used to divide internal areas, while utilitarian furnishings were kept to an absolute minimum. The strong lines incorporated in these interiors produced a dynamism, while a

▼ **Gerrit Rietveld**,
Sideboard, 1919
(executed by G. van
de Groenekan)

sense of lightness was achieved through the purging of ornament. This dematerialist approach to design was highly influential to the development of the Modern Movement, as was De Stijl's use of geometric formalism. Although the De Stijl group was never formally organized, its output was highly distinctive and shared a common visual language – that of geometric abstraction. The application of this new vocabulary of form and colour blurred the traditional distinctions between the fine and decorative arts, but sadly the group's intention of bringing a greater universality to the arts was never fully realized. The De Stijl move-

▼ **Bart van der Leck,** Carpet for Metz & Co., 1918–1919

ment's vision of Utopia was inspired by the vitality of the modern city, while its utilitarian approach to the design of objects for use was influenced by Dutch Puritanism. Though sharing many of the ideas propounded by Russian Constructivism, such as spatial dynamism, De Stijl is generally acknowledged as the first modern design movement, because it heralded a new aesthetic purity. The *De Stijl* magazine was published until Theo van Doesburg's death in 1931, after which the movement gradually lost its focus and was unable to maintain its former momentum.

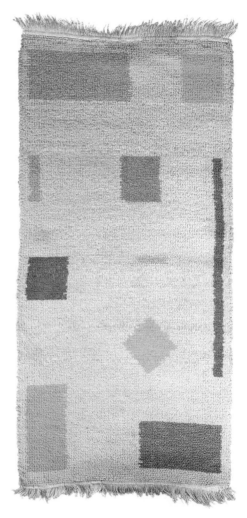

## Christopher Dresser

*1834 Glasgow*
*1904 Mulhouse/Alsace,*
*France*

Christopher Dresser trained from 1847 to 1854 under the botanist John Lindley at the Government School of Design, London, where he then lectured for fourteen years. His advocacy of "Art Botany" – the stylized yet scientifically based depiction of nature – helped replace the overblown and false naturalism common to the High Victorian style with a more formalized type of ornamentation. In 1856, Dresser contributed a plate showing "Plants and Elevations of Flowers" to Owen Jones' seminal work, *The Grammar of Ornament*. In 1857, he was appointed professor of "Botany Applied to the Fine Arts" at the School of Design, South Kensington. He also published various articles in the *Art Journal* and three books, which helped establish his reputation and contributed to his receiving an honorary doctorate from the University of Jena. Having adopted the title "Doctor", Dresser applied for the Chair of Botany at the University of London in 1860. He was unsuccessful in winning this position and so instead embarked on a career in design. He established his own studio, which from the outset was enormously successful. Dresser supplied designs for metalware, ceramics, glass, tiles, textiles, wallpapers and cast-iron furnishings to at least thirty of the most eminent manufacturers in Britain. He was also highly influential as a design theorist and was one of the first to promote the special qualities of Japanese applied art. His forward-looking designs reflected his belief in industrial production and his pursuit of "Truth, Beauty, Power". Apart from his prominence as a design reformer, Dresser was also one of the first professional industrial designers.

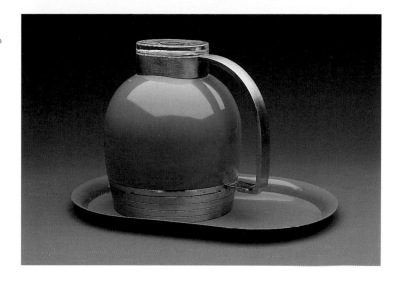

*Model No. 539 thermos flask and tray for the American Thermos Bottle Company, 1935*

Henry Dreyfuss studied at the Ethical Culture School in New York before becoming apprenticed to the industrial designer Norman Bel Geddes in 1923. While working in Geddes' office, Dreyfuss mainly concentrated on theatrical work and designed costumes, sets and lighting for the Strand Theater, New York, and for the R. K. O. (Radio-Keith-Orpheum) chain of Vaudeville theatres. For a while Dreyfuss worked as a consultant to Macy's department store, before establishing his own New York-based industrial design practice in 1929. His straightforward and business-like approach to the design process contributed to the success of his office, which attracted a large corporate clientele including Bell Telephone, AT&T, American Airlines, Polaroid, Hoover and RCA. His designs such as the *Trimline* telephone of 1965 were characterized by the use of sweeping sculptural forms, and as such exemplified Streamlining in American design. Like Raymond Loewy, Norman Bel Geddes and Walter Dorwin Teague, Dreyfuss re-styled many products for manufacturers to increase consumer demand, not so much through technical innovation but by means of stylistic novelty. Some of his designs bore a facsimile of his signature – an early example of designer labelling. Dreyfuss was a founder member of the Society of Industrial Design and the first president of the Industrial Designers Society of America. He also published two highly influential books on anthropometrics, *Designing for People* (1955) and *The Measure of Man* (1960). Dreyfuss and his wife committed suicide in 1972.

**Henry Dreyfuss**
*1904 New York*
*1972 South Pasadena, California*

► Leg splint designed for U. S. Navy and made by Evans Products Company, 1943

## Charles Eames

1907 *St. Louis, Missouri*
1978 *St. Louis*

## Ray Eames

1912 *Sacramento, California*
1988 *Los Angeles*

Charles Eames initially studied architecture at Washington University, St Louis. During this period, from 1925 to 1928, he worked in his vacations as a draughtsman for the architectural practice of Trueblood & Graf and in 1929 travelled to Europe, where he was exposed for the first time to the work of Modern Movement architects such as Le Corbusier, Ludwig Mies van der Rohe and Walter Gropius. In 1930, Charles Eames and Charles Gray opened an architectural office in St. Louis, and were later joined by Walter Pauley. Although the firm executed a number of private residences, by 1934 no more commissions were forthcoming owing to the depression and so Eames left St Louis and briefly resided in Mexico. Returning to St Louis in 1935, he established a new architectural partnership with Robert Walsh, and a year later designed the Meyer House in Huntleigh Village. For this project, Eames sought the advice of the Finnish architect Eliel Saarinen and in 1937 met his son Eero Saarinen. In 1938, Eames was offered a fellowship at the Cranbrook Academy of Art by Eliel Saarinen and so began studying design and architecture there in the autumn of that year. In 1939, he was made an instructor of design and in 1940 was appointed head of Cranbrook's industrial design department. That autumn a new student arrived at Cranbrook, Ray Kaiser, who had previously studied painting in New York at Hans Hofmann's school – an important centre for the development of Abstract expressionism. She studied weaving under Marianne Strengel (b. 1909) and assisted Charles Eames and Eero Saarinen with their entries for the "Organic Design in Home Furnishings Competition", held at the Museum of

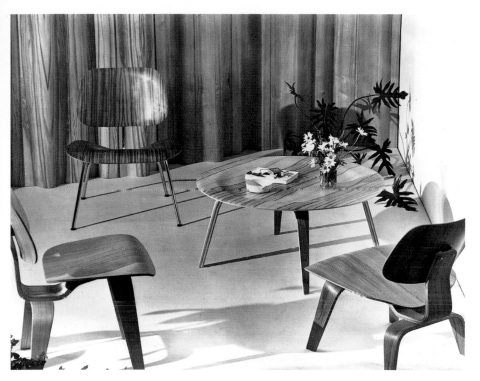

Modern Art, New York in 1940. Their revolutionary and prize-winning design proposals for seating incorporated two state-of-the-art manufacturing techniques – the moulding of plywood into complex curves and cycle-welding, an electronic bonding process developed by the Chrysler Corporation, which enabled wood and metal to be joined. A year later, having obtained a divorce from his first wife, Eames married Ray Kaiser in Chicago. The couple moved to California and Charles began working as a set designer for MGM. It was then that they started experimenting with moulding techniques for plywood in their apartment and developed the "Kazam! Machine" – a press for moulding plywood over two geometric planes into complex curves. In 1942, they were commissioned by the United States Navy to design plywood leg and arm splints as well as litters and they then established the Plyformed Wood Company to mass-produce the first trial run of 5000 splints. Due to financial difficulties, the Eameses were forced to sell this manufacturing company and so it became the Molded Plywood Products Division of the Detroit-based Evans Products Company. For a while, Charles acted as the division's director of research and development. In 1945, a series of com-

▲ Interior showing *LCW* chairs (1945), *LCM* chair (1945–1946), *CTW* table (1946) and *FSW* screen (1946) for Herman Miller

pound-moulded plywood children's furniture designed by the Eameses was produced and distributed by the Evans Products Company. In 1946, the Museum of Modern Art staged a one-man show entitled "New Furniture by Charles Eames", which displayed prototypes of the couple's famous series of plywood chairs (1945–1946). These innovative chairs were born out of the Eameses' mission "to get the most of the best to the greatest number of people for the least". Initially, Evans produced the chairs and shortly into production, they were exclusively marketed and distributed by Herman Miller, who took over their manufacture in 1949. In 1948, Charles Eames won second prize at MoMA's "International Competition for Low-Cost Furniture Design" for the couple's innovative proposal for a series of moulded fibreglass chairs. This revolutionary seating programme was amongst the very first unlined plastic seat furniture to be mass-produced and its concept of a universal seat shell that could be used in conjunction with a variety of bases to provide numerous variations was extremely influential. Throughout the 1950s and 1960s, the Eameses worked closely with Herman Miller and created more highly innovative furniture, including their *Aluminium Group* seating (1958). Apart from their furniture designs, they also received much acclaim for their architectural projects, particularly Charles Eames and Eero Saarinen's Case Study Houses No. 8 and No. 9, completed in 1949. Both

were built in Pacific Palisades – No. 8 was designed for the Eameses own use and became better known as the Eames House, while No. 9 was designed for John Entenza, the editor and publisher of *Arts & Architecture* magazine, who sponsored the project. The interior of the Eames House was remarkable for its lightness and sense of space and was decorated with an eclectic and colourful mix of ephemera – toys, kites, eastern wares – that humanized the otherwise unforgiving modern aesthetic of the interior. During their careers, the Eameses were also celebrated for their numerous short films, including *A Communications Primer* (1953), *Tops* (1969) and *Powers of Ten* (1977), some of which were made as accompaniments to their many exhibitions. They excelled in exhibition design for they were able to powerfully yet playfully communicate often complex ideas to an audience through a variety of media, including beautifully designed time-lines. The Eameses were also early pioneers of multi-media presentations and their landmark exhibitions such as *Mathematica* (1961), *Nehru: His Life and His India* (1965), *A Computer Perspective* (1971), *Copernicus* (1972) and *The World of Franklin and Jefferson* (1975–1977) were highly influential. Another significant contribution by the Eameses to communication design, were their screen presentations,

▼ *No. 670* lounge chair and *No. 671* ottoman for Herman Miller, 1956

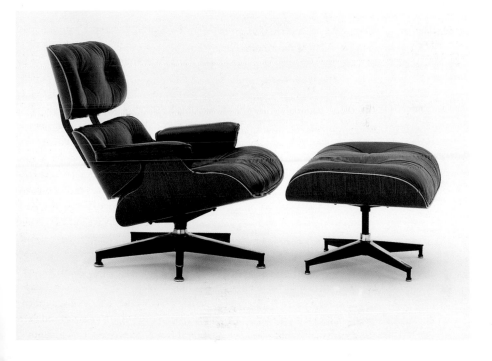

such as *Glimpses of the USA* (1959), which visually communicated everyday life in America to the Russians who could see the show at the American National Exhibition in Moscow. With their designs, film-making and photography the Eameses created a new and exciting visual language that had an enormous impact both in America and abroad. Through their work, they communicated the values of appropriateness, social morality, egalitarianism, optimism, informality and dematerialism, and while their message was distinctly American in tone, it enjoyed worldwide approval as it offered an acceptable face of Modernism. What made the Eameses' output so compelling was not just its underlying humanity but the way in which it balanced the poetic with the pragmatic. While both were driven by the same moral imperatives and shared a deep affinity for structure, Charles approached design from a technological, material and production point of view, while Ray put more emphasis on formal, spatial and aesthetic considerations. This dynamic approach to problem solving helped them to make structural, functional, psychological, intellectual, and cultural connections across the broad spectrum of their output. As the greatest exponents of Organic Design and two of the most important designers of the 20th century, the Eameses demonstrated through practice how modern design can and should be used to improve the quality of life, human perception, understanding and knowledge.

Two Swedish design groups founded in the late 1960s, the Designgruppen and Ergonomi Design, amalgamated in 1979 to form the 14-member Ergonomi Design Gruppen, based in Bromma. The group is dedicated to the research and development of safe, reliable and efficient designs based on ergonomic principles. It analyses user-system problems by, for instance, building full-scale models to evaluate designs in experimental situations. Many of the projects undertaken by the group have been part-sponsored by government bodies including the Swedish Work Environment Fund and the National Board for Occupational Health and Safety, as well as by manufacturers such as Gustavsberg. Its most notable designs include the Eat and Drink combination cutlery, drinking vessels and plates (1980), manufactured by RSFU Rehab for use by the disabled, and machinery for printing and welding that reduces the risk of accidents and repetitive strain injury. Founders of the group include Maria Benktzon (b. 1946) and Sven-Eric Juhlin (b. 1940), both alumni of the Konstfackskolan (School of Arts & Crafts), Stockholm. Before setting up the group, Benktzon had studied the design of clothing for the handicapped and Juhlin had worked as an in-house designer for Gustavsberg. Both subsequently undertook research in 1972 into muscular ability and its relationship to the actions of gripping and holding and have since then specialized in design for disability.

**Ergonomi Design Gruppen**
Founded 1979
*Stockholm*

▼ **Maria Benktzon & Sven-Eric Juhlin,**
*Eat/Drink* cutlery for RFSU Rehab, 1980

## Kaj Franck

1911 Viipuri, Finland
1989 Santorini, Greece

▲ *Kartio* glassware,
1958 with *Teema*
ceramics, 1981

Kaj Franck studied furniture design under Arttu Brummer at the Taideteol-linen Korkeakoulu, Helsinki, graduating in 1932. In 1938, he became a textile designer at the Hyvinkää United Wool Factory and a year later was con-scripted into the military. During the war, he met many fellow countrymen from less privileged backgrounds and this experience profoundly influenced his views on society. In 1945, he began working for the Arabia ceramic factory and a year later, designed a range of utilitarian tableware for the Väestöliition (Family Welfare Association). In 1950, he became art director of Arabia, and during the 1950s created ranges of everyday modern crockery and kitchenware that were designed for multi-purpose use. In 1955, Franck received an Asla grant to study design teaching in America and during his time in the USA he researched eating habits, which had a direct bearing on his subsequent design work. From 1954, until he left Arabia in 1973, Franck also designed limited-production wares, such as his *Lumipallo* (Snowball) series. Glassware designed by him was produced by Iittala (1946–1950) and Nuutajärvi-Notsjö (1950–1976). Franck's informal tableware and glassware designs not only addressed contemporary functional needs, but through their adoption of elemental forms also had an aesthetic purity.

Émile Gallé studied at the Lycée Impérial in Nancy and by the age of sixteen had learnt much about decorating ceramics and glass in the workshops of the St Clément pottery, which supplied wares to his father's shop. His father, Charles Gallé-Reinemer, later acquired part-ownership of the St Clément pottery and Émile worked for him decorating both faience and glassware. During this period, Gallé also studied botany under Professor Vaultrin, draughtsmanship with Professor Casse and landscape painting with Paul Pierre. From 1864 to 1866, Gallé was in Weimar studying botany, mineralogy and art history. After completing his formal education, Gallé returned to Lorraine and spent a year working for his father before taking up a three-year-apprentice-ship at Burgun, Schverer & Co, the glassworks and decorating studio in Meisenthal that supplied the Nancy-based family firm with undecorated wares. In 1870, he returned to France and shortly afterwards enlisted in the military for the Franco-Prussian war. A year later, Gallé represented the family firm in the "Art de France" section at the "First Annual Inter-national Exhibition" in London, and on his return to France per-suaded his father to re-site the family firm in Nancy, as St Clément was now under German occupation. In 1873, a new glassworks was founded in Nancy and four years later Gallé became director of the family firm. He developed many new techniques and his decorations became increas-ingly informed by the natural world. In 1878 Gallé achieved critical acclaim and was awarded four gold medals at the "Exposition Univer-selle" in Paris. Spurred on by this success, he built larger workshops so as to achieve greater production ca-pacity and in 1884, after a fruitless

**Émile Gallé**
1846 *Nancy, France*
1904 *Nancy*

▼ Carved mahogany and marquetry cabinet, c. 1900

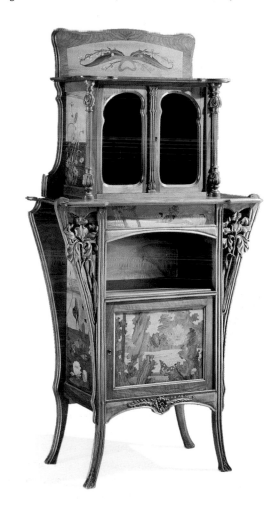

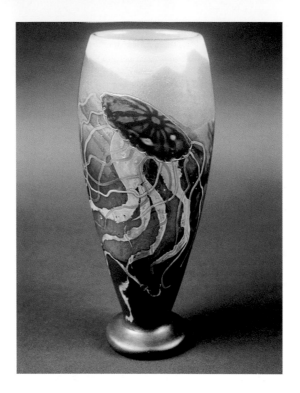

search for suitable wooden bases for his Art Nouveau glassware, he ac-
quired land for a new cabinet-making workshop. Gallé's subsequent furni-
ture designs, the structure and decoration of which was inspired by plant
forms, were first exhibited at the 1889 "Exposition Universelle", where he
also received praise for his new glass designs that incorporated a wide
range of techniques, including etching, wheel-carving and gilding. At this
exhibition, he was awarded a Grand Prix and the highest of French acco-
lades – the "Légion d'Honneur". In 1894, he opened a larger glassworks
with an immense production capacity. In 1901, he became the first president
of the "Alliance Provinciale des Industries d'Art" group, later known as the
École de Nancy.

Walter Gropius studied architecture at the Technische Hochschule, Munich from 1903 to 1905 and then at the Technische Hochschule, Berlin from 1905 to 1907. His first building project in 1906, was for low-cost housing to accommodate farm-workers. From 1908 to 1910, Gropius worked in the Berlin-based office of Peter Behrens, designing offices and furniture for the Lehmann department store in Cologne. Then, in 1910, Gropius established an architectural partnership with Adolf Meyer (1881–1929) in Neubabelsberg and became a member of the Deutscher Werkbund (established 1907). As an active member of the Werkbund, Gropius initially opposed Hermann Muthesius' (1861–1927) urgings for standardization and sided with Henry van de Velde, who advocated individualism and personal creativity in design. Gropius' Fagus Factory (1911) innovatively incorporated a curtain wall that was suspended from the building's vertical elements and was featured in the Werkbund's *Jahrbücher* (Year-Books), which Gropius edited from 1912 to 1914. He also designed a model factory for the "Deutsche Werkbund Ausstellung" held in Cologne in 1914, which with its steel and glass construction was a powerful expression of the Modern Movement. After the devastation of the First World War, Gropius accepted the need for Standardization in design and became the director of the Hochschule für angewandte Kunst, which he merged with the Kunstakademie in Weimar in 1919 to form the Staatliches Bauhaus. During his directorship of the school from 1919 to 1928, Gropius stressed unity of the arts and instigated a system of workshops headed by "masters". During this period, he undertook a number of private architectural commissions, including the Sommerfeld House (1921–1922), designed several pieces of white-painted furniture and developed a pre-fabricated house for the "Weissenhof-Siedlung" exhibition held in Stuttgart in 1927. When the Bauhaus moved to Dessau, the school embraced by necessity a new rationalism and in 1925, Gropius designed purpose-built premises for it that embodied

**Walter Gropius**
1883 *Berlin*
1969 *Boston*

▼ Mahogany cabinet with bronze inlay designed for the salon of Dr. Karl Herzfeld in Hanover, 1913

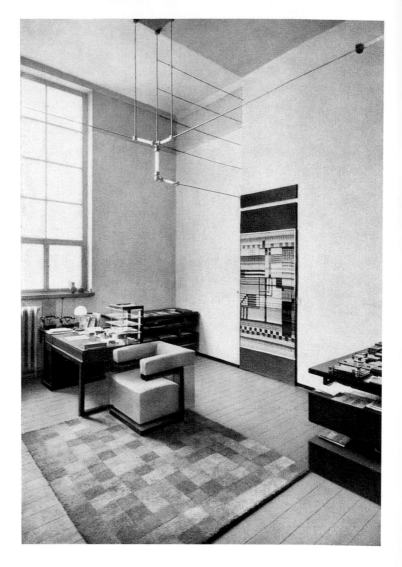

this shift towards industrial modernity. In 1934, Gropius emigrated to Great
Britain where he worked in partnership with the architect E. Maxwell Fry
(1899–1987) until 1937. While in London, Gropius also worked for Jack
Pritchard's company, Isokon, where he was appointed controller of design
in 1936. A year later, he emigrated to the United States and became professor
of architecture at Harvard University.

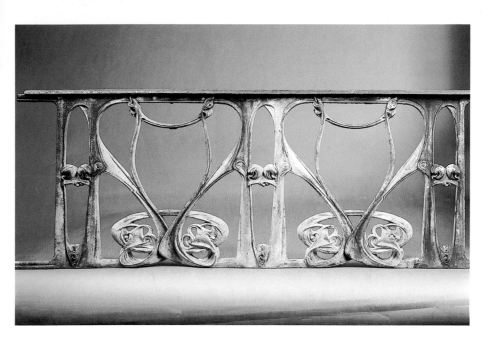

Hector Guimard studied in Paris, from 1882 to 1885 under Eugène Train and Charles Génuys at the École Nationale des Arts Décoratifs and in 1889 under Gustave Gaulin at the École des Beaux-Arts. His first project was the interior design of the Au Grand Neptune Restaurant, Paris. This was followed by several commissions for private residences in and around the city including Charles Jassedé's villa (1893), which with its integrated interior and exterior scheme was conceived as a Gesamtkunstwerk.

He then became inspired by English Domestic Revival architecture and the swirling Art Nouveau designs of Victor Horta, and between 1894 and 1897 designed the Castel Béranger apartment building in Paris, which was especially influenced by the Gothic Revival and Henry II styles. Guimard was the main exponent of French Art Nouveau and his Castel Béranger can be viewed as a manifesto of the style, which in France was often referred to as "Style Guimard".

From 1899 to 1901, Guimard undertook many architectural commissions including the Maison Coilliot in Lille (1898–1900), the Castel Henriette in Sèvres (1899–1900) and the Humbert de Romans concert hall (1898–1900), for which he designed site-specific furniture and fittings that embodied a remarkable sense of organicism.

His most famous designs, however, were the cast-iron entrances to the

**Hector Guimard**
1867 *Lyons*
1942 *New York*

▲ Balcony railing for the Fonderies de Saint-Dizier, c. 1909

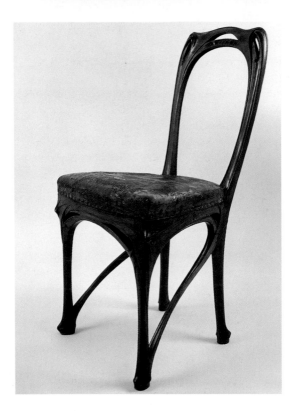

▶ Chair for the dining room of the Maison Coillet, c. 1898–1900

Paris Métro (1903), which exemplified the swirling exuberance of Art Nouveau. In 1920, Guimard created his first pieces of standardized furniture for serial production and a year later developed housing for workers and an apartment building with standardized elements.

With the ascendancy of Art Deco in the 1920s, Guimard, like many other designers associated with Art Nouveau, fell out of fashion and faded into relative obscurity. In 1938, he emigrated to the United States and settled in New York.

Poul Henningsen trained as an architect at the Tekniske Skole, Copenhagen, from 1911 to 1914 and at the Polyteknisk Laeranstalt from 1914 to 1917. After his formal studies, he took up journalism for eight years, first working as an art critic for the magazine *Klingen* and then writing for the newspapers, *Politiken* and *Extra Bladet*. From 1924, he began to design lighting for Louis Poulsen and the first lamp from his *PH* series was exhibited to great acclaim at the 1925 Paris "Exposition Internationale des Arts Décoratifs et Industriels Modernes". The *PH* lamps were the result of ten years scientific study and were designed to eliminate glare and produce soft warm light. From the mid-1920s until the outbreak of the Second World War, *PH* lamps were exported to Central Europe, North and South America, Africa and Asia. The *PH* lamps were especially popular in Germany and were featured in *Das Neue Frankfurt* magazine, which praised the technical excellence of their three-shade system. During this period, Henningsen also designed furniture for the Copenhagen-based firms, Zeiss and Goertz. From 1926 to 1928, he was editor of the magazine *Kritisk Revy*, after which he founded and edited his own short-lived review, *PH-Revy*. In 1929, he began writing for music hall revues and subsequently became a film writer. From 1935 to 1939, he also contributed to the anti-Nazi journal *Kulturkampen* and in 1941 undertook architectural projects in Tivoli. From 1943 to 1945, Henningsen lived as a political exile in Sweden, and on his return to Copenhagen after the Second World War worked as a correspondent and editor for a number of journals including the *Social-Demokraten*. Henningsen denounced the artistic pretensions of Scandinavian design and advocated a more utilitarian approach that would bring Good Design to the masses. Unlike the majority of Modern Movement designers, however, Henningsen regarded traditional forms and materials as eminently suitable for the manufacture of more democratic products. On his death in 1967, he left over one hundred lighting designs, some of which have been issued posthumously.

**Poul Henningsen**
1894 *Ordrup, Denmark*
1967 *Copenhagen*

▼ *PH4-3 table lamp for Louis Poulsen, 1966*

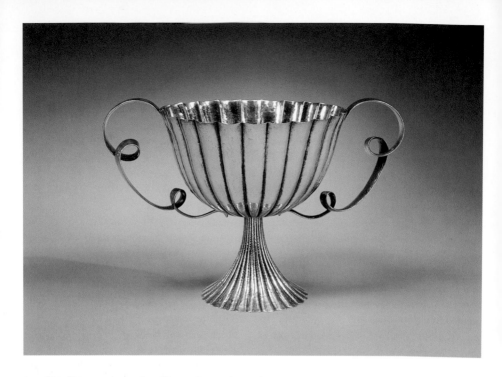

## Josef Hoffmann

1870 *Pirnitz, Moravia*
1956 *Vienna*

▲ Brass fruit-cup
for the Wiener
Werkstätte, 1925

Josef Hoffmann began his architecture studies in 1887 at the Höhere Staats-gewerbeschule in Brünn and continued his training under Otto Wagner and Carl von Hasenauer at the Akademie der Bildenden Künste in Vienna. After graduating in 1895, he became a founding member of the artistic group, Siebener-Club (Club of Seven) and travelled with Josef Maria Olbrich to Italy, having been awarded a Prix de Rome. In 1897, he worked in Otto Wagner's architectural practice and became a co-founder of the Wiener Secession – a reformist group of artists and architects that was established to counter the then prevalent Art Nouveau style. From 1899 to 1936, Hoffmann taught ar-chitecture and design at the Kunstgewerbeschule in Vienna. In 1900 he trav-elled to Britain, and while there met members of the British Arts & Crafts Movement, including Charles Robert Ashbee and Charles Rennie Mackin-tosh whom he invited to design installations for the VIII Secessionist Exhib-ition held in Vienna the same year. Hoffmann's work like that of other Se-cessionist designers was subsequently much influenced by the work of the Glasgow School, especially Mackintosh. In 1903, Hoffmann and Koloman Moser established the Wiener Werkstätte with the financial backing of the wealthy banker, Fritz Wärndorfer (1869–1939), who was the main patron of

the Vienna Secession. Hoffmann was the artistic director and one of the most prolific designers of this co-operative workshop, which was inspired by Ashbee's Guild of Handicraft. Many of Hoffmann's metalwork designs for the Wiener Werkstätte were architectural in nature, while other more commercial and less expensive metalwares incorporated a grid-like pattern that became known as the Hoffmann-Quadratl. This type of pierced decoration was used on many of his chair designs, including the famous *Sitzmaschine* (c. 1908), which was manufactured by Jacob & Josef Kohn. Hoffmann also designed glassware for the J. L. Lobmeyr and Loetz Witwe glassworks, in which coloured overlays were cut and etched to reveal white underlays. Apart from his product design work, Hoffmann also ran a highly successful architectural office in Vienna and executed wholly integrated Gesamtkunstwerk schemes, such as the Purkersdorf Sanatorium (1904), the Palais Stoclet, Brussels (1905–1911) and the Cabaret Fledermaus (1907). In 1905, Hoffmann left the Vienna Secession and established the Kunstschau with the painter Gustav Klimt (1862–1918). Two years later, Hoffmann became a founding member of the Deutscher Werkbund and from 1912 to 1920 was chairman of the Österreichischer Werkbund. Hoffmann took part in many international exhibitions including the 1914 Cologne "Deutsche Werkbund-Ausstellung", the 1925 Paris "Exposition Internationale des Arts Décoratifs

▼ Bar room of the Cabaret Fledermaus in Vienna, 1907

et Industriels Modernes" and the 1930 Stockholm "Stockholmsutstä-liningen". While his approach to architecture and design was much influenced by the British Arts & Crafts Movement, Hoffmann's work was strongly anti-historicist. The characteristic and innovative pared-down rectilinear forms he evolved had a marked influence on the geometric vocabulary of form adopted by the Modern Movement.

**International Style**

The term International Style was first coined in 1931 by Alfred H. Barr Jr., the director of the Museum of Modern Art, New York, for the title of a catalogue, *International Style: Architecture Since 1922*, which accompanied Henry-Russell Hitchcock's and Philip Johnson's landmark exhibition of 1932. In the work of Modernists such as Le Corbusier, Jacobus Johannes Pieter Oud, Walter Gropius and Ludwig Mies van der Rohe, Barr identified a universal style that transcended national borders – the like of which had not been seen in Western art and architecture since the Middle Ages, when the so-called International Gothic Style had flourished across Europe. The new 20th-century movement was named accordingly in tribute to this earlier precedent.

The term International Style referred specifically to the work of Modern Movement architects and designers, who married function and technology with a geometric vocabulary of form to produce a pared-down modern aesthetic. Although it is sometimes used to describe early Modernism (c. 1900 to 1933) and the work of designers such as Adolf Loos and J. J. P. Oud, it is now generally associated with the less utilitarian form of Modernism that emerged after the closure of the Bauhaus in 1933. The term also refers to the work of Le Corbusier and his followers, who during the late 1920s and 1930s promoted a more stylish and less austere version of Modernism. Perhaps the greatest exponents of the International Style, however, were Ludwig Mies van der Rohe and Walter Gropius, who having emigrated to the United States, tirelessly attempted to "internationalize" the Modern

◄ Le Corbusier, Pierre Jeanneret and Charlotte Perriand, Dining room exhibited at the Salon des Artistes Décorateurs in Paris, 1928

Movement not only through their architectural commissions and exhibitions but through their high profile teaching positions in America during the post-war years. Many advocates of the International Style adopted the Functional-ist aesthetic of the Modern Movement for purely stylistic reasons. Others, however, developed an aesthetic purity so as to promote a greater universal-ism in architecture and design. Later post-war designers – especially in America – such as Florence Knoll, Charles Eames and George Nelson mar-ried this modern and democratic approach to design with methods of in-dustrial mass-production so as to create products that fulfilled all the crite-ria of Good Design.

During the 1920s and 1930s, International Style in architecture and interior design was characterized by geometric formalism, the use of industrial ma-terials such as steel and glass and a widespread preference for white render-ing. Later, some architects and designers, including Eero Saarinen and Charles Eames, sought to humanize the International Style through the adoption of sculptural forms and the contrasting of geometric and organic shapes, while Kenzo Tange (b. 1913) and others took International Style to its logical conclusion in the creation of Brutalism, an architectural style that employs dehumanizing materials and surfaces treatments such as exposed rough-cast concrete and rigid geometry.

▼ Le Corbusier, Pierre Jeanneret and Charlotte Perriand, *Model No. B306* chaise longue for Thonet, 1928 (reissued by Cassina)

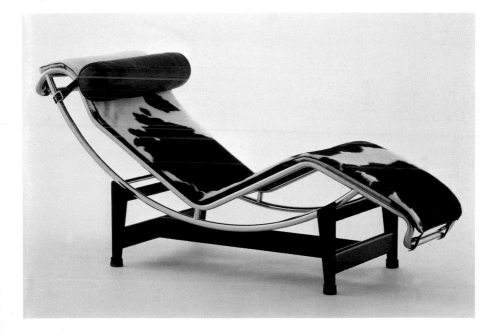

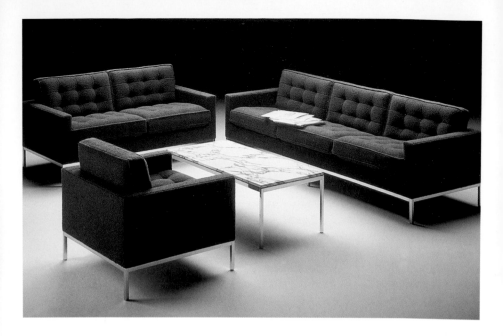

▲ **Florence Knoll,**
The *Florence Knoll*
Collection – *1205S1*
lounge chair, *1205S2*
two-seater sofa,
*1205S3* three-seater
sofa and *2511T*
table – for Knoll
International, 1954

Although it appeared in the late 1970s and 1980s that the emergence of Post-Modernism had tolled the death knell of the International Style, by the late 1980s and 1990s architects such as Norman Foster and Richard Rogers (b. 1933) were winning acclaim for their highly engineered buildings, which bore the unmistakable characteristics of International Style – power, elegance and clarity.

In recent years, there has also been a return to a rational aesthetic within product and furniture design, as manufacturers seek global solutions that, like International Style, are trans-cultural. The term International Style can therefore refer to a very specific period and type of Modernism, while also alluding to the aesthetics resulting from a Functionalist approach to design, the ancestry of which can be traced back to the earliest beginnings of the Modern Movement.

Maija Isola studied painting at the Taideteollinen Korkeakoulu (Central School of Industrial Arts) in Helsinki from 1946 to 1949. Then, for eleven years she was principal designer for the Finnish textile firm, Printex, which had been established by Vilho Ratio and was under the artistic directorship of Armi Ratia (1912–1979). Isola created numerous printed textiles for interior use that were produced by Printex. From 1951, she also did designs for Printex's sister company, Marimekko, which had been founded with the intention of promoting the use of Printex textiles in fashion and interior design. Her designs for dress and furnishing fabrics for this newly established company, as well as her textiles for Printex, were displayed at the Brussel's World Fair in 1958. Isola's earliest designs were inspired by African art and in the mid-1950s, she produced textiles decorated with botanical motifs. She also designed fabrics influenced by Slovakian folk art in the late 1950s and by traditional Karelian peasant motifs in the late 1960s and early 1970s. Many of her silk-screened textiles were translations of her artwork. In the mid-1960s, she produced her most famous range of printed cotton textiles, which incorporated large-scale geometric patterns that were printed in strong flat colours. These bold designs such as *Kaivo* (c. 1964), *Melooni* (1963) and *Cock and Hen* (1965) reflected contemporary artistic trends, most notably the influence of Colour Field painters in America. Isola's fabrics from this range had a strong graphic quality and came to epitomize not only Marimekko textiles but also a new direction in Finnish design. She received ID awards in 1965 and 1968, and until recently remained, together with Fujiwo Ishimoto (b. 1941), one of the few in-house designers working at Marimekko. Isola's colour saturated and elemental patterned fabrics have been exhibited widely in Europe, America and Australia and have had a powerful influence on contemporary textile design.

**Maija Isola**

b. 1927 *Riihimäki, Finland*

▼ *Kaivo* textile for Marimekko, c. 1964

## Arne Jacobsen

1902 Copenhagen
1971 Copenhagen

▲ *Model No. 3100*
*Ant* chairs for Fritz
Hansen, 1951–1952

Arne Jacobsen trained as a mason before studying at the Kongelige Danske Kunstakademi, Copenhagen, where he graduated in 1927. As a student, Jacobsen showed early promise, winning a silver medal for a chair that was exhibited at the 1925 Paris "Exposition Internationale des Arts Décoratifs". Between 1927 and 1929, Jacobsen worked in the architectural offices of Paul Holsøe, after which he established his own design office in Hellerup and began practising independently as an architect and interior designer. His early work was influenced by the achievements of Le Corbusier (whose "Pavillon de l'Esprit Nouveau" he had seen in Paris), Gunnar Asplund and other Modern Movement designers such as Ludwig Mies van der Rohe. Jacobsen was among the first to introduce Modernism to Danish design through his projects such as "House of the Future", which he co-designed with Flemming Lassen in 1929. His first important architectural commissions were for the Bella Vista housing project, Copenhagen (1930–1934) and the Functionalist Rothenborg House, Ordrup (1930), which was conceived as a Gesamtkunstwerk. For his best-known and most fully integrated works, the SAS Air Terminal and Royal Hotel, Copenhagen (1956–1960), Jacobsen designed every detail from textiles and sculptural furnishings, such as his

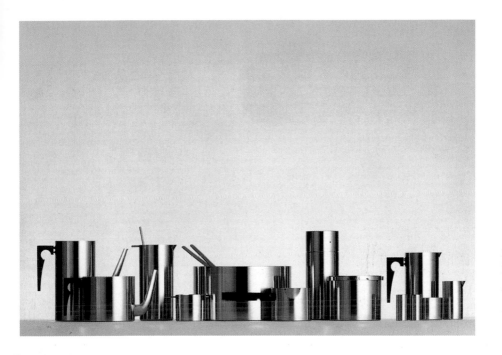

Swan and Egg chairs (1957–1958), to light fittings, ashtrays and cutlery.
A decade earlier, Jacobsen had also worked as an industrial designer and
achieved considerable success, most notably with his famous chair designs
for the furniture manufacturer Fritz Hansen. His *Ant* chairs (1951–1952) and
his *Series 7* chairs (1955) are still among the most commercially successful
seating programmes ever produced. Jacobsen also designed lighting for
Louis Poulsen, metalware for Stelton and Michelsen, textiles for August
Millech, Grautex and C. Olesen, and bathroom fittings for I. P. Lunds. From
1956 until 1965, he was a professor emeritus at the Skolen for Brugskunst
in Copenhagen. During the 1960s, Jacobsen's most important architectural
scheme was St Catherine's College, Oxford, which, like his earlier work,
was conceived as a wholly unified project and as such involved the design
of site-specific furniture. Jacobsen combined sculptural and organic forms
with the traditional attributes of Scandinavian design – material and struc-
tural integrity – to produce simple, elegant and functional designs that have
a remarkable, timeless appeal.

▲ *Cylinda-Line*
stainless steel series
for Stelton, 1967

## Georg Jensen

1866 *Raavad/Denmark*
1935 *Hellerup/Denmark*

Georg Jensen was apprenticed to a gold and silversmith in Copenhagen, and from 1884 worked as a journeyman in that craft. From 1887 to 1892, he trained as a sculptor at the Kongelige Danske Kunstakademi. In 1898, Jensen started to produce sculptural ceramics for Mogens Ballin's workshop near Copenhagen and later, he worked at the Aluminia pottery and at the Bing & Grøndahl porcelain factory in Copenhagen before establishing his own silversmithing workshop in 1904. Jensen detested the prevalent taste for reproduction silver and so began designing Arts & Crafts style jewellery and silverware that was influenced by natural forms, such as berries, leaves and swirling tendrils. Jensen's most notable designs were the *Blossom* (c. 1904–1905) and *Grape* (c. 1918) ranges, which included a diversity of items from tableware to jewellery. In 1907, Jensen persuaded the artist, Johan Rohde (1856–1935) to produce designs for the workshop. When the company exhibited at the "Panama-Pacific International Exposition" held in San Francisco, the newspaper baron William Randolph Hearst was so impressed with the quality of the work on show that he purchased their complete inventory. The company subsequently became so commercially suc-

▼ Silver fruit bowls from *Grape* range, 1918

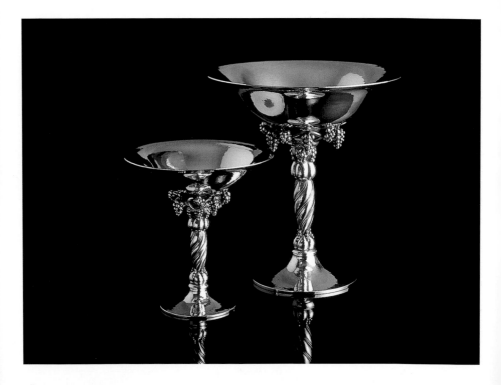

cessful that in 1924 they opened a showroom on Fifth Avenue, New York. During the 1920s Jensen recruited other avant-garde designers, such as Harald Nielsen (1892–1977) and Gundorph Albertus (1887–1970) and to produce designs for the firm. At the same time, Rohde introduced unornamented modern forms to the firm's line of silverware. Upon the death of Georg Jensen in 1935, the running of the company was taken over by his son Jørgen Jensen (1895–1966) who perpetuated their forward-looking ethos. After the Second World War, they began producing modern and supremely elegant handcrafted silverware designed by Henning Koppel and Tias Eckhoff (b. 1926), which exemplified the functional and aesthetic purity of Scandinavian Modernism. During the post-war years, the firm also began manufacturing stainless steel products, such as Arne Jacobsen's flatware (1957) and glassware designed by Finn Juhl. Since the 1920s, the Georg Jensen name has been synonymous with Scandinavian Modernism and to this day, the company continues to produce beautiful metalware, jewellery and wristwatches of innovative forms and superlative craftsmanship, by designers such as Nanna Ditzel, Vivianna Torun Bülow-Hübe (b. 1927) and Jørgen Møller (b. 1920).

◀▼ **Sigvard Bernadotte,** *Bernadotte* silver flatware, 1939

▼ **Harald Nielsen,** *Pyramid* silver flatware, 1926

◄ *Beogram 4000*
record player for
Bang & Olufsen,
1972

**Jakob Jensen**
b. 1926 *Copenhagen*

On completing his training in industrial design at the Kunsthandvaerker-skolen (School of Arts & Crafts), Copenhagen in 1952, Jakob Jensen became chief designer for the first Danish industrial design consultancy founded in 1949, Bernadotte & Bjørn. In 1959, he moved to the USA where he established a design office with Richard Latham (b. 1920) among others, and taught at the University of Illinois, Chicago. On his return to Copenhagen in 1961 Jensen founded his own industrial design office, and from 1964 began designing audio equipment for Bang & Olufsen. His sleek, high-performance designs, such as the *Beogram 1200* hi-fi (1969), which was awarded a Danish ID prize for its harmonious balance between "apparatus" and "furniture", and the *Beogram 4000* record player (1972), which innovatively incorporated a tangential pick-up arm, set the aesthetic and technological standards for audio systems. Although best known for his pioneering work for Bang & Olufsen, Jensen has also designed products for other Danish manufacturers, including the *E76* pushbutton telephone (1972) for Alcatel-Kirk, an office chair (1979) for Labofa, ultrasound scanning equipment (1982) for Bruel & Kjaer and a wristwatch (1983) for Max René. Jensen has received numerous awards for his product designs including the German Award "Die Gute Industrieform" and the IDSA prize.

Jugendstil translates literally as "Youth Style" and refers to the branch of Art Nouveau that emerged in Germany during the 1890s. The term was derived from the title of the magazine *Jugend*, which was founded in Munich by Georg Hirth in 1896 and did much to popularize the new style. Inspired by the reforming ideas of John Ruskin (1819–1900) and William Morris, Jugendstil designers such as Hermann Obrist, Richard Riemerschmid and August Endell had more idealistic aims than other proponents of the Art Nouveau style in Europe. They not only sought to reform art but also advocated a return to a simpler and less commercial way of life. They possessed a youthful optimism and a reverence for nature that was expressed vigourously through their work. Like their contemporaries in Brussels and Paris, Jugendstil designers were inspired by the workings of the natural world as revealed through advances in scientific research and technology. The swirling vegetal motifs and whiplash forms employed by August Endell and Hermann Obrist, for example, were directly influenced by Karl Blossfeldt's (1865–1932) photographic studies of plant structures, which depicted remarkable spiral growth patterns, and by the botanical drawings of Ernst Haeckel (1834– 1919). The new understanding of nature provided by detailed analyses such as these helped Jugendstil designers to capture a sense of dynamism and energetic organic growth in their work. In Germany, this new ahistorical style challenged the official imperial art policy emanating from Berlin, and regions wishing to express their sense of cultural autonomy, such as Dresden, Munich, Darmstadt, Weimar and Hagen, embraced Jugendstil wholeheartedly. Although this desire for artistic independence was a theme that united the emerging schools of Art Nouveau in other European cities such as Brussels, Nancy and even Glasgow, it was perhaps felt most strongly across Germany. Jugendstil designers came closer than any of their European contemporaries associated with Art Nouveau to bridging the

## Jugendstil
*Germany*

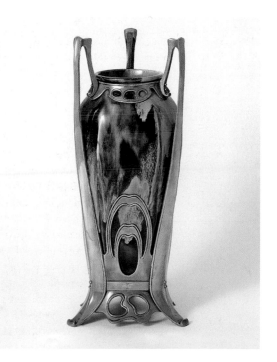

▼ **Otto Eckmann**,
Stoneware vase with
bronze mount,
c. 1900

▲ **August Endell,**
Design for the boxes
in the Buntes
Theater in Berlin,
1901

gulf that existed between "artistic manufacture" and industrial production. Many workshops were established to produce their reformed designs, most notably the Vereinigte Werkstätten für Kunst im Handwerk (United Workshops for Artist Craftsmanship) in 1897 and the Dresdener Werkstätten für Handwerkskunst (Dresden Workshops for Artist Craftsmanship) in 1898. These ventures were set up with the objective of producing honest domestic wares through ethical manufacturing practices. The objects produced in Dresden were less elaborate and hence less expensive than those manufactured in Munich but were still beyond the means of the average householder. Richard Riemerschmid, chief designer at the Dresden workshop, adopted a simple vernacular style that was similar to the work of British Arts & Crafts designers such as Charles Voysey. Riemerschmid sought to reform design through standardization and his adoption of rational manufacturing practices at the Dresdener Werkstätten für Handwerkskunst was extremely influential, contributing to the founding of the Deutscher Werkbund. The Vereinigte Werkstätten für Kunst im Handwerk, which were founded in Munich by Bruno Paul and others, also played a key role in the promotion of Jugendstil. Paul designed boldly outlined cartoons and graphics for the journal *Simplicissimus,* which, like the magazine *Jugend,* popularized the new aesthetic. His linear style was shared by his fellow Munich designer

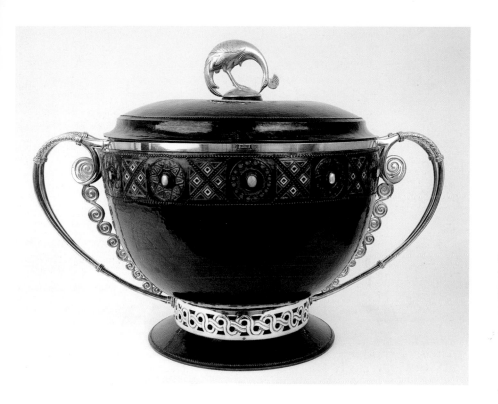

Bernhard Pankok, whose Lange house in Tübingen (1902) was conceived as
a Gesamtkunstwerk. The building was influenced by vernacularism, as were
the Jugendstil interiors, which were startlingly modern in their simplicity.
In Darmstadt, the Jugendstil cause was heavily patronized by Grand Duke
Ernst Ludwig of Darmstadt Hesse who instigated an exhibition entitled,
"Ein Dokument Deutscher Kunst" (A Document of German Art) in 1901.
The exhibition celebrated the artistic achievements of the Darmstädter
Künstlerkolonie (Darmstadt Artists' Colony), which had been established
with the Grand Duke's private funding in 1899. The Darmstädter Künstler-
kolonie initially comprised eight buildings including Josef Maria Olbrich's
"House for Decorative Art" studio building and seven artists' residences
built for members of the colony. The Darmstädter Künstlerkolonie was not
only important for the new civic architectural style it promoted, which em-
braced Jugendstil, but also for its encouragement of the manufacture of art
works. In Weimar, the promotion of Jugendstil was similarly prompted by
both civic pride and economic necessity and also received ducal patronage.

▲ Covered bowl,
c. 1900

In 1860, the Grand Duke Karl Alexander of Saxony-Weimar privately funded the establishment of an art school in Weimar. He was succeeded by his grandson in 1901 who was persuaded by Count Harry Kessler to appoint the Belgian architect Henry van de Velde as art counsellor to his court. The belief that the local economy would be boosted through art education eventually led to van de Velde's being commissioned to design the Weimar Kunstgewerbeschule (School of Applied Arts) in 1904. He directed the institution until 1914, and during his tenure, produced many Jugendstil designs for silverware and ceramics that were remarkable for their simplicity of form. Jugendstil architecture and design often united structural innovation with abstracted naturalistic forms to produce an extraordinary combination of monumentality and visual lightness. The style reached its zenith around 1900 and was shortly afterwards superseded by the industrial rationalism of the Deutscher Werkbund, founded in 1907 by a group of designers and architects who had been affiliated with Jugendstil. Through its promotion of natural forms and "folk" types as a means of reforming design and ultimately society, Jugendstil had much in common with the British Arts & Crafts Movement, while its adoption of more industrialized methods of production paved the way for later developments in German design. The term 'Jugendstil' can also be used to refer to Scandinavian Art Nouveau.

▼ Ferdinand Morawe, Clock for the Vereinigte Werkstätten für Kunst im Handwerk, 1903

Henning Koppel studied drawing under Bizzie Høyer in Copenhagen from 1935 to 1936 and sculpture under Anker Hoffmann at the Kongelige Danske Kunstakademi (Royal Danish Academy of Fine Arts), Copenhagen from 1936 to 1937. He then trained at the Académie Ranson, Paris for a year, where he was undoubtedly exposed to new currents in avant-garde sculpture. Koppel spent the Second World War in Stockholm, and while there produced designs for Orrefors and Svenskt Tenn and began designing gold and silver jewellery. He then returned to Denmark and began his long association with the Georg Jensen silversmithy, which lasted until his death in 1981. From 1961, Koppel produced sculptural ceramics such as the *Form 24* service (1962) for Bing & Grøndahl Porcelaensfabrik, and also designed clocks and lighting for Louis Poulsen, glassware for Orrefors and even Danish postage stamps. It was, however, his beautiful sculptural silverware designed for Georg Jensen that brought him the greatest international acclaim. Inspired by the abstract sculptures of Hans Arp (1887–1966) and Constantin Brancusi (1876–1957), Koppel created biomorphic silver jewellery, such as his brace-

**Henning Koppel**
1918 *Copenhagen*
1981 *Copenhagen*

let *Model No. 89* (1946), which had a wonderful plasticity of form and was exceptionally forward-looking. Although he followed the traditions of craftsmanship for which Denmark was so renowned, Koppel's designs, such as the wine pitcher *Model No. 978* (1948) and fish dish (1954), expressed a universal language of organic form that was fundamentally modern. His ideas for designs were initially sketched in ink and then modelled in clay, which allowed him to perfect the lines from every side before they were translated into silver. His *Caravel* cutlery of 1957 introduced expressive form to the Georg Jensen flatware collection. Koppel was awarded three gold medals at the Milan Triennale exhibitions (1951, 1954 and 1957), and was awarded the Lunning Prize in 1953.

▼ *Model No. 992*
silver pitcher for
Georg Jensen, 1952

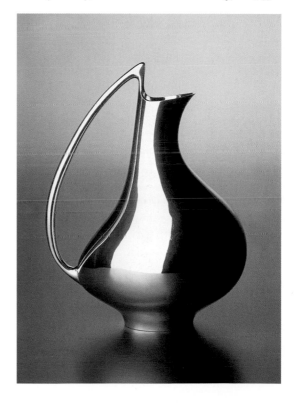

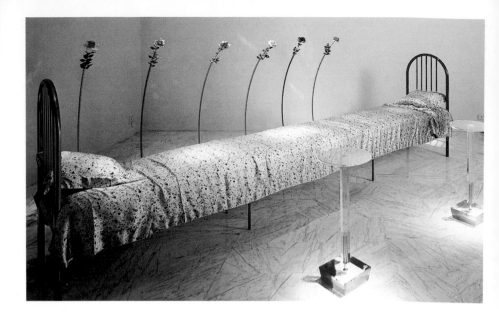

## Shiro Kuramata

1934 Tokyo
1991 Tokyo

▲ Interior at the
"Il Dolce Stile Nuove
– delle casa" exhib-
ition held at the
Palazzo Strozzi in
Florence, 1991 –
showing a *Laputa*
bed, *Placebo* tables
and *Ephemera* vases
for Cappellini, 1991

Shiro Kuramata studied architecture at the Tokyo Municipal Polytechnic High School until 1953 and then worked for the furniture manufacturer, Teikokukizai for a year. He also trained in the department of living design at the Kuwazawa Institute for Design, Tokyo, graduating in 1956. For the next seven years, Kuramata worked in the San-Ai design studio of the Maysuya department store in Tokyo, concentrating on retail design. In 1965, he founded his own Tokyo-based practice, the Kuramata Design Studio, and designed interiors for over three hundred bars and restaurants, including the Judd Club (1969), as well as furniture that tempered Japanese minimalism with a Western sense of irony. He received a Mainichi Design Award in 1972 and became a consultant to the Mainichi board in 1975. Kuramata's extraordinary *Drawers in an Irregular Form* (1977) was one of the first furniture designs to bring him international recognition. In the 1980s, he used unusual materials, such as steel expand-metal and acrylic resin, to create highly original and poetic furniture with remarkable spatial qualities such as his *How High The Moon* chair (1986) and *Miss Blanche* chair (1988). The titles of these illusory designs made reference to Western culture – namely, the title of Duke Ellington's jazz number and a character from Tennessee William's play *A Streetcar Named Desire*. In 1981, Kuramata was awarded the Japanese Cultural Prize for Design, and over the next six years designed several pieces for Memphis, including his cement and glass

▶ *How High the Moon* chair for Kurosaki, 1986 (reissued by Vitra)

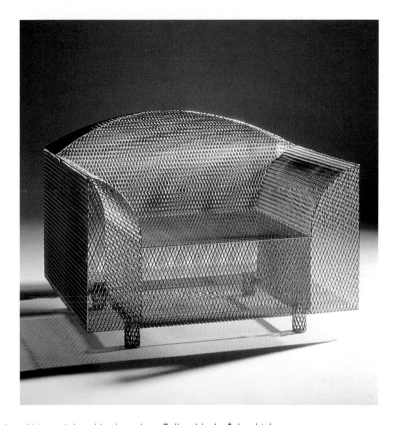

*Kyoto* table (1983) and his metal and broken glass *Sally* table (1987), which were more refined and aesthetically reserved than designs normally associated with the Italian group. Throughout the 1980s, Kuramata designed minimalist furnishings and fittings for the Issey Miyake stores in Tokyo (1986), Paris (1984) and New York (1987) and created interiors for the Seibu store in Tokyo (1987). He purchased a house in Paris in 1988 that had originally been designed by Robert Mallet-Stevens for Jöel and Jan Martell and established his own design office on the Rue Royale, Paris. Kuramata's designs have been manufactured by many companies including Vitra, Cappellini, XO, Fijiko, Ishimaru, Mhoya Glass Shop, Aoshima Shoten and Kurosaki.

**René Lalique**

1860 Ay, France
1945 Paris

After leaving the Turgot School in 1876 at the age of sixteen, René Lalique became apprenticed to a leading Parisian goldsmith, Louis Aucoc, and attended classes at the École des Arts Décoratifs, Paris. He spent two years in England, completing his formal studies at Sydenham College, London, and on his return to Paris in 1880 worked briefly for the jewellers, Petit Fils, before setting up his own studio with a family friend known as M. Varenne. He independently created jewellery for Cartier, Boucheron, Destape and Aucoc, as well as designing wallpapers and textiles, and studying sculpture under Lequien. In 1886, a year after being appointed manager of Jules Destape's jewellery workshop, Lalique acquired the small manufacturing business for himself. This workshop, which supplied designs to other established jewellers, moved twice to larger premises, and by 1894 Lalique was exhibiting his work regularly at the Paris Salons. In stark contrast to the contemporary taste for precious and ostentatious gems set in unobtrusive mounts, Lalique's jewellery designs incorporated carved ivory, horn, semi-precious stones and enamelling and were conceived as *objets d'art*. During the 1890s, Lalique made several pieces for the actress Sarah Bernhardt (1844–1923) and displayed his jewellery in Siegfried Bing's shop, Maison de l'Art Nouveau. He then began experimenting with clear and coloured engraved glass in jewellery, exhibiting the resulting work at the 1900 Paris "Exposition Universelle et Internationale" where it received much critical acclaim. Bolstered by this success, Lalique established a small glass workshop at Clairefontaine in 1902, and five years later was commissioned by François Coty to design perfume bottles, which were produced at the Legras & Cie glassworks. In 1909, Lalique purchased a glassworks, the Verrerie de

▼ *Pierrefonds* vase for René Lalique et Cie., 1926

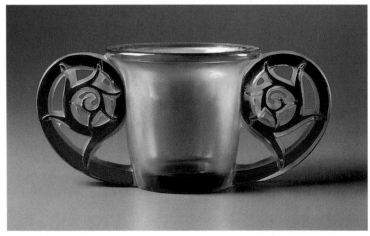

► *Sirène* opalescent
dish for René
Lalique et Cie., 1920

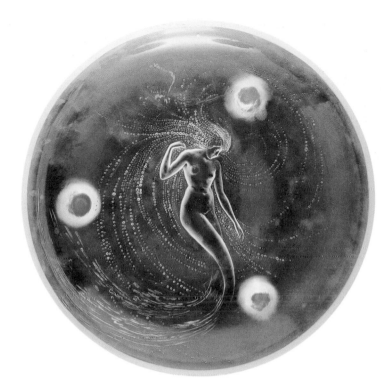

Combs-la-Ville, in Seine-et-Marne for the production of perfume bottles for
his clients, including Worth and Roger & Gallet. This was followed by the
acquisition of a second, much larger glassworks at Wingen-sur-Moder,
Alsace, where he began to apply modern industrial production techniques
to his designs. A stamping press was developed that enabled them to do
high-relief moulding in addition to more traditional techniques such as *cire-
perdue* casting and blow-moulding. Lalique produced a vast range of glass,
which ranged stylistically from delicate and naturalistic Art Nouveau designs
to chunky and highly stylized Art Deco items. Although he used many differ-
ent colours of glass for his vessels, mascots, buttons, lighting etc., Lalique
was particularly noted for his opalescent glass, which was widely copied
but never matched in quality by other manufacturers. The glassworks was
closed in 1937, but in 1945 the firm was re-established by René Lalique's
son, Marc.

## Le Corbusier

1887 *La Chaux-de-Fonds, Switzerland*
1965 *Cap Martin, France*

Charles-Édouard Jeanneret studied metal engraving at the School of Applied Arts at La Chaux-de-Fonds, Switzerland, where he was urged by his teacher, Charles L'Eplattenier, to take up architecture. He built his first house, the Fallett Villa, in 1905 for a member of the teaching staff at the school. After travelling around Italy and visiting Budapest and Vienna, he moved to Paris in 1908, where he worked in the architectural practice of Auguste Perret (1874–1954), who was noted for his pioneering use of concrete and reinforced steel. While there, he met Wolf Dohrn, the director of the Dresdener Werkstätten für Handwerkskunst, as well as the German design theorist, Hermann Muthesius (1861–1927) and the German architect and industrial designer, Peter Behrens. He worked in Behrens' office in Berlin for a year, gaining valuable experience and then, in 1911, returned to Switzerland for two years to teach at his alma mater. He also developed a concept for a serially produced reinforced concrete housing kit, the *Dom-ino-houses* (1914–1915) and designed and built the Schwab Villa, La Chaux-de-Fonds (1916). Jeanneret moved to Paris in 1917, and around 1920 adopted the pseudonym "Le Corbusier". In Paris, he developed a new approach to painting with the artist, Amédée Ozenfant (1886–1966), known as Purism and in 1918 they published a manifesto entitled *Après le cubisme, le purisme*. For the next two years, Le Corbusier edited the journal *L'Esprit Nouveau* to which he contributed many articles. His affection for Classical Greek architecture and his attraction to the concept of the machine was outlined in these highly influential articles, which were eventually republished under the title *Vers une Architecture* (1923). Wishing to transform the humble house into an industrialized product, he developed a system of building units known as the Citrohan Houses (1920–1922). He also executed plans for a large utopian city of standardized high-rise blocks known as "The Contemporary City for Three Million Inhabitants" (1922), which were exhibited at the 1922 Salon d'Automne. In the same year, Le Corbusier and his architect cousin, Pierre Jeanneret, established an architectural partnership in the Rue de Sèvres, Paris, and built a number of private residences and housing developments. Le Corbusier designed the Pavillon de l'Esprit Nouveau for the 1925 "Exposition Internationale des Arts Décoratifs et Industriels Modernes", which was a model building unit for a later apartment block. The pavilion attracted both acclaim and criticism – the latter eventually leading Le Corbusier and others to leave the conservative Société des Artistes Décorateurs and to form the UAM (Union des Artistes Modernes) in 1929. Le Corbusier's concept of the house as "a machine for living" included appropriately functional furniture or "équipment de l'habitation". Accordingly, he co-designed a range of systemized tubular steel furniture with Pierre Jeanneret and Charlotte

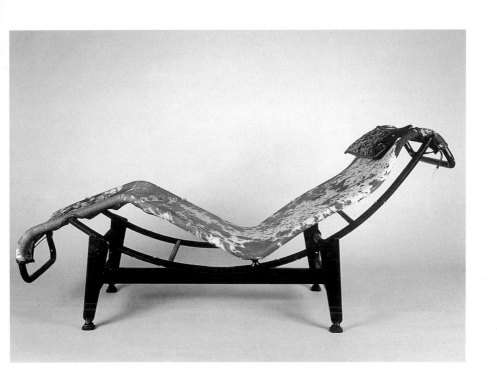

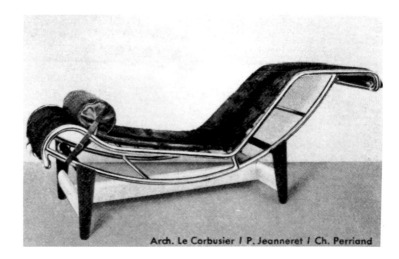

▲ Le Corbusier,
Pierre Jeanneret &
Charlotte Perriand,
*Model No. B306*
chaise longue for
Thonet and Embru,
1928

► Illustration from
Thonet catalogue
showing *Model No.
B306* chaise longue
in tilted position

Arch. Le Corbusier / P. Jeanneret / Ch. Perriand

Perriand, who entered the design and architectural partnership in 1927. Having first appeared in 1928, these seminal modern designs, which included the *Basculant No. B301* chair (c. 1928), the *No. B306* chaise-longue (1928) and the *Grand Confort No. LC2* club chair (1928), projected a new aesthetic purity and epitomized the International Style. During the late 1920s and 1930s, Le Corbusier concentrated on architectural commissions, including his famous Villa Savoye, Poissy (1928–1929), Cité du Refuge, Paris (1930–1933), the Pavillon Suisse, Cité Universitaire, Paris (1930–1931) and utopian architectural concepts such as the La Ville Radieuse city plan (1935). These relentlessly modern projects were extremely influential to the evolution of architecture, especially in the areas of high-density housing and office buildings. During the 1950s, Le Corbusier moved away from the formalism of the International Style towards a freer and more expressive idiom. He demonstrated his increasing interest in the sculptural potential of con-

▼ **Le Corbusier, Pierre Jeanneret, Charlotte Perriand**, *Model No. LC2* sofa, 1928 (reissued by Cassina)

crete with the roof of his Unité d'Habitation housing complex in Marseilles (1946–1952) and with his remarkable Notre Dame du Haut church at Ronchamp (1950–1955). Le Corbusier was one of the most influential architects, designers and design theorists of the 20th century and his promotion of geometric formalism had far-reaching consequences. Ironically, it was Le Corbusier-style public housing built in the 1960s – much of which was poorly constructed – that led to the discrediting of the Modern Movement when it appeared to have failed the very people it was intended to benefit.

**Raymond Loewy**
1893 *Paris*
1986 *Monaco*

At the age of fifteen, Raymond Loewy designed, built and flew a toy model aeroplane that won the famous James Gordon Bennett Cup. He subsequently studied at the Université de Paris and later at the École de Laneau from where he obtained an engineering degree in 1918. During the First World War, he served in the French army as a second lieutenant and, after his demobilization in 1919, travelled to America. On his arrival in New York, Loewy was still wearing his French army uniform and had only fifty dollars in his pocket. He initially found employment as a window dresser for Macy's, Saks Fifth Avenue and Bonvit Teller, and then worked as a fashion illustrator for five years for *Vogue*, *Harper's Bazaar* and *Vanity Fair* among others. Loewy established his own industrial design office in New York in 1929 and designed a casing for Sigmund Gestetner's mimeograph machine using modelling clay to create a sleek form – a technique he later used for auto-motive designs. His *Hupmobile* car was already less box-like than existing automobiles, and his improved tapering model of the car with integrated headlamps from 1934 anticipated the streamlined forms for which he later became celebrated. He also de-signed the *Coldspot* refrigerator in 1934 for Sears Roebuck, which was the first domestic appliance to be marketed for its aesthetic appeal, and that same year the Museum of Modern Art, New York, displayed a mock-up of his office. From 1935, Loewy was commissioned to replan several large department stores, in-cluding Saks Fifth Avenue. Around this time, he was also designing aerodynamic locomotives, such as the K4S (1934), the GG-1 (1934) and the T-1 (1937), and in 1937 he pub-lished a book entitled *The New Vision Locomotive*. After remodel-ling coaches for Greyhound, he designed his innovative *Champion* car (1947) for Studebaker – a pre-cursor of his European-styled *Avanti* car for that company. Loewy also became celebrated for his corporate identity work, in particular for his

▼ Cover of *Time Magazine*, 31st October 1949

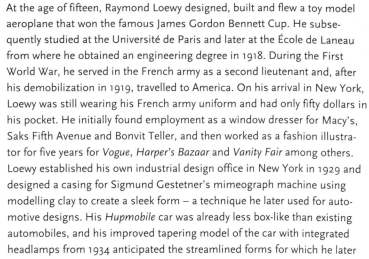

# TIME

THE WEEKLY NEWSMAGAZINE

DESIGNER RAYMOND LOEWY
He streamlines the sales curve.

▶ Raymond Loewy
Associates, *Model
2000* coffee service
with *Patina* pattern
for Rosenthal,
1954

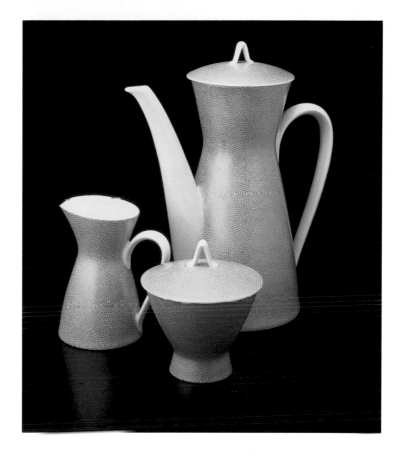

repackaging of Lucky Strike cigarettes (1942). Other clients of his included
Coca-Cola, Pepsodent, National Biscuit Company, British Petroleum,
Exxon and Shell. He founded a partnership with four other designers known
as Raymond Loewy Associates, which in 1949 was expanded to undertake
architectural projects and renamed the Raymond Loewy Corporation. That
year, Loewy became the first designer to feature on the cover of *Time* maga-
zine. During the 1960s and 1970s, as a consultant to the United States Gov-
ernment, he was responsible for the re-designing of Air Force One for John
F. Kennedy and for the interiors of NASA's Skylab (1969–1972). Loewy's
MAYA (most advance, yet acceptable) design philosophy was crucial to the
success of his products. Undoubtedly the greatest pioneer of Streamlining
in the 20th century, few design consultants have been as influential or pro-
lific as Raymond Loewy.

**Ross Lovegrove**

b. 1958 *Cardiff/Wales*

Ross Lovegrove studied industrial design at Manchester Polytechnic, gradu-
ating in 1980. He subsequently trained at the Royal College of Art, London,
receiving an MA in 1983, and then worked for the industrial design consul-
tancy Frogdesign in Altensteig, where he was assigned to projects that
included the design of Walkmans for Sony and computers for Apple.
Lovegrove was associated with a number of companies in the mid-1980s.
As an in-house designer for Knoll International in Paris he designed the
successful Alessandri Office System, and as a co-member of the Atelier de
Nîmes, France, with Philippe Starck, Jean Nouvel, Martine Bedin (b. 1957)
and Gérard Barrau (b. 1945), he acted as a consultant designer to Louis
Vuitton, Cacharel, Dupont and Hermès. In 1986, Lovegrove returned to
Britain and set up an office with Julian Brown. However, this partnership
was dissolved in 1990 when Lovegrove established his own London-based
industrial design practice, Studio X. Since then, his clients have included
British Airways, Parker Pens, Kartell, Ceccotti, Cappellini, Phillips, Moroso,
Driade, Apple, Connolly Leather, Olympus, Luceplan, Tag Heuer, Fratelli

▼ *John II* stapler
for Acco, 1997

► Detail of suit carrier for Connolly Leather, 1994

Guzzini and Herman Miller. His visually seductive and technologically persuasive designs — such as the *Organic* cutlery (1990) for Pottery Barn, the *Basic* thermos flask (1990) for Alfi Zitzmann (co-designed with Julian Brown), the *Crop* chair (1996) for Fasem, and the *Eye* digital camera (1996) for Olympus — are inspired by the natural world and informed by his broad understanding of ergonomics, state-of-the-art materials and cutting-edge manufacturing techniques. Lovegrove curated the first permanent collection at the Design Museum, London in 1993, and since 1997 has had solo exhibitions of his work in Copenhagen and Stockholm and Tokyo, the latter staged by the Yamagiwa Corporation and Idée. Lovegrove is keenly aware of current ecological and Green Design issues and many of his product designs, such as his *Solar Bud* solar-powered garden lighting (1996–1997) for Luceplan directly address these concerns. He also worked on a proposal for lightweight product architecture known as the *Solar Seed* that is similarly solar powered and was inspired by the form of a cactus. Lovegrove's dematerialist, holistically derived and forward-looking products embody a new organic sensibility and have set the stage for design in the 21st century.

## Charles Rennie Mackintosh

1868 *Glasgow*
1928 *London*

▲ Drawing room of the Mackintoshes' home – 6, Florentine Terrace, Glasgow, 1906 (reconstruction at the Hunterian Art Gallery, Glasgow)

Charles Rennie Mackintosh served an apprenticeship in the architectural practice of John Hutchinson in Glasgow while taking evening classes in drawing and painting at the Glasgow School of Art. He went on a scholarship tour of Italy in 1891, returning via Paris, Brussels, Antwerp and London, and in 1892 was awarded the National Gold Medal at South Kensington, London. Seven years later he joined the newly established architectural practice of Honeyman & Keppie in Glasgow, where he remained until 1913. Mackintosh, Herbert MacNair (1868–1955), Francis Macdonald (1873–1921) and Margaret Macdonald (1864–1933) formed "The Four", later dubbed the "Spook School", exhibiting together for the first time in 1894, then at the Arts & Crafts Exhibition Society, London in 1896 and at the VIII Secessionist Exhibition in Vienna in 1900 to great acclaim. That same year, Mackintosh married Margaret Macdonald, with whom he collaborated on many of his decorative schemes. Mackintosh's white interiors had a profound influence on the subsequent designs of Josef Maria Olbrich and Josef Hoffmann, and one of the chairs he exhibited was actually purchased by Koloman Moser.

He was awarded a special prize at Alexander Koch's "Haus eines Kunst-freundes" (House for an Art Lover) competition in 1901, and the following year was commissioned by Fritz Wärndorfer (1869–1939), the main financial backer of the Vienna Secession and later of the Wiener Werkstätte, to design a music salon (1902–1903), which was described by the critic Ludwig Hevesi as "a place of spiritual delight". Mackintosh designed several public build-ings and private residences in Glasgow and its environs at the turn of the century, including his masterwork, the Glasgow School of Art (1896–1909). Some of his projects, such as Hill House (1902–1903), were conceived as Gesamtkunstwerks and were thus provided with site-specific soft furnish-ings and furniture. Among his most important interiors, were the Glasgow tea rooms that he decorated for Catherine Cranston; the two in Buchanan Street (1896) and Argyle Street (1897) being designed in conjunction with

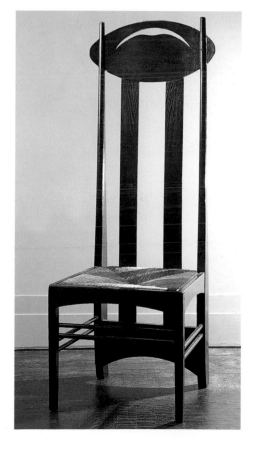

George Walton. Mackintosh's famous elliptical high-backed chairs adorned the Argyle Street tea rooms, and the later rooms in Ingram Street and Willow Street were decorated entirely by him, down to the cutlery. His holistic approach to architecture and design included the use of symbolism and the balancing of opposites – modernity with tradition, light with dark, the mas-culine with the feminine. In 1914, he left Glasgow and moved to London, where he designed colour-saturated and rhyth-mically patterned textiles for Foxton's and Sefton's that anticipated Art Deco. Unable to secure any architectural com-missions in London, he moved to Port Vendres, France in 1923 and dedicated himself entirely to the painting of wa-tercolours. Mackintosh was the leading designer of the Glasgow School and both his early organic style and his later geometric style were enormously influential to the Vienna Secession and the Wiener Werkstätte.

◄ *Atollo* table lamp
for O-Luce, 1977

## Vico Magistretti
b. 1920 *Milan*

Vico Magistretti studied at the Champ Universitaire Italien de Lausanne, and while there took a course on architecture and urban planning devised by Ernesto Rogers (1909–1969). As a strong advocate of Modernism, Rogers' influence on the younger generation of Italian designers, including Magistretti, was immense. Magistretti returned to Milan in 1945 to take his degree in architecture, and a year later designed a tubular metal bookcase and a simple deck chair for the RIMA (Riunione Italiana per le Mostre di Arredamento) exhibition. His nesting tables and a highly rational, ladder-like bookcase were exhibited alongside the works of Marco Zanuso, Franco Albini, Ignazio Gardella (b. 1905) and the Castiglioni brothers in an exhibition organized by Fede Cheti (1905–1978) in 1949. During the 1950s, Magistretti was mainly active as an architect, and his office block on the Corso Europa, Milan established his avant-garde credentials. His design of the Villa Arosio, which was presented at the CIAM (Congrès Internationaux d'Architecture Moderne) conference of 1959, created much discussion as Magistretti had attempted to humanize Modernism with the incorporation of Neo-Liberty elements. He used a similar tempered approach for the design of his clubhouse at the Carimate Golf Club in 1959. For this project,

Magistretti created a modern re-working of a traditional rush-seated chair that countered the industrial aesthetic of the International Style. The manufacturer Cesare Cassina, who had met Magistretti in 1960, began mass-producing the *Carimate* chair in 1962. During the 1960s, Magistretti started to design plastic furniture – his first success being the *Demetrio* tables of 1966, which married technical innovation with purity of form. Many of his later designs, such as the *Eclisse* table lamp (1965), the *Chimera* lamp (1966), the *Stadio* table, the single-piece *Selene* chair (1969), the *Gaudi* and *Vicario* armchairs (1970), also demonstrated the noble attributes of plastic through their high quality constructions and ingenious forms. Other famous designs of Magistretti's include the *Maralunga* sofa with adjustable headrest (1973), the *Nuvola Rossa* folding bookcase (1977), the *Atollo* lacquered metal lamp (1977), the *Sindbad* chair and sofa with blanket-like upholstery (1981), the adjustable *Veranda* chair and sofa (1983) and the multipurpose polypropylene and tubular aluminium *Silver* chair (1989). As one of the foremost industrial designers of the 20th century, Magistretti has been awarded numerous prizes, including a gold medal and a Grand Prix at the Milan Triennale exhibitions, two Compasso d'Oro and a SIAD (Society of Industrial Artists and Designers) gold medal. He has taught at the Domus Academy, Milan, and in 1983, was made an honorary fellow of the Royal College of Art, London, where he is a visiting professor. Throughout his career, whether working with traditional or state-of-the-art materials, Magistretti has harmoniously balanced technical ingenuity with sculptural elegance to create timeless modern designs that have a remarkable integrity. He regards design and styling as complimentary to one another and believes that usefulness and beauty are both essential to the creation of quality products. Throughout his career, Magistretti has consistently urged for long-lasting design solutions that do not perpetuate the "throw-away" culture.

▼ *Selene* chairs for Artemide, 1969

## Louis Majorelle

1859 *Toul, France*
1926 *Nancy, France*

▼ Detail of a stair-
case balustrade for
the Hôtel Bergeret
in Nancy, 1904

Louis Majorelle studied painting in Nancy and later at the École des Beaux Arts, Paris from 1877 to 1879. Upon the death of his father Auguste Majorelle in 1879, he took over the running of the family's furniture and ceramics firm in Nancy, which had been established in 1860. Initially, Majorelle designed furniture in the Rococo style, but in the 1890s he became increasingly influenced by the naturalism of Émile Gallé's work and began producing Art Nouveau designs. His room display at the 1900 "Exposition Universelle et Internationale de Paris", for instance, had a water lily theme. His furniture became more structurally inventive than Gallé's, although it employed similar marquetry decoration. From 1900, Majorelle also designed metal stands and mounts for Auguste Daum's glassware and lamp shades, while Daum Frères produced glass elements for Majorelle's own range. Marjorelle was appointed vice-president of the newly established École de Nancy in 1901, and exhibited his flamboyant furniture and gilt-bronze lighting at the school's exhibition in Paris two years later. In 1916, the Majorelle factory in Nancy was badly damaged by fire and Louis Majorelle fled to Paris. After the First World War, he returned to Nancy and his factory recommenced production. During the 1920s, his work became more formal and less ornamented, reflecting the influence of the new Art Deco style. Assisted by his factory manager, Alfred Lévy, Majorelle designed a room for the Nancy Pavilion at the 1925 "Exposition Internationale des Arts Décoratifs et Industriels Modernes", while sitting on the exhibition jury. After Majorelle's death in 1926, the Nancy-based workshops of the Atelier Majorelle remained under the management of Lévy, who was joined by Paul Beucher around 1935. The company had showrooms in Nancy, Paris and Lyons, and produced not only very expensive and elaborate designs but also restrained and affordable products.

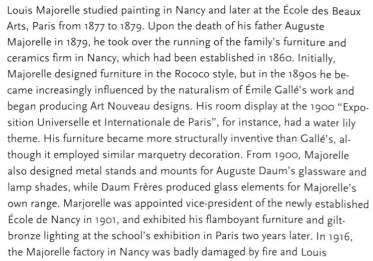

Herbert Matter studied painting at the École des Beaux-Arts, Geneva from 1925 to 1927, and completed his training at the Académie de l'Art Moderne, Paris. Between 1929 and 1932, he designed typography and worked as a photographer for the Paris-based type foundry, Deberny & Peignot. He also collaborated on the design of posters with A. M. Cassandre and worked with Le Corbusier on displays and buildings. Like Jan Tschichold, Matter used his understanding of photography and knowledge of industrial printing techniques to pioneer a method of over-printing, which not only gave more visual depth to his posters but also created a dynamism between the photographic image and the typography. By combining powerful images with bold typography, Matter's posters, such as those for the Swiss Tourist Board, appeared extremely modern and had a remarkable directness. Matter emigrated to New York in 1936, where he worked as a photographer for the magazines *Vogue* and *Harper's Bazaar*. During the Second World War, he was commissioned by the US Government to design propaganda posters including his "America Calling" poster (1941), which featured a photographic image of an American eagle in flight. From 1943 to 1946, Matter worked as a graphic designer in the Eames Office in Venice, California. He then began to design colourful, humourous and eye-catching advertisements and posters for Knoll and also developed the company's distinctive "K" trademark. His art-direction of the Knoll advertisement (1959) for Eero Saarinen's *Tulip* chair was remarkable in that the images, which were displayed on sequential pages – one showing the chair wrapped in brown paper and the other showing it unwrapped – carried the message so powerfully, there was no need for copy. Matter's graphics, that combined the visual clarity of the Swiss School with American popular culture, defined the "look" of avant-garde graphics in the United States during the post-war years.

**Herbert Matter**
1907 *Engelberg, Switzerland*
1984 *Southampton, New York*

▼ Travel poster for the Swiss Tourist Board, 1935

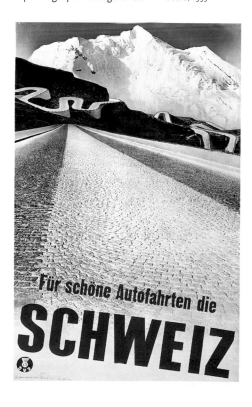

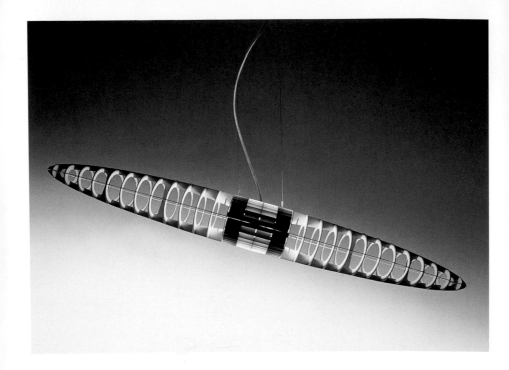

## Alberto Meda

b. 1945 *Lenno*
*Tremezzina, Italy*

Alberto Meda studied mechanical engineering at the Politecnico di Milano, graduating in 1969. He subsequently worked for Magneti Marelli, and in 1973 was appointed technical director and head of planning for the design-oriented plastics manufacturer, Kartell. He went independent in 1979, working as a designer and engineer, and acting as a design engineering consultant to Alfa Romeo and Italtel Telematica among others. In 1983, Meda began teaching industrial technology at the Domus Academy. Four years later he created his *Light Light* chair using state-of-the-art materials – a piece which, with its Nomex-honeycomb core and matrix of carbon-fibre, achieved remarkable strength and lightness. His lighting for Luceplan, such as the *Titania* lamp (1989) with its polycarbonate filters, is likewise technically innovative. The range of cast-aluminium seating, including the *Armframe* chair and *Longframe* lounger (1996), designed by Meda for Alias in the 1990s, combined structural soundness with visual coherence, testifying to his engineering background. Other clients of his include Gaggia, Lucifero, Cinelli, Anslado, Mondedison, Carlo Erba, Fontana Arte and Mandarina Duck. Meda has received many international accolades, including a Compasso d'Oro and a Design Plus award.

▲ Alberto Meda &
Paolo Rizzato,
*Titania* lamp for
Luceplan, 1989

◄ **Martine Bedine,**
*Super* lamp for
Memphis, 1981

Memphis was founded in Milan in 1981 with the aim of re-invigorating
the Radical Design movement. During the late 1970s, avant-garde Italian
designers such as Ettore Sottsass, Andrea Branzi and Alessandro Mendini,
and other members of Studio Alchimia, experimented with alternative artis-
tic and intellectual approaches to design. Mendini's promotion of "re-design"
and "banal design" became central to the output of Studio Alchimia, and
Sottsass, who found these approaches too creatively restricting, eventually
left the group. On the 11th of December 1980, Sottsass hosted a gathering
at his house of designers such as Barbara Radice (b. 1943), Michele De
Lucchi, Marco Zanini, Aldo Cibic (b. 1955), Matteo Thun and Martine Bedin
(b. 1957) to discuss the need for a new creative approach to design. They
decided to form a design collaborative, and that very night it was christened
Memphis, after a Bob Dylan song entitled "Stuck Inside of Mobile with the
Memphis Blues Again", which had been played repeatedly throughout the
evening. The name, Memphis, also made reference to the ancient Egyptian
capital of culture and the Tennessee birthplace of Elvis Presley and was
therefore suitably "double-coded". The group, now including Nathalie du
Pasquier and George Sowden, convened again in February 1981, by which

**Memphis**
Founded 1981
*Italy*

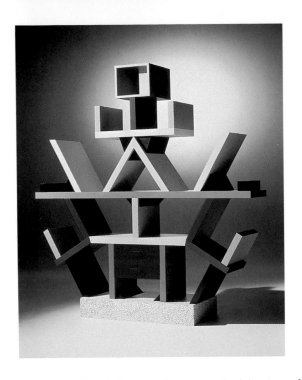

▶ **Ettore Sottsass**,
*Carlton* bookcase for
Memphis, 1981

time its members had executed over a hundred drawings of bold and colour-
ful designs, drawing inspiration from either futuristic themes or past decora-
tive styles including Art Deco and 1950s Kitsch, and intentionally mocking
the pretensions of Good Design. They threw themselves into the project:
finding furniture and ceramics manufacturers willing to batch produce their
designs; convincing Abet to make new laminates printed with extraordinarily
vibrant patterns inspired by Pop Art, Op Art and electronic imagery; design-
ing and producing promotional material and so on. The head of Artemide,
Ernesto Gismondi, subsequently became the president of Memphis, and on
the 18th of September 1981 the group showed its work for the first time at
the Arc '74 showroom in Milan. The furniture, lighting, clocks and ceramics
exhibited by Memphis had been designed by an international array of archi-
tects and designers including Hans Hollein, Shiro Kuramata, Peter Shire,
Javier Mariscal, Massanori Umeda and Michael Graves. The group's prod-
ucts caused an immediate sensation, not least owing to their blatant Anti-
Design agenda, and the same year, the book *Memphis, The New International
Style* was published as a means of promoting their work. Artemide, which
produced Memphis' 1982 designs, gave the group space to display their

◄ **Ettore Sottsass,**
*Mizar* vase for
Memphis, 1982

products at the company's showroom on Corso Europa, Milan. From 1981
to 1988, Barbara Radice was art director of Memphis and organized exhi-
bitions in London, Chicago, Düsseldorf, Edinburgh, Geneva, Hanover,
Jerusalem, Los Angeles, Montreal, New York, Paris, Stockholm and Tokyo.
Many of Memphis' monumental designs used colourful plastic laminates, a
material favoured for its "lack of culture". The vibrancy, eccentricity and or-
namentation of Memphis' output evolved from a knowledge of Modernism
and then an utter rejection of it. The hybrid themes and oblique quotations
of past styles used by Memphis produced a new post-modern vocabulary of
design. The group always acknowledged that Memphis was a "fad", tied to
the ephemerality of fashion, and in 1988, when its popularity began to wane,
Sottsass disbanded it. Although a short-lived phenomena, Memphis, with
its youthful vitality and humour, was central to the internationalization of
Post-Modernism.

◄ Re-designed
*Wassily* chair for
Studio Alchimia,
1978

**Alessandro
Mendini**

b. 1931 *Milan, Italy*

Alessandro Mendini studied architecture at the Politecnico di Milano, receiv-
ing a doctorate in 1959. He subsequently became a partner of the industrial
design practice, Nizzoli Associati, where he remained until 1970. While there,
he worked on a project for experimental accommodation – the Italsider – in
Taranto. From 1970 to 1976, Mendini was editor-in-chief of *Casabella*, after
which he founded the journal *Modo* that he edited until 1981. He was a
founding member of Global Tools, a school of counter-architecture and de-
sign established in 1973, and in the late 1970s was closely associated with
the design collective Studio Alchimia, becoming its leading propagandist. In
1978, Mendini produced his first examples of "re-design" – Joe Colombo's
*Universale* chair with a faux marble finish, Marcel Breuer's *Wassily* chair with
applied motifs and Gio Ponti's *Superleggera* chair to which ensigns were
attached. The point of "re-design" was to convey, in a humorous way, the
idea that truly innovative design was no longer possible in respect of what
had gone before. Re-design also sought to strip away the pretensions of
Modernism while showing that the meaning and value of a design could be

communicated solely through applied decoration. As a design theorist, Mendini also promoted the idea of "banal design", which attempted to address the intellectual and cultural void that was perceived to exist in the mass-design of industrialized society. The banality of existing objects was emphasized by applying bright colours and quirky ornamentation to them, as in Mendini's famous *Proust* armchair (1978). With the same purpose in mind, Mendini organized "L'oggetto banale" (The Banal Object) exhibition at the Venice Biennale in 1980. The Anti-Design activities of Mendini heralded the end of Modernism's "prohibitionism" and the rebirth of a symbolic language in design. His *Kandissi* sofa (1978), which was introduced in 1980 as part of Studio Alchimia's ironically named *BauHaus I* collection, mocked the distinctions between fine art and design with its brightly coloured applied wooden cut-outs that were inspired by the work of Wassily Kandinsky. Between 1980 and 1985, Mendini was chief editor of the design journal *Domus,* and from 1983 he taught design at the Hochschule für angewandte

▼ *Manici (Handles)* vases produced by Zabro-Zanotta for Studio Alchimia, 1984

Kunst, Vienna. In 1981, he was invited by the furniture manufacturer, Cassina, to participate in the company's Bracciodiferro project. For this he developed his *Mobile Infinito* series that included decorative magnetic cutouts, allowing the user a degree of creative interaction. Mendini also acted as design and communications director for Alessi and took part in the company's *Tea & Coffee Piazza* project in 1983. Alessi then commissioned Mendini together with Achille Castiglioni and Aldo Rossi to design the Casa della Felicità (1983–1988), after which Mendini designed the Groninger Museum, Groningen, The Netherlands (1988–1993). He has received several awards including a Compasso d'Oro in 1979. As a prolific designer and a leading design theorist, Mendini has contributed much to the Anti-Design debate and the propagation of Post-Modernism.

▲ Interior of the German Pavilion at the "Exposición Internacional", de Barcelona", 1929

## Ludwig Mies van der Rohe

1886 *Aachen, Germany*
1969 *Chicago*

Ludwig Mies, as he was originally known, trained first as a builder, and from 1900 to 1904 worked as a draughtsman of stucco ornaments for a local architectural firm in Aachen. He moved to Berlin in 1905 and worked for Bruno Paul until 1907 – the year he designed his first building. In 1908, Mies joined Peter Behrens' design practice, where he assisted with designs for AEG and for the German Embassy in St Petersburg. In this office, he worked alongside Walter Gropius, Hannes Meyer (1889–1954) and Le Corbusier, and, like Behrens, was inspired by the Neo-Classical architecture of Karl Friedrich Schinkel (1781–1841). Mies left Behrens' practice in 1911, and the following year established his own Berlin-based studio. He added his mother's maiden name, van der Rohe, to his surname in 1913, and between 1914 and 1918 undertook military service. In 1922, he became actively involved in the revolutionary Novembergruppe, organizing the group's exhibitions for the next three years. His architectural proposals for offices, houses and tower-blocks were "ideal" plans that promoted a modernist agenda. He became vice-president of the Deutscher Werkbund in 1926, and in 1927 organized the Werkbund's "Die Wohnung" (The Home) exhibition held at the Weissenhofsiedlung, Stuttgart. Inspired by Mart Stam's drawing of a cantilevered chair constructed of welded gas pipes (1926), Mies designed his

own versions in 1927 – the *MR10* chair and *MR20* armchair – which were made of resilient tubular metal and were first exhibited at the Weissenhof exhibition. The German Pavilion for the 1929 "Exposición Internacional de Barcelona" was furnished with a number of his designs, including his famous *Barcelona* chair which was used as a "throne" for King Alfonso XIII at the exhibition's opening ceremonies. The interiors of this pavilion, with its marble partitions, were quintessentially of the International Style and were blatantly distanced from the utilitarianism normally associated with the Modern Movement. Between 1928 and 1930, Mies designed the Tugendhat House in Brno, Czechoslovakia, for which he also created site-specific furniture. The majority of his architectural designs of the 1920s, such as his proposals for towering glass and steel structures, were speculative and relatively experimental. His furniture designs, however, were put into production by Berliner Metallgewerbe Josef Müller (1927–1931) and by the Bamberger Metallwerkstätten (from 1931). He exhibited his designs at the German Building Exhibition in 1931 and signed a contract with Thonet-Mundus granting them the exclusive marketing rights for fifteen models of his chairs, some of which had been

designed in collaboration with Lilly Reich. In 1930, Mies became the last director of the Bauhaus, where he taught architecture. He was responsible for the school's move from Dessau to Berlin and eventually oversaw its closure in 1933. From 1933, he worked as a freelance architect in Berlin, and in 1937 emigrated to the United States. He subsequently established a large architectural office in Chicago and acted as director of the architectural department at the Armour Institute (later to become the Illinois Institute of Technology) in Chicago. One of his students in Chicago was Florence Schust – who later married Hans Knoll – and in 1947, Knoll Associates re-issued Mies van der Rohe's furniture. Mies acquired American citizenship in 1944, and

**MR Stuhl**

D. R. P.
A. P. a

Entwurf: **Mies van der Rohe**

Ausführung: Stahlrohr vernickelt, verchromt, lackiert, mit Rindleder oder Korbgeflecht.

Prospekt und Preisliste durch

# Berliner Metallgewerbe
# Jos. Müller
### Neukölln, Lichtenraderstrasse
Telefon Nr. 1122                          32

until his death in 1969 worked on architectural projects including the Farnsworth House, Plano, Illinois (1946–1950), the Mannheim Opera House (1953) and his masterwork, the famous Seagram Building, New York (1954–1958), which was designed with assistance from Philip Johnson. Johnson also wrote the catalogue to the "Ludwig Mies van der Rohe" retrospective held at the Museum of Modern Art, New York in 1948. Mies van der Rohe was a leading exponent of the Modern Movement and one of the most influential architects and designers of the 20th century.

▶ *Model No. MR50 Brno* chair for Berliner Metallgewerbe Josef Müller, 1929–1930

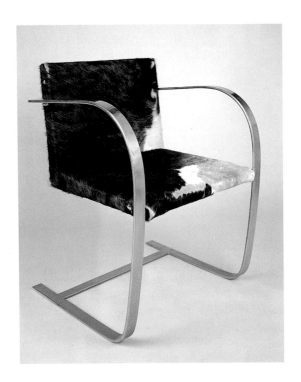

Carlo Mollino was the son of Turin's most prominent architect and engineer, Eugenio Mollino. He studied engineering and art history prior to enrolling at the School of Architecture, University of Turin, from where he graduated in 1931. He subsequently worked in his father's practice, and in 1933 won first prize in the competition for the Federazione Agricoltori headquarters in Cuneo. The same year, he designed the interior of his own home, the Casa Miller, which he used as a photographic studio for his erotic female studies. In 1937, he designed the Società Ippica in Turin – home of the Turin riding club that is generally considered his architectural masterwork but has since been destroyed. Mollino designed site-specific furniture, which was very often biomorphic in form, for his interior design projects. His highly expressive approach to design, which was inspired by Futurism and Surrealism, became known as the "Turinese Baroque" style and countered the Rationalism emanating from Milan. Between 1952 and 1968, Mollino also taught a course on the history of architecture at the Faculty of Architecture, Turin. He was an esteemed designer of racing cars – his *Osca 1100* was the winner of its class in the 1954 Le Man 24-hour race. The exuberant form of Biomorphism pioneered by Mollino had a powerful influence on post-war Italian styling.

**Carlo Mollino**
1905 *Turin*
1973 *Turin*

▲ *Arabesque* table for Apelli & Varesio, 1950

► *Pimpernel*
wallpaper produced
by Jeffrey & Co. for
Morris & Co., 1876

**William Morris**

1834 *Walthamstow*
1896 *London*

William Morris studied theology at Exeter College, Oxford, and later trained briefly as an architect with George Edmund Street (1824–1881). He was inspired by the social and artistic reforming ideas of John Ruskin (1819–1900) and by the Romantic escapism of the Pre-Raphaelites. Upon the insistence of Dante Gabriel Rossetti (1828–1881), Morris took up painting, which he quickly abandoned in favour of the decorative arts. His first large-scale decorating project was on his own home, the Red House in Bexleyheath, that had been designed in 1859 by Philip Webb (1831–1915). It was furnished by Morris and his circle of friends with Pre-Raphaelite-style embroideries, murals, stained glass and painted furniture – a collaborative exercise that led to the formation of Morris, Marshall, Faulkner & Co. in 1861. With this enterprise, Morris sought to put reformist theory into practice. In the 1860s, Morris forged a "look" that promoted the virtues of simplicity, utility and beauty. The company not only designed complete interior schemes but also retailed a wide range of items including furniture, stained glass, wallpapers, metalware, ceramics, tiles, embroideries, carpets and textiles. While Morris wished to bring good design to the masses, he refused to embrace mechan-

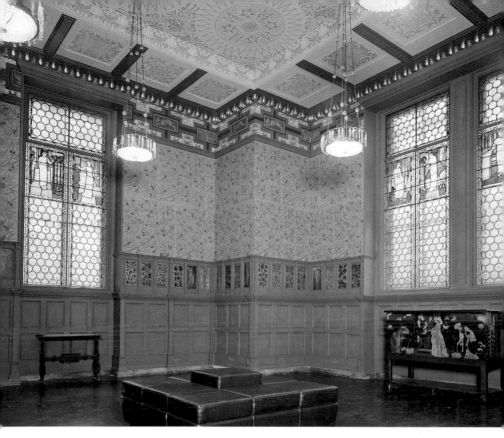

ization, because he believed that the division of labour disconnected the worker from his work and, ultimately, from society. Paradoxically, this rejection of industrialized production meant that Morris' designs were expensive and could only be afforded by the wealthy. He nevertheless revitalized many handcrafts through his activities at Morris & Co. and was an early pioneer of ethical manufacturing practices. Apart from being the greatest proponent of the Arts & Crafts Movement, a prolific designer and a successful design manager, Morris was a highly celebrated poet and author whose writings reflected his yearning for a social utopia. He was also a leading Socialist who laid some of the foundations of the British Labour Movement. Morris' reforming ideas – the supremacy of utility, simplicity and appropriateness over luxury; the morality of producing objects of quality, and the use of design as a democratic tool for social change – had a fundamental impact on the early origins of the Modern Movement.

▲ Morris, Marshall, Faulkner & Co., *The Green Dining Room* at the South Kensington Museum (now the Victoria & Albert Museum), 1866–1867

## Koloman Moser

1868 Vienna
1918 Vienna

▼ Sherry decanter
with silver-plated
metal mount for
E. Bakalowits &
Söhne, 1901

Koloman Moser studied design and painting at the Akademie der Bildenden Künste, Vienna from 1885 to 1892, as well as attending classes given by Professor Franz Rumpler (1848–1922) at the Allgemeine Malerschule, Vienna in 1886. While still a student, Moser contributed graphic work to the magazines *Wiener Mode* and *Meggendorfers Humoristische Blätter*. From 1893 to 1895, he trained as a graphic designer at the Kunstgewerbeschule, Vienna, and taught drawing to Archduke Karl Ludwig's children. He became associated with many progressive artists including Gustav Klimt (1862–1918), and in 1894 co-founded the Siebener Club (Club of Seven) with Josef Hoffmann and Josef Maria Olbrich. Moser worked as an independent graphic designer from 1895 onwards, and participated with other artists and the publisher Martin Gerlach in the issuing of a series of folio volumes entitled *Allegorien, Neue Folge* (1895). He was a founding member of the Vienna Secession and in 1898 became editor of the group's journal, *Ver Sacrum*, for which he produced numerous illustrations. He started to teach painting at the Kunstgewerbeschule, Vienna, in 1899, obtaining a professorship in 1900. The same year, Moser exhibited his furniture and other forward-looking designs, including a series of liqueur glasses that were later distributed by Bakalowits & Söhne, at the VIII Secessionist Exhibition in Vienna and at the Paris "Exposition Universelle et Internationale". He co-founded the Wiener Kunst im Haus group in 1901, and two years later joined Josef Hoffmann and Fritz Wärndorfer (1869–1939) in establishing the Wiener Werkstätte. As an artistic director of this progressive manufacturing venture, Moser contributed furniture, silverware, metalwork, textile, jewellery and graphic designs. He also designed costumes and stage sets for the Cabaret Fledermaus – a theatre established by Hoffmann that was conceived as a Wiener Werkstätte Gesamtkunstwerk. From around 1901, Moser substituted Secessionist-style abstracted and naturalistic

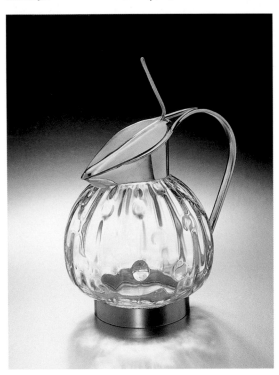

motifs for geometric patterning, including his characteristic black and white square grids that were inspired by Egyptian and Assyrian art. The severe geometry of these later designs anticipated the geometric formalism promoted by the Bauhaus in the 1920s. Apart from his work for the Wiener Werkstätte, Moser also designed glassware for Loetz, textiles for Johann Backhausen & Söhne and furniture for J. & J. Kohn. In addition, he worked as a book designer for various publishing houses including H. Bruckmann, and between 1904 and 1906 designed the stained glass windows for Otto Wagner's Am Steinhof church. After quarrelling with Fritz Wärndorfer, Moser left the Wiener Werkstätte in 1908 and concentrated on painting. However, he went on to produce a number of stage sets for the State Opera. His paintings were exhibited in Düsseldorf, Dresden, Budapest, Rome and Berlin between 1909 and 1916. Moser was a prolific and multi-talented designer whose work made the stylistic transition from a naturalistic to a geometric manner, and in so doing bridged the 19th and 20th centuries.

▲ Clock for the Wiener Werkstätte, c. 1906

## Alphonse Mucha

1860 *Ivancice, Moravia*
1939 *Prague*

Alphonse Mucha was employed from 1879 as a theatrical painter in Vienna, where he became influenced by the work of the artist Hans Makart (1840–1884). In 1883, Mucha worked on a decorative scheme for Schloß Emmahof, near Grussbach, that was owned by Count Khuen-Belassi. He also designed a three-panelled screen for the count who subsequently financed Mucha's fine art studies in Munich from 1884 to 1887 and then in Paris. Shortly after his arrival in Paris, Mucha began working as a designer, illustrator and graphic artist. In 1889 he executed his first designs for postage stamps, and in 1892 produced his first poster. After the printing of his famous poster of Sarah Bernhardt as Gismonda, the actress contracted him for six years to produce posters of her productions. Mucha also designed jewellery for Bernhardt, which was manufactured by the goldsmith George Fouquet (1862–1957), and created several interiors with his characteristic swirling motifs, including that of Fouquet's shop on the Rue Royale, Paris, for which he designed every detail including door handles, furnishings, stained glass and lighting. An exhibition was held of Mucha's work in Paris in 1897 and a special issue of *La Plume* magazine was dedicated to his oeuvre. The show later travelled to Prague, Munich, Brussels, London and New York and helped to establish his international reputation. Mucha designed the award-winning Bosnia-Herzegovina pavilion at the 1900 Paris "Exposition Universelle et Internationale" and published two books on his work in 1902 and 1905. He travelled to America in 1903, where he designed jewellery in collaboration with Louis C. Tiffany. His advertising posters for Waverley Cycles (1898), Job cigarette papers (1898) and Moët & Chandon champagne (1899) helped popularize his work, and in 1907 a soap was launched bearing his name on its packaging. Mucha's book illustrations, textile designs, advertising posters, publicity material, postcards and series of decorative lithographic prints, such as *Les Saisons* (1896), *Les Fleurs* (1897) and *Les Arts* (1898), are quintessential expressions of Art Nouveau.

▼ Zodiac for the magazine *La Plume*, 1896–1897

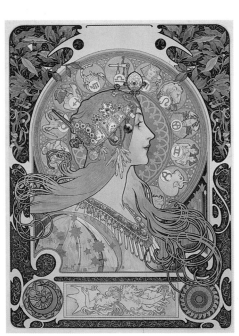

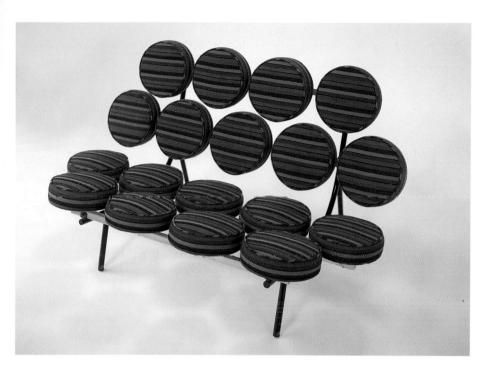

George Nelson studied architecture at Yale University until 1931, and then attended the Catholic University in Washington for a year and the American Academy in Rome from 1932–1934, having won a Rome Prize. In 1935, he became an associate editor of the magazines *Architectural Forum* and *Fortune*, and then wrote profiles of important architects for the journal, *Pencil Points*, which promoted the modernist cause. Between 1936 and 1941, Nelson and William Hamby ran an architectural partnership in New York, after which Nelson joined the faculty of architecture at Yale University and developed numerous innovative architectural and planning concepts, including the pedestrianized shopping mall in his "Grass on Main Street" proposal of 1942. He also pioneered the concept of built-in storage with his Storagewall of 1944. From 1941 to 1944, he taught at the School of Architecture at Columbia University, New York, and in 1946, became a consultant on interior design at the Parsons School of design, New York. The same year, Nelson succeeded Gilbert Rohde as director of design at Herman Miller – a position that he held until 1972. During his tenure there, Nelson brought in other talented designers including Charles Eames, Alexander Girard and Isamu Noguchi to design modern furnishings for the company. Nelson also

**George Nelson**
1907 *Hartford, Connecticut*
1986 *New York*

▲ *Marshmallow* sofa for Herman Miller, 1956 (upholstered in *Jacob's Coat* textile designed by Alexander Girard)

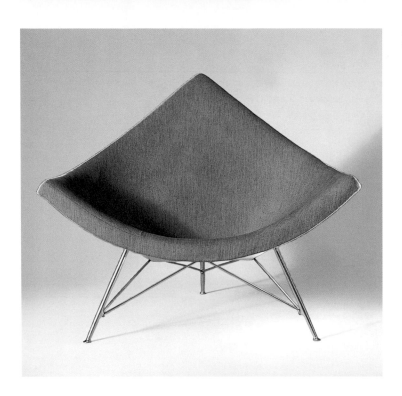

developed his own furniture designs, including a system of modular storage
units that rested on slatted platform benches (1945), a home-office desk
(1946), a moulded plywood tray table (1949), the *Comprehensive* Storage
System (1957), the *Marshmallow* sofa (1956), the *Swaged-Leg* Group of chairs,
tables and desks (1958), the *Catenary* chair and table (1962), the *Sling* Sofa
(1963) and, most importantly, the *Action Office I* system (1964–1965). In
1947, he established his own office, George Nelson & Co. in New York,
which, when he went into partnership with Gordon Chadwick in 1953, be-
came known as George Nelson & Associates. As an industrial designer,
Nelson created the Prolon melamine line of dinnerware for the Pro-Phy-Lac-
Tic Brush Co. (1952–55), several wall and table clocks for the Howard Miller
Clock Company (late 1940s and early 1950s), the *Bubble* lamps made of self-
webbing plastic (1947–52) and the *Omni* extruded aluminium pole system
for Dunlap. Nelson was also interested in the concept of product architec-
ture, and in 1957 he designed the modular plastic domed Experiment House.
He mooted the futuristic concept of the "hidden city" in which buildings are
constructed underground so as to create a more "humane environment". As

a prolific writer and design critic, Nelson's ideas were extremely influential and forward-looking. He predicted in 1978, for example, that advances in computer technology would result in greater "miniaturization, ephemeralization, dematerialization" in the future. He was a close friend of Buckminster Fuller and, like him, promoted the still highly relevant notion of "doing much more with much less", implying that the ultimate goal of technology should be to do "everything with nothing". Nelson was not only an extremely talented and innovative designer, he was also an early environmentalist and a powerful communicator of ideas through his writings and teaching.

▼ *Platform* bench for
Herman Miller, 1946

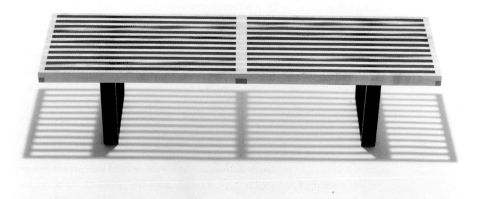

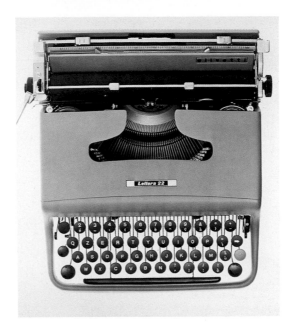

**Marcello Nizzoli**

1887 *Boretto, Italy*
1969 *Camogli, Italy*

Marcello Nizzoli studied art, architecture and graphic design at the Scuola di Belle Arti, Parma from 1910 to 1913, and subsequently worked as a painter, exhibiting in 1914 with the Futurist group Nuove Tendenze (New Tendencies) in Milan. Nizzoli also designed textiles and posters, most notably for Campari and OM. In 1918, he founded his own design office in Milan, and during the 1920s became associated with the Rationalists. From 1934 to 1936, Nizzoli worked in partnership with the architect, Edoardo Persico (1900–1936) with whom he designed two Parker Pen stores (1934) and the Hall of Gold Medals for the 1934 "Aeronautical Exhibition" in Milan. Nizzoli also undertook a number of joint projects with Giuseppe Terragni between 1931 and 1936. At the same time, he was employed as a freelance graphic designer by Olivetti, and around 1938 became the company's chief product design consultant. His *Lexicon 80* and *Lettera 22* typewriters (1948 and 1950) were remarkable for their sculptural forms, and his designs for offices and workers' housing for Olivetti underlined the company's commitment to total design. Nizzoli produced sculptural designs for other manufacturers, including sewing machines and a kitchen mixer for Necchi, furniture for Arflex, lighters for Ronson and petrol pumps for Agip.

▲ *Mirella* sewing
machine for Necchi,
1957

## Verner Panton

1926 *Gamtofte,*
*Denmark*
1998 *Copenhagen*

Verner Panton trained at the Odense Tekniske Skole and later studied architecture at the Kongelige Danske Kunstakademi, Copenhagen, graduating in 1951. Between 1950 and 1952, he worked as an associate of Arne Jacobsen, and together they collaborated on a number of experimental furniture designs including Jacobsen's well-known *Ant* chair (1951–1952). In 1955, Panton established his own design and architectural office and became well known for his innovative architectural proposals, including a collapsible house (1955), the Cardboard House (1957) and the Plastic House (1960). He received greater recognition, however, for his numerous seating, lighting, textiles and carpet designs and exhibition installations. In 1958, Baron Schilden Holsten commissioned Panton to rebuild and expand his Komigen Inn (Come Again Inn), sited in a forest on the Danish island of Funen. For this inn, Panton designed an all-red interior and his famous *Cone* chair (1958). This unusual seating solution and the slightly later *Heart* chair (1959) were subsequently manufactured by Percy von Halling-Koch's newly established firm, Plus-Linje. In 1959, a Panton exhibit at the Købestaevnet trade fair literally turned the world upside down – the ceiling was carpeted and all the furniture and lighting was inverted. Panton produced a equally unconventional installation at the 1960 Cologne Furniture Fair with a ceiling

▼ *Panton* chairs
for Herman Miller,
1959–1960 (reissued
by Vitra)

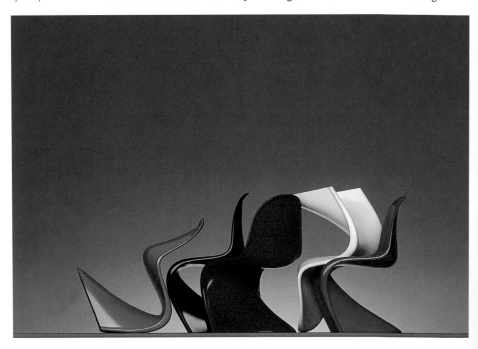

covered in silver foil, and that same year a commission to redesign the
Astoria Restaurant in Trondheim resulted in an interior that was shocking
not only for the unusual forms adopted but also on account of the bright-
ness of the colours used. In 1955, Panton designed the single-form can-
tilevered plywood S-chair, which was developed in co-operation with Thonet,
and for several years afterwards, he attempted to translate this design into
plastic. Eventually, he achieved his goal with the revolutionary *Panton* chair
(1959–1960), and in 1962 offered the production rights to Herman Miller.
Panton left Denmark in 1962 and stayed briefly in Paris before establishing a
design office in Cannes. He subsequently moved to Basel, however, to assist
Willy Fehlbaum (the Basel-based Herman Miller licensee and founder of
Vitra) with the five-year-long production development of the *Panton* chair,
which eventually became the first single-material, single-form chair to be
injection-moulded. Having established a design office in Basel, Panton

*▲ Mira-Spectrum*
textile for Mira X,
c. 1969

cultivated a wide-ranging clientele including A. Sommer, Kaufeld, Haiges, Schöner Wohnen, Nordlys, Kill, Wega Radio, Thonet, Knoll International, Lüber and Bayer. Panton also designed psychedelic "spacescape" installations for Bayer at the 1968 "Visiona O" and 1970 "Visiona II" exhibitions in Cologne, which combined fantastic sculptural shapes with pure saturated colour. From 1969 to 1985, he produced geometrically patterned textiles for Mira-X, using his characteristically bright rainbow palette. During the late 1960s and early 1970s, Panton designed a range of seating for Fritz Hansen and a system of storage units as well as floor and desk lamps with chromed wire constructions for Lüber. These designs were inspired by Op Art and were developed from his earlier wire seat furniture of 1959 to 1960. In 1973, he designed the *1-2-3* seating system for Fritz Hansen, which comprised twenty different models, and two years later designed a colourful block-system toy, the *Pantonaef,* for Naef, Switzerland. During the 1970s, Louis Poulsen produced several lights designed by Panton, including the spherical *VP-Globe* and *Panto* lamps (1975), while in the next decade Panton created his *Art Chairs-Chair Art* series (1981) of sixteen plywood single-form chairs with unusual amorphous cut-out shapes, and experimented with pure geometric forms – cubes, spheres, cones – for a proposed seating range (1985). Unlike many other Danish designers, Panton took a revolutionary rather

▼ Chair, *Cone* chair and *Heart* chair for Plus-Linje, 1960, 1958 & 1959

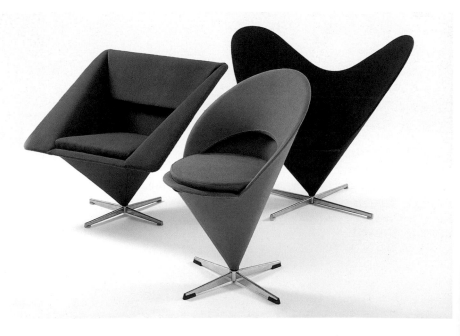

than evolutionary approach to design. Throughout his career, he produced highly innovative, bold and playful designs that often utilized state-of-the-art technology and reflected his optimistic belief in the future.

▲ Room installation for Bayer's "Visiona II" exhibition in Cologne, 1970

**Gaetano Pesce**
b. 1939 *La Spézia, Italy*

Gaetano Pesce studied architecture and industrial design at the University of Venice, graduating in 1965. Between 1959 and 1967, he worked as an independent film-maker and artist in Padua, experimenting with both serial and kinetic art forms, and during this period became a founding member of Group N – a group of artists who explored the concept of programmed art. Pesce also worked as a designer in Padua from 1962 to 1967 and in Venice from 1968, producing furniture and interior designs for C&B Italia, Cassina, Bernini, Venini and Bracciodiferro among others. His furniture designs were highly innovative, both in the materials they employed and the methods of their production. The polyureathane foam *Up Series* (1969), for example, was compressed and vacuum-packed into PVC envelopes, which when opened allowed the colourful seating to literally mutate into life. As a "contesting" designer, Pesce participated in the exhibition "Italy: The New Domestic Landscape" held at the Museum of Modern Art, New York in 1972. For this key event, celebrating Radical Design, he designed a curious installation that comprised a series of "archeological" documents relating to a fictional settlement from the "Great Contaminations" age. In 1973, Pesce formulated

▼ *Up 3* chair for
C&B Italia, 1969

▲ *Airport* lamp, 1986

the theory that architecture and design should be a "representation of real-
ity" and a "document of the times", while his search for liberation of expres-
sion led him to explore the idea of "performance design" in many of his pro-
jects. In the *Golgotha Suite* (1972–1973), with its coffin-shaped table and
shroud-like chairs, Pesce experimented for the first time with the idea of a
"diversified series". This concept was also employed in his *Sit Down* chairs
and sofa (1975) for Cassina – each example, though similar, being slightly
different owing to the variability of the materials used in the manufacturing
process. Similarly, his *Airport* lamp (1986) was constructed from randomly

coloured urethane and its form could be manipulated into innumerable po-
sitions. Now resident in New York, Pesce continues to explore the expres-
sive potential of new materials and production techniques while often imbu-
ing his designs with humour, as in his folding *Umbrella* chair (1992–1995)
for Zerodisegno and his translucent epoxy-resin *543 Broadway* chair (1993)
for Bernini that rocks and rolls on its spring-mounted feet. He is a professor
at the Institut d'Architecture et d'Etudes Urbaines, Strasbourg, and has for
many years taught at the Cooper Union school of architecture and art, New
York. Throughout his career, Pesce's unconventional and highly innovative
work counters the Modern Movement's precepts of standardization and de-
sign uniformity, since for Pesce, architecture and design are multi-disciplinary
activities that should allow the creator unrestrained freedom of expression.

Giovanni (Gio) Ponti studied architecture at the Politecnico di Milano, graduating in 1921. He subsequently worked in the architectural office of Emilio Lancia and Mino Fiocchi, and from 1923 to 1930 was art director of the Richard Ginori ceramics factories in Milan and Florence. His porcelain designs for Richard Ginori, many of which were decorated with neo-classical motifs in the Novecento style, won a Grand Prix at the 1925 Paris "Exposition Internationale des Arts Décoratifs et Industriels Modernes". Around this period, Ponti also designed low-cost furniture for the La Rinascente department store as well as other more luxurious pieces. From 1925 to 1979, he was the director of the Monza Biennale exhibitions where he showed his own work along with that of other progressive designers. Ponti designed his first building – his own neo-classical style house on the Via Randaccio in Milan – in 1925, and a year later established an architectural partnership with Emilio Lancia in Milan, which continued until 1933. In 1928, at the suggestion of the journalist Ugo Ojetti, Ponti launched the prestigious design

**Gio Ponti**
1891 *Milan*
1979 *Milan*

▼ *Model No. 699*
*Superleggera* chair
for Cassina, 1957

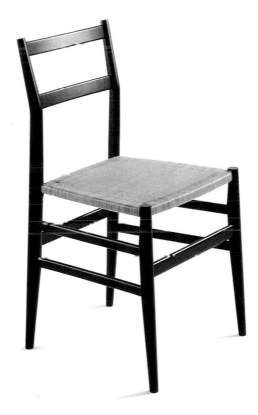

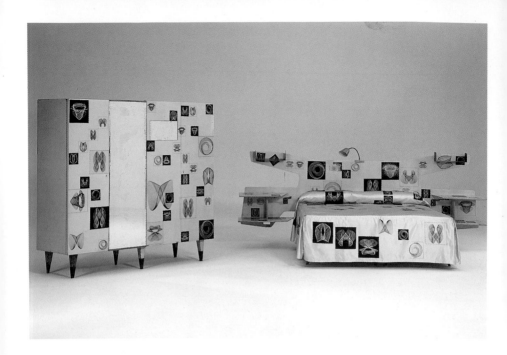

journal, *Domus* that was published by Gianni Mazzocchi. *Domus* was initially established to promote the Novecento Movement, which sought to counter both "the fake antique" and "the ugly modern" in architecture and design. Between 1933 and 1945, Ponti worked in partnership with the engineers Antonio Fornaroli and Eugenio Soncini in Milan, and during this period undertook many architectural commissions for both private and public buildings, including the School of Mathematics for the University of Rome (1934), and the first Montecatini Building (1936) and the "Domuses"(typical houses) apartment buildings in Milan (1931–1936). Ponti was also commissioned by the Italian Cultural Institute in 1936 to re-design the interiors of the Fürstenberg Palace in Vienna, which he executed in a Neo-Secessionist style. From 1930, he designed lighting and furniture for the Fontana company, and in 1933 was made artistic co-director, with Pietro Chiesa, of its subsidiary Fontana Arte. During the 1940s, Ponti contributed extensively to *Stile* magazine (1941–1947), produced sets and costumes for La Scala opera house (1947), created multi-coloured glass bottles, glasses and a chandelier for Venini (1946–1950) and designed his famous coffee machine for La Pavoni (1948). He collaborated with Piero Fornasetti on several furniture designs and interiors schemes in the late 1940s and 1950s, including those

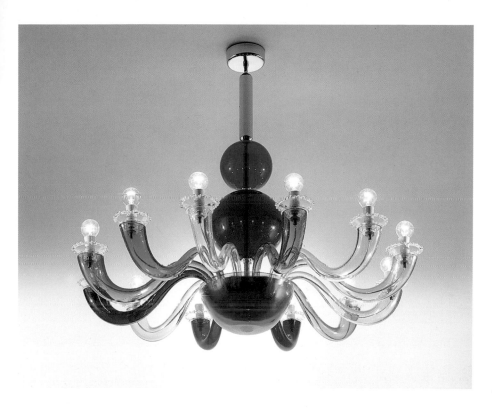

for the Casino at San Remo (1950). Apart from several prestigious building commissions, such as the second Montecatini Building, Milan (1951) and the Pirelli Tower, Milan (1956), Ponti also designed flatware for Krupp Italiana (1951) and Christofle (1955), sanitary fixtures for Ideal Standard (1953) and the legendary *Superleggera* chair (1957) for Cassina, which possessed the timeless classicism that was so characteristic of his work. During the 1960s and 1970s, Ponti's architecture, such as the Denver Art Museum (1971), and his design work became increasingly expressive and began to incorporate strong geometric forms. Beyond his remarkably productive career as a designer and architect, Ponti also taught at the Politecnico di Milano from 1936 to 1961, and, as a regular contributor to both *Domus* and *Casabella*, contributed much to the post-war revival of Italian design.

▲ Murano glass chandelier for Venini, 1946

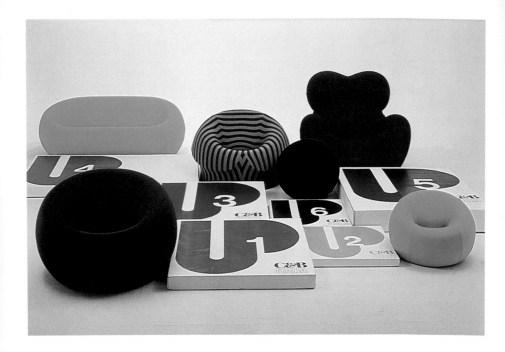

## Pop Design

The term Pop was coined in the 1950s and referred to the emergence of popular culture during that decade. In 1952, the Independent Group was founded in London and its members, including the artist Richard Hamilton (b. 1922), the sculptor Eduardo Paolozzi (b. 1924), the design critic Reyner Banham (1920–1988) and the architects, Peter and Alison Smithson, were among the first to explore and celebrate the growth of popular consumer culture in America. In the 1960s, American artists too, such as Andy Warhol (1928–1987), Roy Lichtenstein (1923–1998) and Claes Oldenburg (b. 1929) began drawing inspiration from the "low art" aspects of contemporary life such as advertising, packaging, comics and television. Not surprisingly, Pop also began to manifest itself in the design of objects for everyday use, as designers sought a more youth-based and less serious approach than had been offered by the Good Design of the 1950s. The ascendancy of product styling in the 1950s, in the name of productivity-increasing built-in obsolescence, provided fertile ground for the "use-it-today, sling-it-tomorrow" ethos that permeated industrial production during the 1960s. Peter Murdoch's polka-dotted cardboard *Spotty* child's chair (1963) and De Pas, D'Urbino and Lomazzi's PVC *Blow* chair (1967) were eminently disposable and epitomized the widespread culture of ephemerality. So too did the plethora of

▲ Gaetano Pesce,
*Up Series* for C&B
Italia, 1969

short-lived gimmicks such as paper dresses, which were lauded for their novelty in the large number of colour supplements and glossy magazines that became increasingly dependent on featuring such items. For many designers working within the Pop idiom, plastics became their materials of choice. By the 1960s, many new types of plastics and aligned processes, such as injection-moulding, became available and relatively inexpensive to use. The bright rainbow colours and bold forms associated with Pop Design swept away the last vestiges of post-war austerity and reflected the widespread optimism of the 1960s, which was bolstered by unprecedented economic prosperity and sexual liberation. Since Pop Design was aimed at the youth-market, products had to be cheap and were therefore often of poor quality. The expendability of such products, however, became part of their appeal as they represented the antithesis of the "timeless" modern classics that had been promoted in the 1950s. Pop Design with its Anti-Design associations countered the Modern Movement's sober dictum "Less is More" and led directly to the Radical Design of the 1970s. It drew inspiration from a wide range of sources – Art Nouveau, Art Deco, Futurism, Surrealism, Op Art, Psychedelia, Eastern Mysticism, Kitsch and the Space Age – and was spurred on by the growth of the global mass-media. The oil crisis of the early 1970s, however, necessitated a more rational approach to design and Pop Design was replaced by the Craft Revival on the one hand and High Tech on the other. By questioning the precept of Good Design, and thereby Modernism, the influence of Pop Design was far-reaching and laid some of the foundations on which Post-Modernism was to grow.

▼ *Nivico 3240 GM television for JVC, (Yokohama Plant Victor Co. of Japan), 1970*

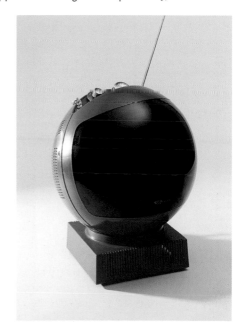

**Post-Modernism**   The ancestry of Post-Modernism can be traced to the 1960s and the emergence of Pop and Anti-Design. During that decade, the status quo was disputed in all areas of life, including the field of modern design. The first questioning of Modernism appeared most notably in Jane Jacobs, *The Death and Life of Great American Cities* (1961), which focused on the break up of social cohesion brought about in cities by the Modern Movement's utopian building and planning schemes and Robert Venturi's *Complexity and Contradiction in Architecture* (1966), which argued that modern architecture was fundamentally meaningless, for it lacked the complexity and irony that enriched historical buildings. In 1972, Venturi, Denise Scott Brown (b. 1932) and Steven Izenour published the seminal book *Learning from Las Vegas,* which lauded the cultural honesty of the commercialism found in the signage and buildings of this desert city. That same year, the translation of Roland Barthes' *Mythologies* (1957) into English led to the widespread dissemination of his theories on Semiotics – the study of signs and symbols as a means of cultural communication. The understanding then was that if buildings and objects were imbued with symbolism, viewers and users would be more likely to relate to them on a psychological level. The early proponents of Post-Modernism argued that the Modern Movement's espousal of geometric abstraction, which denied ornament and thereby symbolism, rendered architecture and design dehumanizing and ultimately alienating. From the mid-1970s, American architects, such as Michael Graves, began to introduce into their designs decorative motifs that frequently made reference to past decorative styles and were often ironic in content. Designers aligned to Studio Alchimia, such as Alessandro Mendini and Ettore Sottsass, began producing work within the post-modern idiom that made ironic comments on Modernism through the application

▾ Norbert Berghof,
Michael Landes &
Wolfgang Rang,
*Frankfurter FIII* chair
for Draenert,
1985–1986

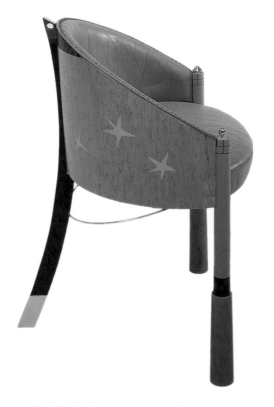

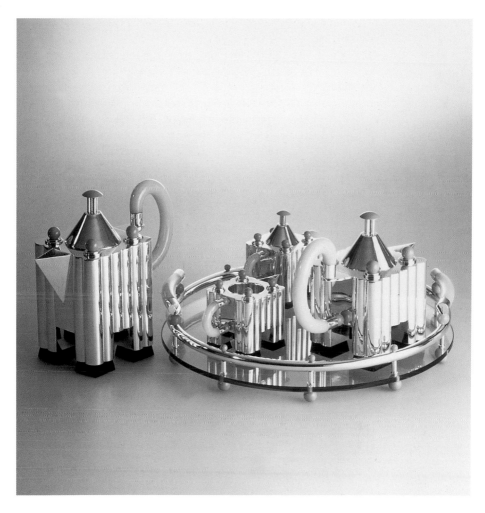

of applied decoration. Later, Memphis produced monumental and colourful "Neo-Pop" designs that, when exhibited for the first time in 1981, caused an international sensation. Memphis' output was influenced by an eclectic range of sources and intentionally mocked the notion of "good taste" through its use of boldly patterned plastic laminates and quirky forms. Significantly, Memphis helped to popularize Anti-Design and in so doing contributed significantly to the acceptance of Post-Modernism as an international style during the 1980s. Post-modern designs embraced the cultural pluralism of contemporary global society and used a language of shared

▲ **Michael Graves**, *Tea & Coffee Piazza* for Alessi, 1983

symbolism so as to transcend national boundaries. The forms and motifs
found in such "symbolic objects" were not only drawn from past decorative
styles, such as Classicism, Art Deco, Constructivism and De Stijl but at
times also made reference to Surrealism, Kitsch and computer imagery.
Among the most notable Post-Modern designers (apart from those already
mentioned) were Mario Botta, Andrea Branzi, Michele de Lucchi, Nathalie
du Pasquier, Hans Hollein, Arata Isozaki, Shiro Kuramata, Richard Meier,
Aldo Rossi, Peter Shire, George Sowden, Matteo Thun and Masanori Umeda.
Their bold designs for ceramics, textiles, jewellery, watches, silverware, furni-
ture and lighting were produced on a limited-scale by companies such as
Alessi, Artemide, Alias, Cassina, Formica, Cleto Munari, Poltronova, Sunar,
Swid Powell and Draenert Studio. As Hans Hollein noted, Post-Modernism's
rejection of the industrial process meant that products in this style were
invariably "an affair of the élite", and as such represented capitalism's tri-
umph over the social ideology that was the basis of the Modern Movement.
The eclectic nature of Post-Modernism reflected not only the ascendancy
of individualism but also the increasingly fragmented nature of society
during the 1980s. The credit-fuelled boom of this decade allowed the anti-
rationalism of the Post-Modern style to flourish and by the late 1980s, Post-
Modernism had become even more stylistically diverse, encompassing Matt
Black, Deconstructivism and Post-Industrialism. The global recession of the

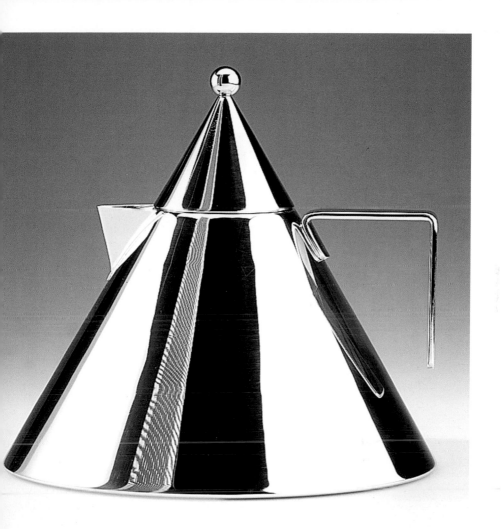

early 1990s, however, motivated designers to seek less expressive and more rational approaches to design and the appeal of Post-Modernism began to wane. Although the bold statements of 1980s Anti-Design have been replaced with the muted purity of 1990s minimalism, the influence of Post-Modernism endures in that its questioning of the Modern Movement has led to an important and ongoing reassessment of what is essential in design.

▲ **Aldo Rossi,**
*Il Conico* kettle for
Alessi, 1988

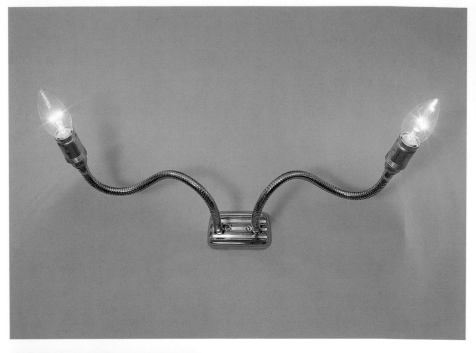

▲ **Stiletto (Frank Schreiner)**, *Suzuki* ready-made lamp for Stiletto Studios, 1988

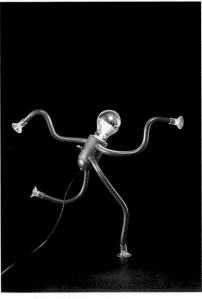

◄ **Marco Ferreri & Carlo Bellini**, *Eddy* lamp for Luxo Italiana, 1986

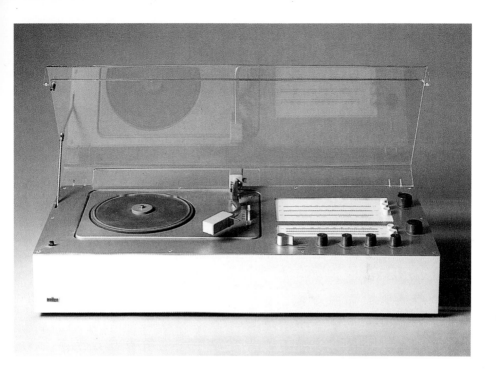

From an early age, Dieter Rams was exposed to construction techniques in his grandfather's carpentry workshop. He studied architecture and interior design at the Werkkunstschule, Wiesbaden from 1947 to 1948, served a three-year carpentry apprenticeship in Kelkheim to gain practical experience and then resumed his training at the Werkkunstschule, graduating in 1953. Between 1953 and 1955, he worked in Otto Apel's architectural office in Frankfurt, which was affiliated to the American practice, Skidmore, Owings & Merrill. In 1955, Rams joined the staff of Braun as an architect and interior designer, and the following year began working as a product designer for the company, most notably co-designing with Hans Gugelot the *Phonosuper SK4* hi-fi system of 1956. Rams also designed other audio equipment for Braun including the portable *Transistor 1* radio (1956) and the combination phonograph and pocket radio (1959), which embodied the practical and or-dered approach to design promoted by the Bauhaus and the Hochschule für Gestaltung, Ulm. In 1961, Rams was appointed head of the company's de-sign department and during the 1960s, he designed the *KM 2* kitchen appli-ances, the *M140* hand mixer, the *Sixtant* electric razor and a cylindrical table lighter. Modern designs such as these were characterized by the pared-down

**Dieter Rams**

b. 1932 *Wiesbaden, Germany*

▲ *Audio 1* record player for Braun, 1962

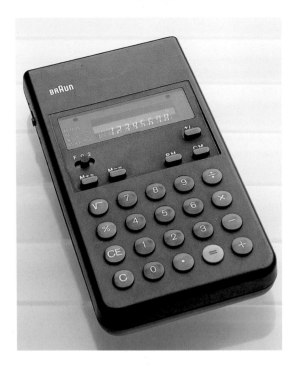

aesthetic of Functionalism and exemplified the attributes of Good Design.
During the 1960s, Rams also designed the *606* shelving system and *620*
and *601/601* modular seating ranges for the furniture manufacturer Vitsoe
that shared the rational purity of his product designs for Braun. In 1968,
Rams became director of design at Braun, and the same year was elected an
Honorary Designer for Industry by the Royal Society of Arts, London. In the
late 1960s, the idea of "product aesthetics" came under increasing attack
as it was seen by many as a promotion sales tool. Rams, however, remained
unswayed by such criticism and continued to promote a modern industrial
dematerialist aesthetic through well-designed products, executed using
state-of-the-art technology. Rams believes that the central responsibility
of designers is to instil order in contemporary life. He is among the most in-
fluential and pre-eminent product designers of the second half of the 20th
century.

Paul Rand studied art in New York, at the Pratt Institute, the Parson's School of Design, and the Art Students League, where he trained under the German Expressionist painter, George Grosz (1893–1959), graduating in 1934. Rand's graphics, which were much influenced by the ideas in László Moholy-Nagy's book *The New Vision* (1932), were among the first in America to utilize the European avant-garde approach to modern graphic design. In the process, he rejected traditional narrative illustration and symmetrical layout and, instead, dynamically combined typography and imagery to produce work that was powerful, expressive and often humorous. Between 1936 and 1941, Rand was the art director of the magazines *Esquire* and *Apparel Arts*, and from 1938 to 1945 designed covers for the bi-monthly magazine *Direction* that were notable for their incorporation of photomontage and historical quotations. From 1941 to 1954, he was creative director of the New York advertising agency William H. Weintraub, where he collaborated with the copywriter Bill Bernbach.

Together, they established new standards for advertising by harmoniously integrating copy and design. In *Thoughts on Design*, published in 1946, Rand detailed his ideas on the communicative strength of symbols. From 1956, he mainly concentrated on trademark and corporate identity design and acted as a consultant to many large companies including United Parcel Services, American Broadcasting Company, Westinghouse Electric Corporation, Cummins Engine Company and IBM. Rand's programme of corporate communications for IBM, with its use of "coded" symbols and restrained typography, was especially influential. From 1956, Rand was a professor of graphic design at Yale University, New Haven, and in 1972 he was elected to the Hall of Fame of the New York Art Directors Club.

**Paul Rand**
1914 *New York*
1996 *Norwalk, Connecticut*

▼ Poster for IBM, 1981

Richard Riemerschmid studied fine art at the Akademie der Bildenden Künste, Munich, from 1888 to 1890, after which he worked as a painter in Munich, and in 1895 designed his own house and furnishings. He designed a poster for the 1896 Nuremberg Bavarian Exhibition, and in 1897 exhibited a wall-hanging, a sideboard and stained glass at the Munich Glaspalast Exhibition. The same year, he joined Hermann Obrist, Bernhard Pankok and Bruno Paul in founding the Vereinigte Werkstätten für Kunst im Handwerk (United Workshops for Artist Craftsmanship), Munich, for the production of innovative and well-executed designs.

From 1898, Riemerschmid designed furniture for the workshop, such as his oak chair for a music room, which was first exhibited at the 1899 Dresden exhibition, and thereafter designed furniture for Hermann Obrist, collaborating with him on the room for an art collector displayed at the 1900 "Exposition Universelle et Internationale" in Paris. Between 1900 and 1901, Riemerschmid worked on the interior design of the new theatre in Munich, and from 1903 to 1905 directed the Kunstgewerblicher Meisterkurs at the Bayerisches Gewerbemuseum in Nuremberg.

He also began producing designs for the Dresdener Werkstätten für Handwerkskunst in 1902, and from 1905 adopted methods of standardization for a range of furniture for the Dresden Workshops, which was conceived

▼► Stoneware jug
for Reinhold
Merkelbach, c. 1909

▼ Stoneware and
pewter tankard for
Villeroy & Boch
Mettlach, c. 1901

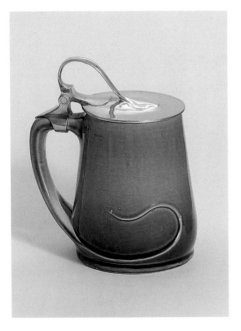

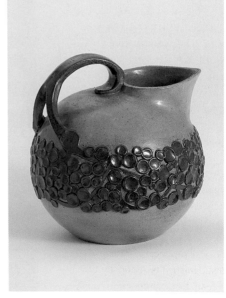

for serial production. Known as *Maschinenmöbel*, this revolutionary furniture was the result of research he had previously undertaken with his brother-in-law, the cabinet-maker Karl Schmidt (1873–1948), into manufacturing processes suitable for low-cost furnishings. Riemerschmid was a founder of the Deutscher Werkbund in 1907 and subsequently became one of the Werkbund's most active members, exhibiting at the 1914 "Deutsche Werkbundausstellung" held in Cologne. Between 1907 and 1913, he also undertook the planning of Germany's first garden city, Hellerau, where he built a number of artists' studios. From 1913 to 1924, Riemerschmid was director of the Kunstgewerbeschule, Munich, which held a major exhibition of his architectural projects in 1913, and from 1918 to 1919 he was a member of the Künstlerrat der Stadt (Artists' Council) in Munich. He was chairman of the Deutscher Werkbund from 1921 to 1926, and principal of the Kölner Werkschulen (Cologne School of Applied Arts) from 1926 to 1931.

On his return to Munich in 1931, he established himself as an independent painter and architect, working in the Neo-Classical style. Riemerschmid's designs for industrial production, which were distinguished by rational yet elegant forms, were enormously

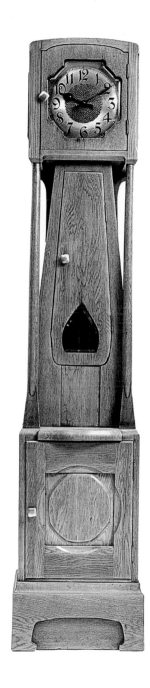

◄ Oak and brass longcase clock for the Dresdener Werkstätten für Handwerkskunst, 1903

influential. His approach to design involved reconciling the artistic endeav-
our of the Arts & Crafts Movement with the industrial standardization of the
Modern Movement so as to produce high-quality yet affordable products.

▼ Wardrobe for
the Dresdener
Werkstätten für
Handwerkskunst,
1905

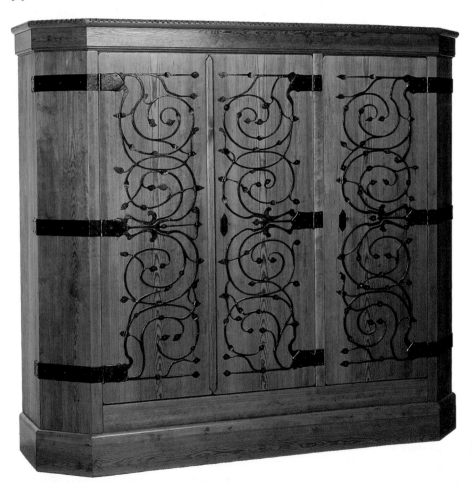

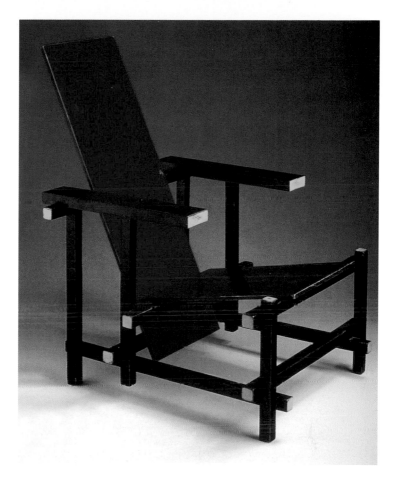

▶ *Red/Blue* chair,
1918–1923

The son of a cabinet-maker, Gerrit Rietveld worked in his father's workshop from the age of twelve until he was fifteen. Between 1904 and 1913, he trained as a draughtsman at the C. J. A. Begeer goldsmith workshops, and in 1906 he attended evening classes in architectural drawing given by P. J. C. Klaarhamer and met Bart van der Leck (1876–1958). From 1911 to 1912, Rietveld was an active member of the Kunstliefde art group, and in 1917 he established his own furniture workshop in Utrecht. Shortly after designing the unpainted prototype of his famous *Red/Blue* chair (1918), he met Theo van Doesburg and Jacobus Johannes Pieter Oud who were exploring similar geometric forms. Rietveld became one of the first members of De Stijl in 1919, and designed a sideboard based on the doctrine of Neo-Plasticism

## Gerrit Thomas Rietveld

1888 *Utrecht, Netherlands*
1964 *Utrecht*

▶ *Beugelstoel* for Metz & Co., 1927

that was promoted by the movement. In 1923, he produced his first painted version of the *Red/Blue* chair, which was first published in *De Stijl* magazine and was included in an exhibition held at the Weimar Bauhaus in the same year. Two years after having established himself as an independent architect in Utrecht, Rietveld started collaborating from 1921 with Mrs Truus Schröder-Schräder, for whom he designed the Schröder house (1924–1925). He kept a studio at the house until 1932 and resided there from 1958. Their joint architectural projects included a terrace of houses in Erasmuslaan (1934) and the Vreeburg Cinema, Utrecht (1936). He also collaborated with fellow De Stijl designer, Vilmos Huszár on a design for the Juryfreie Kunstschau Berlin of 1923. Rietveld's work was exhibited alongside other De Stijl designs in 1923 at Léonce Rosenberg's Galerie l'Effort Moderne in Paris. In 1928, Rietveld became a member of the Congrès Internationaux d'Architecture Moderne (CIAM), and from around this period his work became more international in outlook and he undertook numerous architectural projects both in the Netherlands and abroad. From around 1944, he also taught at a number of universities and designed the Netherlands pavilion for the 1954 Venice Biennale. It was Rietveld's furniture, however, rather than his

◄ *Crate* chair for
Metz & Co., 1934

architecture that was of greatest influence. The geometric formal vocabulary
of his *Red/Blue* chair, for instance, inspired Marcel Breuer's seminal tubular
metal furniture designed at the Bauhaus in the late 1920s, which in turn
briefly influenced Rietveld's choice of materials, as demonstrated by his
*Beugelstoel* (1927). His *Zig-Zag* chair (1932–1934) and *Crate* chair (1934)
reveal his return to elemental constructions in wood and can be seen as a
response to the economic slump of the 1930s. During the 1940s and 1950s,
Rietveld's work achieved much international recognition, and in 1958 he
designed a fully upholstered armchair for the UNESCO building in Paris.
Rietveld was one of the most innovative furniture and interior designers
of the 20th century and was a key pioneer of the Modern Movement.

Gerrit Thomas Rietveld · **155**

### Eero Saarinen

1910 *Kirkkonummi, Finland*
1961 *Ann Arbor, Michigan*

Eero Saarinen was the son of the celebrated Finnish architect, Eliel Saarinen – the first president of the Cranbrook Academy of Art, Bloomfield Hills, Michigan. Born in Finland, Eero emigrated with his family to the United States in 1923. He initially studied sculpture at the Académie de la Grande Chaumière, Paris from 1929 to 1930 and later trained as an architect at Yale University, New Haven, graduating in 1934. He then received a scholarship from Yale, enabling him to travel to Europe for a year. On his return, he took up a teaching position at the Cranbrook Academy, and in 1937 began collaborating with Charles Eames – a fellow staff member at Cranbrook – which culminated in a series of highly progressive and prize-winning furniture designs for the 1940 "Organic Design in Home Furnishings" competition held at the Museum of Modern Art, New York. Their competition entries included a highly rational modular system of storage case furniture and a revolutionary group of chairs with single-form compound-moulded plywood seat shells that advanced the notion of continuous contact and support. The chairs were among the most important furniture designs of the 20th century and heralded a totally new direction in furniture design. They led directly to Saarinen's later highly successful furniture designs for Knoll, including the *No. 70 Womb* chair (1947–1948), the *Saarinen Collection* of office seating

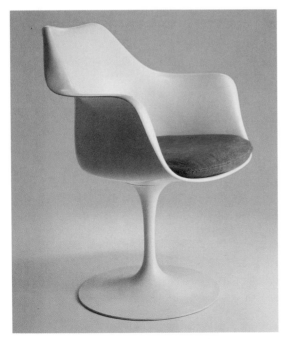

◄ *Model No. 150 Tulip* chair (Pedestal Group) for Knoll Associates, 1955–1956

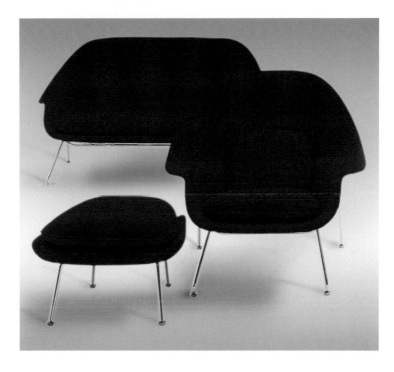

(1951) and the *Pedestal Group* of chairs and tables (1955–1956). With the
*Pedestal Group*, Saarinen's stated objective was to clean up "the slum of
legs" in domestic interiors. His quest for total material, structural and
functional organic unity of design, however, remained unrealized due to
the limitations of materials technology. Saarinen also worked in his father's
practice in Ann Arbor and went into partnership with J. Robert Swanson in
1941. After Eliel Saarinen's death in 1950, he opened his own office, Eero
Saarinen & Associates in Birmingham, Michigan. Like his design work,
Saarinen's architecture was characterized by the use of expressive and
sculptural organic forms. His most notable projects included the Jefferson
National Expansion Memorial, St Louis (1947), the David S. Ingalls Ice
Hockey Hall at Yale University (1953–1959), his masterwork: the extraordin-
ary TWA Terminal at Kennedy Airport, New York (1956–1962), and Dulles
International Airport, Washington DC (1958–1963). Like Charles Eames,
Eero Saarinen promoted a humanized form of Modernism, and in so doing
was one of the most important pioneers of Organic Design.

## Richard Sapper

b. 1932 *Munich*

Richard Sapper studied mechanical engineering and economics from 1952 to 1954 at the University of Munich. From 1956 to 1957, he worked in the car styling department of Mercedes Benz in Stuttgart, and then moved to Italy to work in the Milan studio of Alberto Rosselli (1921–1976) and Gio Ponti, where he stayed until 1959. That year he designed his *Static* table clock for Lorenz, which was awarded a Compasso d'Oro, and became a designer for the in-house design department of the La Rinascente stores, working there and in the studio of Marco Zanuso for the next two years. In 1970, Sapper established his own design office in Stuttgart and acted as a design consultant to Fiat and Pirelli among others. He continued collaborating with Zanuso until 1975 and together they produced an impressive series of landmark designs: the *Lambda* chair for Gavina (1963), the injection-moulded polyethylene *No. 4999/5* stacking child's chair for Kartell (1961–1964), the *Doney 14* television (1962), the *TS 502* radio (1965), the *Algol* and *Black Box* portable televisions for Brionvega (1965 and 1969) and the *Grillo* folding telephone for Siemens (1965).
In 1972, Sapper independently designed the highly successful *Tizio* task lamp for Artemide, which with its blatantly High-Tech design rhetoric became a cult object in the 1980s. The same year, together with Gae Aulenti, he established the Urban Transport Systems Study Group; their research

▶ *Bollitore* kettle for Alessi, 1983

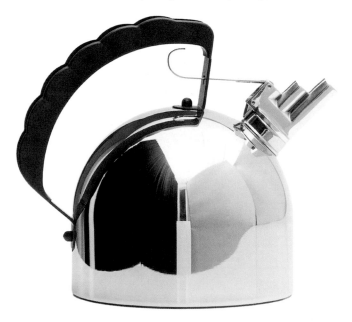

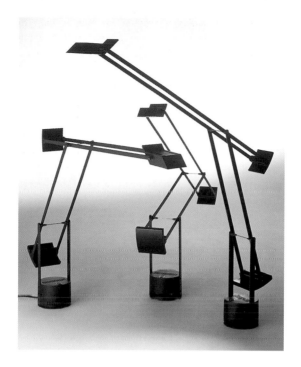

◄ *Tizio* lamps for
Artemide, 1972

culminating in an exhibition held at the XVIII Milan Triennale in 1979.
Sapper has been a product design consultant to IBM since 1980, and during
the 1980s he combined his earlier High-Tech style with Post-Modernism
to create a number of notable designs for Alessi, including the *Cafetlère*
coffee maker (1979), the *Bollitore* whistling kettle (1983) and the *Uri Uri*
watch (1988). He has also designed furniture for Knoll, Unifor, Molteni and
Castelli, and in 1981 became a member of ADI (Associazione per il Disegno
Industriale).

## Timo Sarpaneva

b. 1926 *Helsinki*

▼ *Orkidea* vase for
Iittala, 1953

Timo Sarpaneva studied in the graphic department of the Taideteollinen Korkeakoulu (Central School of Applied Arts), Helsinki from 1941 to 1948, and two years later he became a product designer and head of the exhibition section at the Karhula-Iittala glassworks. One of his first technical innovations at Iittala was a steam blowing method, which was used for his early sculptural vessels, such as *Kajakki* (1953), *Maailmankaunein* (1954) and *Linnunsilmä* (1953), as well as for his delicately colour tinted thin glass plates known as Aquarelles. During the mid-1950s, Sarpaneva introduced his *I-Glass* range, which attempted to bridge the gap between expensive art glass and utility glassware. This industrially manufactured product line comprised seventeen items, which were available in several colours, including lilac-grey, blue-grey, smoke-grey and green-grey, which could be combined to produce different effects. He also developed other glass techniques for his *Ambiente* range (1964), *Archipelago* range (1978) and his *Claritas* range (1984). Many of Sarpaneva's designs, such as his *Claritas* vases (1984) for Iittala and his cast-iron cooking pot with a wooden handle for Rosenlew (1960), used closed "round-square" forms that relate to the smooth pebbles of the Indian Tantric cult, while others, like his large *Lasiaika* glass sculptures, have more open and expressive forms. Sarpaneva taught at the College of Applied Arts, Helsinki from the mid-1950s, and was awarded a Grand Prix at the 1951 and 1957 Milan Triennale exhibitions. He was made an Honorary Royal Designer for Industry in London in 1963 and received an honorary doctorate from the Royal College of Art, London in 1967. Apart from his exquisite glassware, Sarpaneva has also designed ceramics, metalware, textiles, books and theatre sets.

Ettore Sottsass studied architecture at Turin Polytechnic from 1935 to 1939, and while still a student wrote articles on art and interior design in association with the Turin designer Luigi Spazzanpan. From 1942 to 1945, he served in the Italian Army, and after the war worked for the Giuseppe Pagano group of architects before establishing his own Milan-based office, The Studio, in 1947. He went to America in 1956 and briefly worked in the design office of George Nelson, assisting with *The Experimental House* – a system of product architecture. On his return to Italy in 1957, he was appointed artistic director of Poltronova and was involved in the design and production of contemporary furniture and lighting – including the *Mobili Grigi* fibreglass table and chairs (1970). He began working in 1958 as a design consultant to Olivetti and designed a number of well-known products for them including the *Logos 27* calculator (1963), the *Tekne 3* typewriter (1964), the *Praxis 48* typewriter (1964), the *Valentine typewriter* (with Perry King, 1969), the *Synthesis* office system (1973) and the *Lexicon 90* electric

**Ettore Sottsass**

b. 1917 *Innsbruck, Austria*

▲ *Basilico ceramic teapot, 1969*

typewriter (1975). His most remarkable project for Olivetti, however, was the design of the *Elea 9003* main-frame computer (1959) for which he was awarded a Compasso d'Oro in 1959. In 1956, he began designing ceramics for the New York dealer William Hunter, and in 1961 he travelled to India, designing several series of ceramics that were inspired by Eastern forms and transcendentalism on his return. These included *Cemamiche della Tenebre* (1963), the *Offerta a Shiva* series (1964), *Yantra* (1968), *Tantra* (1969), and the gigantic totem-like *Indian Memories* (1972). In 1967, *Domus* published a series of photographs by Sottsass under the title *Memoires di panna montana* (Whipped cream memoirs), which visually documented "Swinging London". Following a prolonged lecture tour of universities in Britain, Sottsass was awarded an honorary degree by the Royal College of Art, London in 1968. He created a "House Environment" for the 1972 "Italy; The New Domestic Landscape" exhibition held at the Museum of Modern Art, New York, which included a prototype system of grey fibreglass "containers" comprising cooker/oven; sink/dishwasher; shower; toilet; shelves/storage; seat/bed and wardrobe modules. As a prominent member of the Radical Design movement, Sottsass became a founding member of Global Tools in 1973, and in 1976 was invited by the Cooper Hewitt Museum of Design, New York to exhibit a series of his photographs of buildings in desert or mountain locations reflecting his ideas on architecture and design. During the same year,

▼ *Mobili Grigi* for Poltronova, 1970

the International Design Centre in Berlin organized a major retrospective exhibition of his work, which was subsequently shown in Venice, Paris, Barcelona, Jerusalem and Sydney. He was asked by the City of Berlin in 1978 to submit proposals for the re-building of the city's Museum of Modern Art, and in 1979 participated in Studio Alchimia's *BauHaus I* collection, designing furniture that incorporated plastic laminates. In 1981, in an attempt to revive Radical Design, Sottsass established the Memphis design group with Renzo Brugola, Mario and Brunella Godani, Ernesto Gismondi (b. 1931) and Fausto Celati. As a long-time advocate of Anti-Design and skillful publicist, Sottsass was the guiding light of Memphis, which was primarily made up of young, recently graduated designers. The first Memphis exhibition, which was held at the Arc '74 showroom in Milan in 1981, comprised several monumental and colourful designs by Sottsass, including the *Casablanca* (1981) and the *Carlton* (1981) case/shelf pieces. In 1981, together with fellow

Memphis collaborators, Aldo Cibic (b. 1955), Matteo Thun and Marco Zanini, he co-founded the design consultancy Sottsass Associati in Milan. During the 1980s, the office worked on the interior design of Fiorucci stores, in close collaboration with Michele De Lucchi who had previously assisted in the planning of the first Memphis exhibition. Sottsass Associati also undertook several architectural commissions, including Maison Wolf in Ridgeway, Colorado (1987–1988), the Esprit House in Wels, Austria (1987–1988), the Bar Zibibbo in Fukuoka, Japan (1988) and Maison Cei in Florence, Italy (1989–1992). Sottsass continued designing furniture, metalware and glassware for Memphis until 1985 and eventually disbanded the group in 1988. During the 1980s, Sottsass also produced designs for other companies, including jewellery for Cleto Munari, metalware for Alessi,

► *Senza Spieganzioni* ceramic vase from the *Rovine Collection* for Design Gallery Milano, 1992

furniture, glass and ceramics for Design Gallery Milano and dinnerware for Swid Powell. Described by his partner, the design critic Barbara Radice (b. 1943), as a "cultural nomad", Sottsass has taken throughout his career an almost "anthropological" approach to design – drawing references from popular culture and other cultures as well as inspiration from his own personal experiences. Sottsass was a leading figure of the Radical Design movement in the 1970s and became the most important exponent of Post-Modernism in design in the 1980s. Reflecting the compelling character of its creator, Sottsass' work ranges from the poetic to the exuberantly colourful. It is always questioning and could never be accused of being dull or bland. In 1994, the Centre Georges Pompidou held a major retrospective of Sottsass' work covering his remarkable and controversial career, which has spanned over forty years.

The son of an aircraft engineer, Philippe Starck studied at the École Nissin
de Camondo. In 1965, he won the La Vilette furniture competition and in
1968, was commissioned by L.Venturi and later Quasar to design inflatable
furniture. The same year he founded his own company to produce this type
of furniture. In 1969, Starck was appointed art director of the Pierre Cardin
studio where he produced sixty-five furniture designs. During the 1970s, he
worked as an independent designer and most notably created interiors for
the nightclubs, La Main Bleue, Montreuil (1976) and Les Bains Douches,
Paris (1978). After an around-the-world trip, Starck returned to Paris, found-
ing his own manufacturing and distributing company, Starck Products, in
1980 to commercialize his earlier designs such as the *Francesa Spanish* chair
(1970), *Easy Light* (1977) and the *Dr. Von Vogelsang* sofa (1978). In 1982,
he received a prestigious commission to oversee the refurbishment of the

**Philippe Starck**
b. 1949 *Paris*

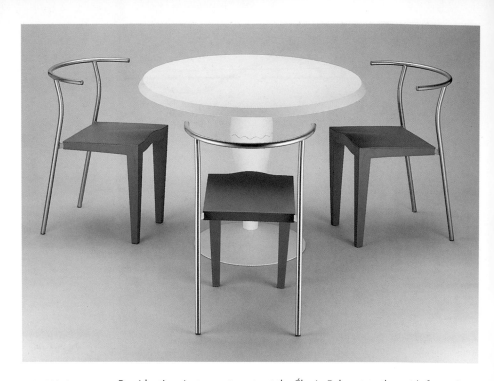

▲ *Dr. Glob* chairs
and table for Kartell,
1990

President's private apartments at the Élysée Palace together with four other
designers, and in 1984 he designed the interior of the Café Costes, Paris –
both projects doing much to establish his international reputation. During
the 1980s, Starck became the leading "superstar of design" and worked pro-
lifically on numerous projects. He designed elegant and sumptuous interi-
ors for hotels, most notably the Royalton Hotel, New York (1988) and Para-
mount Hotel, New York (1990) that were in the great French *décorateur*
tradition. He also planned interiors for numerous nightclubs, shops (Kansäi,
Yamamoto, Bocage, Creeks and Hugo Boss) and restaurants that incorpor-
ated his own designs for furniture, lighting, door handles, vases and other
objects. He became celebrated for his numerous furniture designs – from
the three-legged *Café Costes* chair (1984) and the injection-moulded plastic
*Dr. Glob* chair (1990) to the elegant *Lord Yo* tub chair (1994) and collapsible
*Miss Trip* chair (1996) – for manufacturers such as Vitra, Disform, Driade,
Baleri, XO and Idée. Like his furniture, Starck's lighting and product designs
were also given characterful names and sensual, appealing forms. Amongst
the most commercially successful of these were the *Ara* table lamp for Flos
(1988), and the *Juicy Salif* lemon squeezer (1990–1991), the *Max le Chinois*

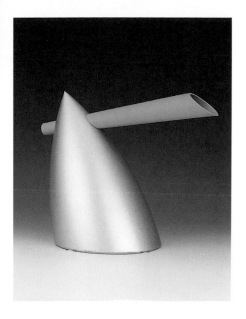

colander (1990–1991) and the *Hot Bertaa* kettle (1990–1991) for Alessi. Apart from his product design work, Starck has also worked internationally as an architect. His public buildings include the golden-horned Asahi Beer Hall in Tokyo (1990), the sculptural Nani Nani building in Tokyo (1989), the Le Baron Vert building in Osaka (1992) and the Groningen Museum (1993). He has also designed several private residences, including Le Moult House in Paris (1985–1987), Formentera House in the Balearics (1995), Placido Arango Jr. House in Madrid (1996) and lastly, the wooden Starck House (1994), the plans and construction information for which were retailed by 3 Suisses. During the 1990s, Starck designed consumer electronics for Thomson, Saba and Telefunken that attempted to humanize technology. His *Jim Nature* television (1994) for Saba, for instance, innovatively incorporates high-density chip-board rather than plastic for its casing. He also designed the *Moto 6,5* motorcycle (1995) as well as a prototype scooter for Aprilia. Today, Starck acknowledges that much of the design produced during the 1980s and early 1990s, including some of his own, was narcissistic "over-design" driven by novelty and fashion. He now promotes product durability or longevity and has stated that this is the central issue of design today, and that it can only be achieved if morality, honesty and objectivity become an integral part of the design process. He has also argued that the role of the designer is to create more "happiness" with less.

▲ *Max le Chinois* colander for Alessi, 1990–1991

◀▲ *Hot Bertaa* kettle for Alessi, 1990–1991

◄ *Model No. 114*
*Executive* desk lamp
for the Polaroid
Corporation, 1939

**Walter Dorwin
Teague**

1883 *Decatur, Indiana*
1960 *Flemington, New
Jersey*

Walter Dorwin Teague attended evening classes at the Art Students League, New York from 1903 to 1907, and subsequently worked as an illustrator for a mail-order catalogue and for Hampton Advertising Agency, New York. In 1912, he established his own studio and worked as a freelance typographer and graphic designer. He took a trip to Paris in 1926, and while there was influenced by the work of Le Corbusier. On his return to New York, he founded an industrial design consultancy – one of the first of its kind – and began designing cameras for Eastman Kodak, including the *Bantam Special* (1936) that was more user-friendly and compact than earlier models. In 1930, assisted by his son, Teague designed the body of the *Marmon Model 16* car, which with its streamlined form produced less air resistance than other contemporary automobiles. He also designed other streamlined products –glassware for Corning Glass Works and its Steuben division, kitchenware for Pyrex, pens and lighters for Scripto, lamps for Polaroid, mimeo-

graphs for A. B. Dick, radios for Sparton and the Centennial piano for
Steinway. Apart from consumer products, Teague also designed a plastic
truck body for UPS, supermarkets for Colonial Stores, interiors for the
Boeing 707 airliner, United States pavilions at various international trade
fairs, exhibition interiors for Ford, service stations for Texaco and a number
of exhibits at the 1939 New York World's Fair, including his gigantic cash
register for the National Cash Register Company. He also published his
influential book, *Design This Day – The Technique of Order in the Machine
Age* (1940), which celebrated the potential of machines and the "new and
thrilling style" of the Machine Age. Teague's innovative and functional de-
signs arose from his interest in proportion and symmetry and his espousal
of mechanized methods of production.

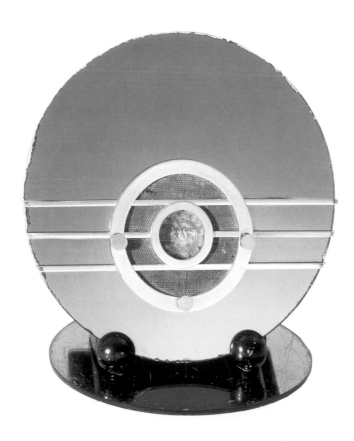

▶ *Bluebird* radio for
Sparton
Corporation,
1934–1936

## Louis Comfort Tiffany

**1848** *New York*
**1933** *New York*

▼ *Jack-in-the-Pulpit*
vase for Tiffany
Studios, 1907

Louis Comfort Tiffany was the son of Charles Lewis Tiffany (1812–1902), who in 1853 established the well-known New York firm of silversmiths and jewellers, Tiffany & Co.. Louis Comfort studied painting in 1986 under George Inness (1825–1894), and the following year exhibited his work at the National Academy of Design, New York. He began experimenting with glass in 1873, and in 1879 established a professional decorating business, with Candace Wheeler, Lockwood de Forest and Samuel Colman, known as Louis C. Tiffany & Associated Artists, which received many commissions including interiors for Mark Twain's house (1880–1981) and several rooms for President Chester A. Arthur at the White House (1882–1883). The decorating firm was disbanded in 1883, and replaced by a new enterprise, the Tiffany Glass Company. This became the Tiffany Glass & Decorating company in 1892, when Tiffany established a glass furnace at Corona, Long Island. A year later, they began producing iridescent *Favrile* glassware and Tiffany displayed his "Byzantine" chapel – a dazzling array of leaded windows, glass mosaics, pressed glass electric lamps and glass chandeliers – at the "World's Columbian Exposition" in Chicago. The *Favrile* vases, conceived as "art glass", were quite unlike any glass being produced elsewhere in America at the time. Siegfried Bing exhibited Tiffany's glassware and leaded panels at his Maison L'Art Nouveau gallery in Paris from 1895 to 1899. Tiffany also exhibited at the 1900 Paris "Exposition Universelle", and the same year changed the name of his company to Tiffany Studios. On the death of his father in 1902, he became design director of Tiffany & Co. for whom he designed jewellery. Tiffany Studios continued to produce his exquisite Art Nouveau designs until the closure of the Corona glass furnaces in 1924.

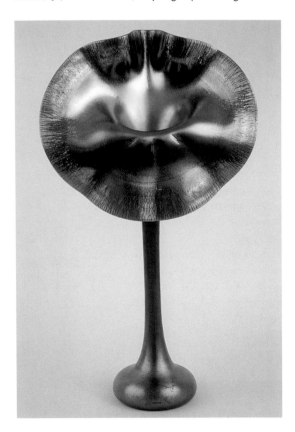

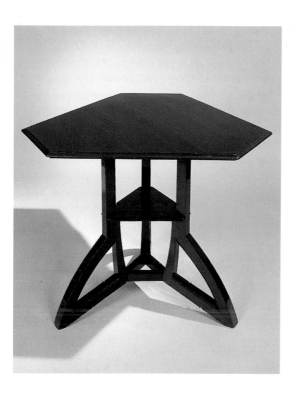

Henry van de Velde studied painting at the Académie des Beaux-Arts in
Antwerp from 1881 to 1884, and trained for one year under Carolus Duran
in Paris. In 1886, he joined Als ik Kan and co-founded L'Art Indépendent –
both Antwerp-based art societies, and two years later became a member of
the progressive Post-Impressionist art group, Les Vingt. Around this period,
he came into contact with Georges Seurat (1859–1891) and Paul Signac
(1863–1935) and his work was strongly influenced by the paintings of
Vincent van Gogh (1853–1890). In 1892, van de Velde abandoned painting
in favour of design, having been inspired by the reforming ideas of John
Ruskin (1819–1900) and William Morris, and the same year he exhibited
an embroidery at the Le Vingt salon and designed various ornaments for
books and journals. In 1894, he published *Déblaiements d'art*, in which he
pleaded for a unification of the arts, and began teaching "Arts d'Industrie
et d'Ornamentation" at the University of Brussels – although later in his
career he opposed the notion of industrial design. His first architectural
project was the Bloemenwerf House, which he built for himself in Uccle near
Brussels in 1895. Both Julius Meier-Graefe (1867–1935), who founded the

### Henry van
### de Velde

1863 *Antwerp*
1957 *Zurich*

journal *Dekorative Kunst* in 1897, and Siegfried Bing visited the house, and van de Velde later designed four rooms for Bing's gallery, Maison L'Art Nouveau, in Paris. He also exhibited a room at the Salon de la Libre Esthétique in 1896 and the following year, the Société de Henry van de Velde workshop was founded in Ixelles, near Brussels, to produce his furniture designs that were shown at the 1897 "Internationale Kunstausstellung" in Dresden. In 1899, he designed the interior and façade of Meier-Graefe's Parisian shop, La Maison Moderne. Van de Velde's designs were more "anglicized" than those of his compatriot Victor Horta, whose work in the Continental Art Nouveau style was more suited to Belgian taste. Eventually, van de Velde moved to Berlin where his less decorative and more functional designs, manufactured by Wilhelm Hirschwald's Hohenzollern Kunstgewerbe-haus, were highly appreciated. While there, he designed interiors for the Havana Tobacco Company (1900) and for the imperial barber, François Haby's salon (1901) – each remarkable for the balancing of expressive form with functional requirements. In 1902, van de Velde moved to Weimar, where he became artistic adviser to the Grand Duke Wilhelm Ernst, re-designed the entrance and reading-room of the Nietzsche library (1903) and designed the Weimar Kunstgewerbeschule (1906). As the leading exponent of Jugendstil in Weimar, van der Velde was made director of this new school

▼► Silver and tortoiseshell snail fork, caviar knife and oyster fork manufactured by Koch & Bergfeld for Theodor Müller, 1902

▼ Stoneware vase with salt-glaze for Steingutfabrik & Kunsttöpferei Reinhold Hanke, 1902

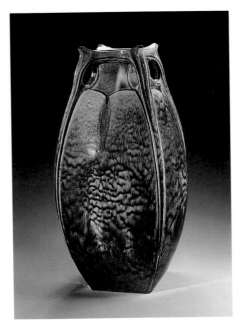

of applied arts when it opened in 1908. He also collaborated with several
local craftsmen and workshops, notably the Scheidemantel cabinet-making
firm and the jeweller, Theodor Müller, who produced his remarkably fluid
silverware designs. In 1903, van de Velde designed an elegant yet functional
dinner service for the Staatliche Porzellanmanufaktur Meißen that also in-
corporated abstracted organic forms and motifs. He was a founder member
of the Deutscher Werkbund but could not accept Hermann Muthesius'
(1861–1927) adherence to industrial standardization and left the Werk-
bund in 1914. A year later, he was forced to give up his teaching position in
Weimar and eventually emigrated to Switzerland in 1917, where he worked
as an independent architect. Between 1926 and 1936, he founded and dir-
ected the Institut Supérieur d'Architecture (ISAD) in Brussels, but in 1947
he returned to Switzerland, where he published his memoirs in 1956. Van
de Velde was an early and highly influential propagandist of modernism and
his Jugendstil designs anticipated functionalism and abstraction – two key
features of modern design.

## Wilhelm Wagenfeld

1900 *Bremen, Germany*
1990 *Stuttgart, Germany*

▲ *Kubus* moulded
glass storage jars for
Vereinigte Lausitzer
Glaswerke, 1938

Wilhelm Wagenfeld was apprenticed to the silverware manufacturer Koch & Bergfeld, and studied at the Kunstgewerbeschule, Bremen from 1914 to 1919. He then attended the Zeichenakademie (Drawing Academy), Hanau for three years and finished his training at the Bauhaus, Weimar, where he took the preliminary course and completed a metalwork apprenticeship under László Moholy-Nagy. At the Bauhaus, Wagenfeld designed his famous *MT8* table lamp (1923–1924), which was put into serial production by the workshop. After completing his journeyman's exam, he became an assistant to Richard Winkelmayer at the metal workshop of the Bauhochschule in Weimar, taking over the running of this workshop in 1928. The functional objects he made there, such as the *M15* tea caddy (c. 1929), incorporated geometric forms that were less severe than those of his earlier Bauhaus designs. During this period, he also designed door handles for S. A. Loevy, Berlin, and a number of household items for Walther & Wagner, Schleiz. Wagenfeld worked as a freelance designer for the Jenaer Glaswerke Schott & Gen. and re-designed their domestic glassware range, which included his *Sintrax* coffee maker (1931) and his famous glass tea set (1930). During the late 1930s, Wagenfeld's designs became increasingly industrial, as shown by his *Kubus* stacking storage jars that were mass-produced by the Vereinigte Lausitzer Glaswerke, for whom he also devised a trademark and promo-

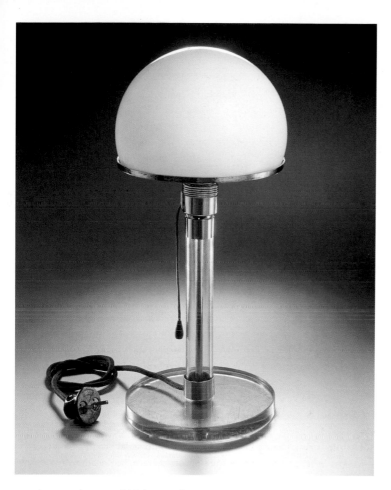

*MT9/ME1* table
lamp for Bauhaus
Dessau, 1923–1924

tional material. Wagenfeld designed ceramics for the Fürstenberg and
Rosenthal porcelain factories in the 1930s, and outlined his functionalist
approach to design in articles for journals such as *Die Form*. He taught in
Berlin at the Staatliche Kunsthochschule Grunewaldstraße from 1931 to 1935
and at the Hochschule für Bildende Künste from 1947 to 1949, and in 1954
he established the Wagenfeld Workshop in Stuttgart to develop products for
industrial production, including a melamine in-flight meal tray for Lufthansa
(1955). As a celebrated Bauhaus designer, Wagenfeld stressed the moral, so-
cial and political obligations of designers and focused on the design of inex-
pensive, functional and democratic products.

## Hans J. Wegner

b. 1914 Tønder, Denmark

▼ *Model No. JH 250 Valet* chair for Johannes Hansen, 1953 (reissued by PP Møbler)

Hans J. Wegner, the son of a master cobbler, grew up with a deep appreciation of handcraftsmanship. He undertook a carpentry apprenticeship in H. F. Stahlberg's workshop, and after serving in the military studied in Copenhagen at the Teknologisk Institut from 1936 to 1938. He later trained under the furniture designer Orla Mølegaard Nielsen (b. 1907) at the Kunsthandvaerkerskolen. In 1938, Wegner worked in Arhus for the architects, Erik Møller and Flemming Lassen, and in 1940 began working with Møller and Arne Jacobsen on the design of Arhus Town Hall, contributing designs for simple yet well-crafted furniture. From 1943 to 1946, Wegner ran his own Arhus-based design studio, and between 1946 and 1948 worked in partnership with the architect Palle Suenson in Copenhagen prior to establishing an office in Copenhagen. From 1940, Wegner also worked with the furniture-maker and chairman of the Cabinet-maker's Guild, Johannes Hansen and designed numerous chairs for his manufacturing company, including the *Round* chair (1949), which became known as *The Chair* or the *Classic Chair*. By the 1950s, Wegner was one of the leading exponents of Scandinavian design and was internationally celebrated for his exquisitely balanced and beautifully crafted chairs that were, for the most part, constructed of solid wood. These were manufactured by Johannes Hansen, Fritz Hansen, Andreas Tuck, Getama. A. P. Stolen, Carl Hansen & Søn and PP Møbler. Wegner's characteristically Scandinavian organic approach to design, as exemplified by his *Chinese* chair (1943), *Peacock* chair (1947), *Y*-chair (1950) and *Valet* chair (1953), countered the geometric formalism of the Modern Movement. As a gifted designer and craftsman, Wegner simplified form and construction to create beautiful modern re-workings of traditional furniture types.

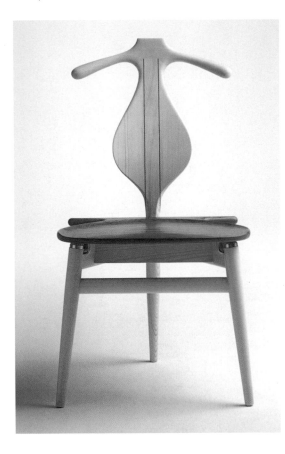

The Wiener Werkstätte were officially founded in June 1903 in Vienna by the Secessionist designers Josef Hoffmann and Koloman Moser and the wealthy banker, Fritz Wärndorfer (1869–1939). The cooperative was based on pioneering British organizations, most notably Charles Ashbee's Guild of Handicraft and was similarly dedicated to the pursuit of artistic endeavour through craftsmanship. By October 1903, various workshops had been established for silver and goldsmithing, metalwork, bookbinding, leatherwork and cabinet-making as well as an architectural office (previously Hoffmann's) and a design studio. The Wiener Werkstätte were remarkable for their cleanliness, lightness and exemplary treatment of workers – workmen in the cabinet-making workshop, for instance, received a virtually unheard of one to two weeks' paid leave. The designs produced by the Werkstätte bore not only the monograms of the designers but also those of the craftsmen who executed them, reflecting the organization's endeavour to promote equality between artist and artisan. Its members, especially Hoffmann, refused to compromise quality for affordablity and insisted on using the best available materials. Although this approach ensured excellence, it also hindered financial success and meant that the Werkstätte's democratizing influence was not as widespread as it might have been. By 1905, however, the Wiener Werkstätte had taken over from the Secession as the leading Viennese arts and crafts organization and was employing over a hundred workers. Its work was published in journals such as *Deutsche Kunst und Dekoration* and *The Studio,* and reached a wider audience through the staging of Wiener Werkstätte exhibitions (Berlin 1904, Vienna & Brünn 1905, Hagen 1906) and through participation in various international exhibitions such as the 1914 Cologne "Werkbund-Ausstellung" and the

## Wiener Werkstätte

1903–1932
*Vienna*

▼ **Dagobert Peche**, Poster for the fashion division of the Wiener Werkstätte, 1920

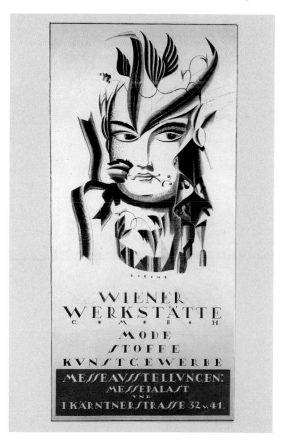

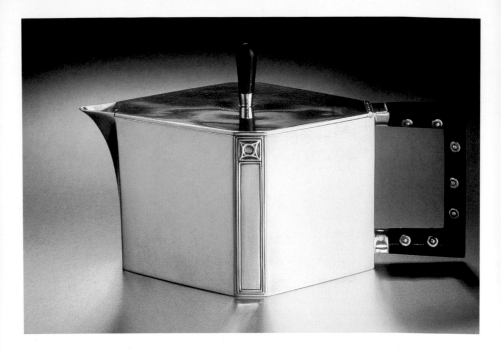

1925 Paris "Exposition Internationale des Arts Décoratifs". Between 1903 and 1932, the Werkstätte produced furniture, glassware, metalware, textiles, jewellery, clothing, wallpapers, ceramics and graphics by over two hundred designers (many of whom had studied at the Kunstgewerbeschule in Vienna), including Otto Prutscher, Jutta Sika, Michael Powolny (1871–1954), Carl Otto Czeschka (1878–1960), Berthold Löffler (1874–1960) and Emmanuel Josef Margold (1889–1962). The Werkstätte also undertook three notable Gesamtkunstwerk projects: their own theatre, the Cabaret Fledermaus (1907), Josef Hoffmann's Purkersdorf Sanatorium (1904–1906) and the Palais Stoclet (1905–1911). This latter building in Brussels exemplified the Werkstätte's early Secessionist style, which was characterized by severe rectilinearism, elaborate constructions and luxury materials. After Fritz Wärndorfer's emigration to America in 1914, the Werkstätte, managed by their new sponsor Otto Primavesi, began to produce less exclusive products that were more curvilinear and stylistically eclectic and were typified by the work by Dagobert Peche. Although branches were established in New York and Berlin in 1921 and 1929 respectively, the Wiener Werkstätte was forced into liquidation in 1932.

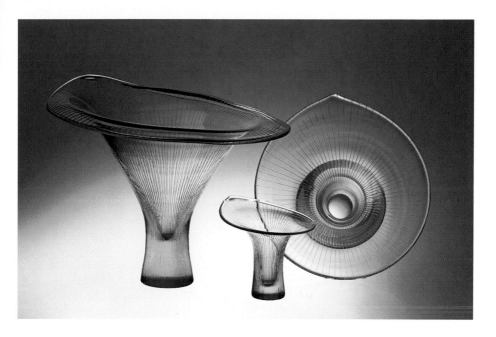

Tapio Wirkkala studied sculpture at the Taideteollinen Korkeakoulu (Central School of Industrial Design), Helsinki from 1933 to 1936, and later worked as a sculptor and graphic designer. In 1947, he shared first prize with Kaj Frank in a glassware competition organized by Iittala, and subsequently produced designs for the glassworks on a freelance basis. His blown-glass *Kantarelli* vases (1946), the forms of which were inspired by chanterelle mushrooms, captured the abstract essence of nature and exemplified Scandinavian Modernism – expressive organic forms combined with traditional crafts-manship. This series of vases, produced between 1947 and 1960, helped to establish his international reputation. Wirkkala was also widely celebrated for his laminated wood leaf-shaped bowls and furniture, which possessed an intrinsic natural beauty. The multicoloured plywood laminations were made up by him and then cut and scooped to reveal a remarkable streaked effect. His designs were exhibited at the 1951 and 1954 Milan Triennales where they were awarded six Grand Prix. Wirkkala was artistic director of Taideteollinen Korkeakoulu, Helsinki from 1951 to 1954, and worked in Raymond Loewy's New York office from 1955 to 1956. He also designed glass for Venini, ce-ramics for Rosenthal, knives for Hackman and lighting for Airam. Wirkkala skillfully balanced craftsmanship with industrial techniques to create beauti-ful functional objects for the home.

**Tapio Wirkkala**
1915 *Hanko, Finland*
1985 *Esbo, Finland*

▲ *Kantarelli* vases for Iittala, 1946

## Frank Lloyd Wright

1867 *Richland Center, Wisconsin*
1959 *Phoenix, Arizona*

Frank Lloyd Wright studied engineering at the University of Wisconsin from 1885 to 1887, and then moved to Chicago, where he worked briefly in the architectural offices of Joseph L. Silsbee before joining the Adler & Sullivan practice. In 1889, he built his own home in Oak Park, Illinois, and the following year was assigned to oversee all residential commissions received by Adler & Sullivan. However, he left the firm in 1892 after a disagreement about some clandestine architectural work he had undertaken, and in 1893 established his own practice in Chicago, focusing chiefly on the design of private houses in the Oak Park area and other suburbs of the city. From 1900 to 1911, Wright designed some fifty residences that became known as "Prairie Houses". These structures were built mainly from natural materials – stone, brick and wood – and were designed to accentuate the natural beauty of the surrounding Mid-West prairie, with their low elevations and gently sloping roof lines emphasizing the horizontal. Their innovative open-plan interiors – similarly in tune with nature – employed screening walls and soft-toned natural colours that maximized the sense of light. Many of these

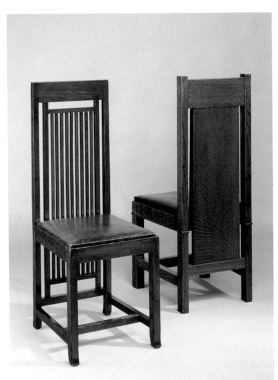

▶ Chairs designed
for the Isabel
Roberts House and
the Francis W. Little
House, 1908 & 1902

residences, as well as later buildings by Wright, were conceived as Gesamt-kunstwerk schemes and incorporated site-specific fittings and furniture, that was partly built-in. Wright intended these unified projects to possess a "naturalness" and a spiritual transcendence. Like the Prairie Houses, his later office and public buildings such as the Larkin Company Administration Building in Buffalo (1903–1905) were integrated schemes that were innovatively planned so as to provide as pleasant an environment as possible. The revolutionary layout of the Larkin Building, for example, was not only functionally efficient but, with its open galleries and light-filled central court, promoted a sense of "family" with all the employees working together rather than separately in private offices. His rectilinear steel office furniture was specially designed for this project and was both functionally and visually unified with its surroundings. Like the Larkin Building, the Unity Temple in Oak Park (1904–1907) had geometric external massing that belied the remarkable sense of space and light inside. The innovative cantilevered construction of this building and its non-supporting screen walls – of

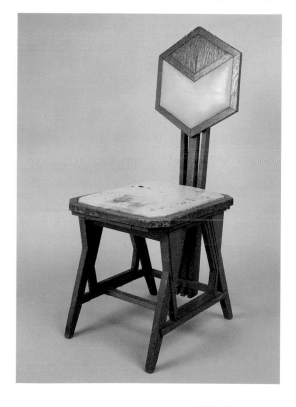

▼ *Peacock* chair designed for the Imperial Hotel in Tokyo, c. 1921–1922

masonry, wood, concrete or glazing – marked a turning point in Wright's career towards what he called, the "destruction of the box". Wright's work became increasingly distanced from its Arts & Crafts Movement origins as he began exploring the structural and decorative potential of "industrial" concrete blocks, which he used to great effect in the design of the Imperial Hotel in Tokyo (1915–1922) and four houses in Los Angeles (early 1920s). During the Depression of the 1930s, when commissions were scarce, Wright founded an educational community known as the Taliesin Fellowship, and in 1932 published an autobiography. His flagging career was then revived by two important commissions – the Johnson Wax Administration Building (1936–1939) and Edgar J. Kaufmann's residence, Fallingwater

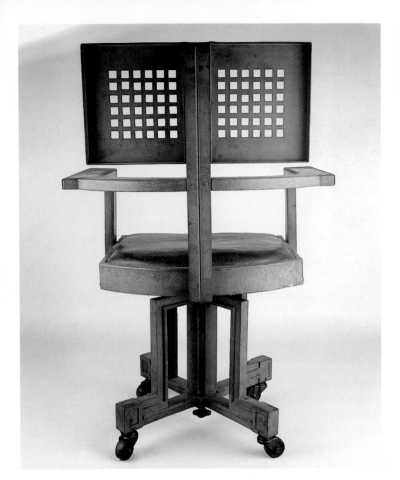

◄ Swivel armchair
designed for the
offices of the Larkin
Company
Administration
Building, c. 1904

(1935–1939). These projects, like his later Guggenheim Museum (1943–1946
& 1955–1959), incorporated reinforced concrete cantilevered constructions
and heralded an entirely new and liberated style of architecture. All of
Wright's projects, whether they used natural or man-made materials, curved
or rectilinear forms, expressed his reverence for nature and his overwhelm-
ing belief in the importance of human values or as he put it, "humanity".
Wright stated that "beauty is but the shining of man's light (soul)", and his
pioneering Organic Design attempted to symbolize and capture the spiritual
essence of both man and nature. Neither a historicist nor a modernist,
Wright was first and foremost a humanist. The astonishing breadth and
vision of his work continues to impress and influence the world of design.

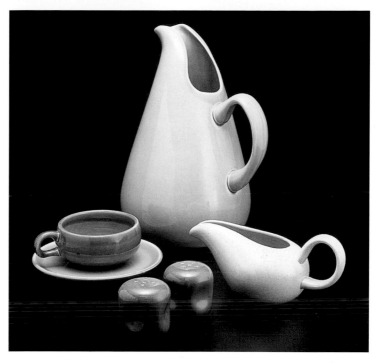

Russel Wright studied painting at the Cincinnati Art Academy and sculpture at the Art Students' League, New York. In 1924, Norman Bel Geddes and the playwright Thornton Wilder offered him a job designing theatrical sets, and he began producing sculptural caricature masks that brought him both publicity and an income. He also designed a range of spun aluminium bar accessories that were equally successful and effectively launched his career as an industrial designer. In 1930, he established his own workshop in New York and began producing metalwares, including cocktail shakers, tea sets and pitchers. Wright's Moderne products, which combined Functionalism, Art Deco styling and mission-style vernacularism, were exhibited at the Museum of Modern Art's "Machine Age" exhibition in 1934. Designs, such as his blonde maplewood *Modern Living* furniture for Conant-Ball (1935), were extremely popular, not least because they were less expensive than modern products imported from Europe and were better suited to American taste. His casual yet modern "American Way" approach to design was typified by his well-known *American Modern* dinnerware (1937). Highly celebrated during his career, Wright was the first designer of domestic products to have his name included in manufacturers' advertising copy.

**Russel Wright**
1904 *Lebanon, Ohio*
1976 *New York*

**Marco Zanuso Sr.**
b. 1916 *Milan*

Marco Zanuso Sr. studied architecture at the Politecnico di Milano, graduating in 1939. He established his own Milan-based office in 1945, which undertook product and furniture design commissions as well as architectural and town-planning projects. As one of the leading Italian designers of the post-war years, Zanuso co-edited the journal *Domus* with Ernesto Rogers (1909–1969) from 1946 to 1947 and edited *Casabella* magazine from 1947 to 1949. He was commissioned by the Pirelli company in 1948 to explore the potential of latex foam as an upholstering material, and his subsequent *Antropus* chair (1949) was the first chair to be produced by Arflex – a manufacturing company set up by Pirelli. This was followed by several other latex foam upholstered seating designs, including the *Lady* chair (1951) and the *Triennale* sofa (1951), which were first exhibited at the IX Milan Triennale where Zanuso won a Grand Prix and two gold medals. He was also awarded a Compasso d'Oro in 1956 for his *Model 1100/2* sewing machine for Borletti – a design that epitomized his work through its rational yet sculptural form. In addition, he undertook several architectural commissions – the Olivetti manufacturing plants in Sao Paulo (1955) and Buenos Aires (1955–1957) and the Necchi factory in Pavia (1961–1962), which revealed his interest in

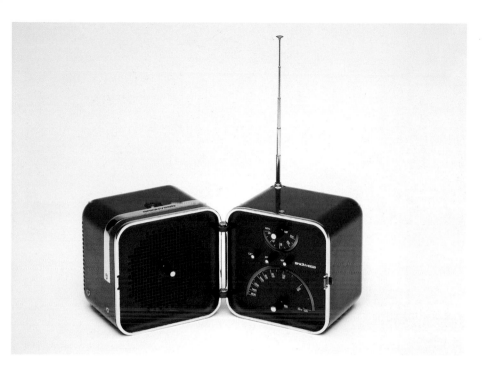

"product architecture" and pre-fabricated structures. From 1958 to 1977, Zanuso collaborated on numerous landmark product and furniture designs with Richard Sapper. These included the enamelled, lightweight, stamped steel *Lambda* chair for Gavina (1959–1964); the *No. 4999/5* stacking child's chair for Kartell (1961–1964), which was the first seating design to be produced in injection-moulded polyethylene; the *Doney 14* (1964) and *Black 12* (1969) televisions for BrionVega that were remarkable for their miniaturized electrical components of technology; the *Grillo* telephone for Siemens (1966) with its innovative folding form; and the *2000* kitchen scales for Terraillon (1970). In 1956, Zanuso became a member of the CIAM (Congrès Internationaux d'Architecture Moderne) and the INU (Istituto Nazionale Urbanista). That same year, he also co-founded the Associazione di Disegno Industriale (ADI) and was its president from 1966 to 1969. He was a town councillor in Milan between 1956 to 1960 and became a member of the planning commission for the city in 1961. Throughout his career, Zanuso experimented with new materials and technologies and designed sleek yet functional products for industrial manufacture that often re-defined the formal potential of existing types.

▲ **Marco Zanuso & Richard Sapper**, *TS502* radio for Brionvega, 1964

# Appendix

Acknowledgements

Photographic Credits

Authors' Biographies

Time-line

We are immensely grateful to those individuals and institutions that have allowed us to reproduce images. We regret that in some cases it has not been possible to trace the original copyright holders of photographs from earlier publications. We would also like to thank the numerous designers, manufacturers and institutions that have kindly supplied portrait images. The publisher has endeavoured to respect the rights of third parties and if any such rights have been overlooked in individual cases, the mistake will be correspondingly amended where possible. The majority of historic images were sourced from the design archives of Thomas Berg Kunsthandel, Bonn; Fiell International Ltd., London and Benedikt Taschen Verlag, Cologne.

**Acknowledge-
ments**

**Photographic
Credits**
L = left
R = right
T = top
B = below

Taschen Verlag Archiv, Cologne **88** Benedikt Taschen Verlag Archiv, Cologne **89** Barry Friedman, New York **90** Benedikt Taschen Verlag Archiv, Cologne **91** Die Neue Sammlung, Munich **92** Cappellini, Milan **93** Vitra, Weil am Rhein **94** Museé des Arts Décoratifs de Montreal, Montreal **95** Sotheby's, London **97** T: Barry Friedman, New York **98** Cassina, Milan **99** Benedikt Taschen Verlag Archiv, Cologne **100** Raymond Loewy Associates, London **101** Museé des Arts Décoratifs de Montreal, Montreal **102** Studio X, London (photo: José Lasheras) **103** Studio X, London **104** Hunterian Art Gallery – University of Glasgow, Glasgow **105** Barry Friedman, New York **106** O-Luce, Milan **107** Fiell International, London (photo: Paul Chave) **108** Benedikt Taschen Verlag Archiv, Cologne **109** Die Neue Sammlung, Munich **110** Luceplan, Milan **111** Memphis, Milan **112** Memphis, Milan **113** Memphis, Milan **114** Alessandro Mendini, Milan **115** Zanotta, Milan (photo: Ramazzotti) **116** Benedikt Taschen Verlag Archiv, Cologne **117** Benedikt Taschen Verlag Archiv, Cologne **118** Barry Friedman, New York **119** Museé des Arts Décoratifs de Montreal, Montreal **120** Haslam & Whiteway, London **121** Victoria & Albert Museum, London (Press Office) **122** Torsten Bröhan, Düsseldorf **123** Barry Friedman, New York **124** Private Collection, London **125** Fiell International, London (Mithra Neuman Collection) **126** Fiell International, London (photo: Peter Hodsoll) **127** Herman Miller, Zeeland, Michigan **128** Olivetti, Milan **129** Die Neue Sammlung, Munich **130** Vitra, Weil am Rhein **131** Bonhams, London **132** Die Neue Sammlung, Munich **133** Bayer, Leverkusen **134** Bonhams, London **135** Bonhams, London **136** Gaetano Pesce, New York **137** Cassina, Milan **138** Galerie Bischofberger, Zurich **139** Venini, Venice **140** B&B Italia, Novedrate **141** Die Neue Sammlung, Munich (photo: A. Bröhan) **142** Draenert Studio, Frankfurt **143** Alessi, Crusinallo **144** Bonhams, London **145** Alessi, Crusinallo **146** T: Stiletto Studios, Berlin **146** B: Luxo Italiana, Presezzo **147** Benedikt Taschen Verlag Archiv, Cologne **148** Die Neue Sammlung, Munich **149** Die Neue Sammlung, Munich **150** L: Benedikt Taschen Verlag Archiv, Cologne **150** R: Benedikt Taschen Verlag Archiv, Cologne **151** Barry Friedman, New York **152** Barry Friedman, New York **153** Torsten Bröhan, Düsseldorf **154** Barry Friedman, New York **155** Barry Friedman, New York **156** Fiell International, London (photo: Paul Chave) **157** Knoll International, New York **158** Alessi, Crusinallo **159** Artemide, Milan **160** Iittala, Helsinki **161** Memphis, Milan **162** Poltronova, Montale **163** Olivetti, Milan **164** Design Gallery Milano, Milan **165** Driade, Milan **166** Kartell, Milan **167** L: Alessi, Crusinallo **167** R: Alessi, Crusinallo **168** Die Neue Sammlung, Munich (photo: A. Bröhan) **169** Die Neue Sammlung, Munich **170** Die Neue Sammlung, Munich **171** Sotheby's, London **172** L: Torsten Bröhan, Düsseldorf **172** R: Torsten Bröhan, Düsseldorf **173** Barry Friedman, New York **174** Barry Friedman, New York **175** Torsten Bröhan, Düsseldorf **176** P.P. Møbler, Allerød (photo: Schakenburg & Brahl) **177** Benedikt Taschen Verlag Archiv, Cologne **178** Torsten Bröhan, Düsseldorf **179** Iittala, Helsinki **180** Torsten Bröhan, Düsseldorf **181** Barry Friedman, New York **182** Christies Images, London **183** Museé des Arts Décoratifs de Montreal, Montreal **184** Arflex, Milan **185** Die Neue Sammlung, Munich (photo: Koller)

Charlotte J. Fiell (born 1965) studied at the British Institute in Florence and at Camberwell School of Arts and Crafts, London, where she received a BA (Hons) in The History of Drawing and Printmaking with Material Science. She later trained with Sotheby's Educational Studies, also in London.

Peter M. Fiell (born 1958) trained with Sotheby's Educational Studies in London. He received an MA in Design Studies from Central Saint Martin's College of Art and Design, London, where he is now a guest lecturer. He is also the founder and managing director of the design research company, Tectonica Limited.

Together, the Fiells run a design consultancy in London, Fiell International Limited, specialising in the sale, acquisition, study and promotion of important design artifacts. They have curated a number of exhibitions and written numerous articles and several books on design, notably TASCHEN's *Charles Rennie Mackintosh*, *1000 Chairs*, *William Morris* and *Industrial Design*. They also edited the six-volume *Decorative Art* series.

The Fiells can be contacted at fiell@btinternet.com

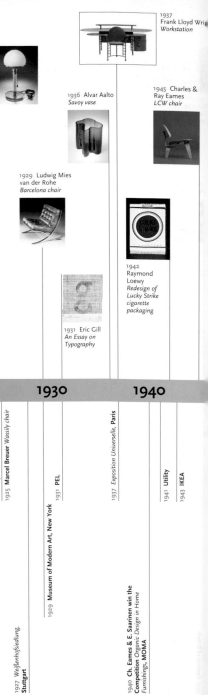

1937
Frank Lloyd Wri[ght]
*Workstation*

1908 Olivetti
founded

1924
Wilhelm Wagenfeld
*MT9/M1 table lamp
for the Bauhaus*

1945 Charles &
Ray Eames
*LCW chair*

1936 Alvar Aalto
*Savoy vase*

1924
Marianne Brandt
*Ashtray for the
metal workshop
at the Bauhaus*

1929 Ludwig Mies
van der Rohe
*Barcelona chair*

WERKBUND
W
COELN 1914

1914
The Deutsche
Werkbund
Exhibition in
Cologne

1903 Wiener
Werkstätte
founded

1942
Raymond
Loewy
*Redesign of
Lucky Strike
cigarette
packaging*

1918–23
Gerrit Rietveld
*Red/Blue chair*

1931 Eric Gill
*An Essay on
Typography*

**1900**      **1910**      **1920**      **1930**      **1940**

1904 **Georg Jensen**
*Silversmithing workshop*

1907 **Peter Behrens designs**
*AEG corporate identity*

1907 **Deutscher Werkbund**

1909 **Futurist Manifest**

1913 **Monotype produces** *Imprint,* **the first
typeface for mechanical composition**

1915 **Kasimir Malevich launches**
*Suprematism in Petrograd*

1917 **De Stijl launched**
*Constructivism emerges in Russia*

1919 **Bauhaus founded in Weimar**

1920 **Vkhutemas**

1925 *Exposition des Arts
Décoratifs et Industriels,* **Paris**

1925 **Marcel Breuer** *Wassily chair*

1927 *Weißenhofsiedlung,*
**Stuttgart**

1929 **Museum of Modern Art, New York**

1931 **PEL**

1937 *Exposition Universelle,* **Paris**

1940 **Ch. Eames & E. Saarinen win the
Competition** *Organic Design in Home
Furnishings,* **MOMA**

1941 **Utility**

1943 **IKEA**

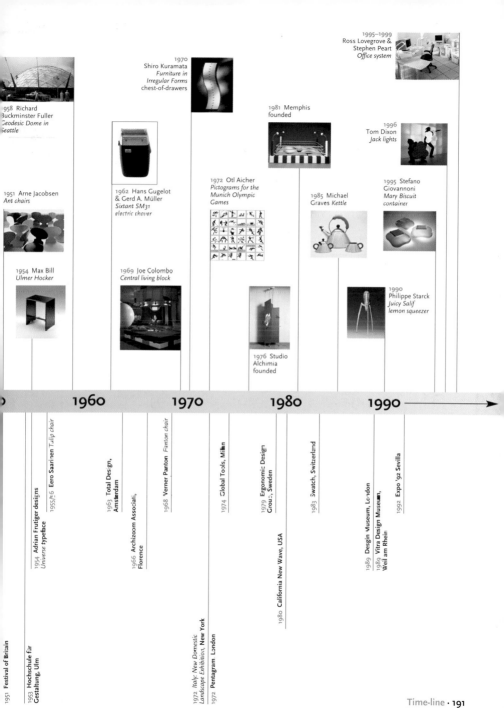

1958 Richard Buckminster Fuller *Geodesic Dome in Seattle*

1970 Shiro Kuramata *Furniture in Irregular Forms* chest-of-drawers

1995–1999 Ross Lovegrove & Stephen Peart *Office system*

1981 Memphis founded

1996 Tom Dixon *Jack lights*

1951 Arne Jacobsen *Ant chairs*

1962 Hans Gugelot & Gerd A. Müller *Sixtant SM31 electric shaver*

1972 Otl Aicher *Pictograms for the Munich Olympic Games*

1985 Michael Graves *Kettle*

1995 Stefano Giovannoni *Mary Biscuit container*

1954 Max Bill *Ulmer Hocker*

1969 Joe Colombo *Central living block*

1990 Philippe Starck *Juicy Salif lemon squeezer*

1976 Studio Alchimia founded

**1960**   **1970**   **1980**   **1990** →

1951 Festival of Britain

1953 Hochschule für Gestaltung, Ulm

1954 Adrian Frutiger designs *Universe typeface*

1955/56 Eero Saarinen *Tulip chair*

1963 Total Design, Amsterdam

1966 Archizoom Associati, Florence

1968 Verner Panton *Fantoni chair*

1972 *Italy: New Domestic Landscape Exhibition*, New York

1972 Pentagram London

1974 Global Tools, Milan

1979 Ergonomic Design Group, Sweden

1980 California New Wave, USA

1983 Swatch, Switzerland

1989 Design Museum, London

1989 Vitra Design Museum, Weil am Rhein

1992 Expo '92 Sevilla

Time-line · 191

# "Buy them all and add some pleasure to your life."

**Art Now**
Eds. Burkhard Riemschneider,
Uta Grosenick

**Art. The 15th Century**
Rose-Marie and Rainer Hagen

**Art. The 16th Century**
Rose-Marie and Rainer Hagen

**Atget's Paris**
Ed. Hans Christian Adam

**Best of Bizarre**
Ed. Eric Kroll

**Karl Blossfeldt**
Ed. Hans Christian Adam

**Chairs**
Charlotte & Peter Fiell

**Classic Rock Covers**
Michael Ochs

**Description of Egypt**
Ed. Gilles Néret

**Design of the 20th Century**
Charlotte & Peter Fiell

**Dessous**
Lingerie as Erotic Weapon
Gilles Néret

**Encyclopaedia Anatomica**
Museo La Specola
Florence

**Erotica 17th–18th Century**
From Rembrandt to Fragonard
Gilles Néret

**Erotica 19th Century**
From Courbet to Gauguin
Gilles Néret

**Erotica 20th Century, Vol. I**
From Rodin to Picasso
Gilles Néret

**Erotica 20th Century, Vol. II**
From Dalí to Crumb
Gilles Néret

**The Garden at Eichstätt**
Basilius Besler

**Indian Style**
Ed. Angelika Taschen

**London Style**
Ed. Angelika Taschen

**Male Nudes**
David Leddick

**Man Ray**
Ed. Manfred Heiting

**Native Americans**
Edward S. Curtis
Ed. Hans Christian Adam

**Paris-Hollywood.**
**Serge Jacques**
Ed. Gilles Néret

**20th Century Photography**
Museum Ludwig Cologne

**Pin-Ups**
Ed. Burkhard Riemschneider

**Giovanni Battista Piranesi**
Luigi Ficacci

**Redouté's Roses**
Pierre-Joseph Redouté

**Robots and Spaceships**
Ed. Teruhisa Kitahara

**Eric Stanton**
Reunion in Ropes & Other Stories
Ed. Burkhard Riemschneider

**Eric Stanton**
She Dominates All & Other
Stories
Ed. Burkhard Riemschneider

**Tattoos**
Ed. Henk Schiffmacher

**Edward Weston**
Ed. Manfred Heiting

## www.taschen.com